STOPPING TIME

STOPPING TIME

FOREWORD BY
HAROLD EDGERTON

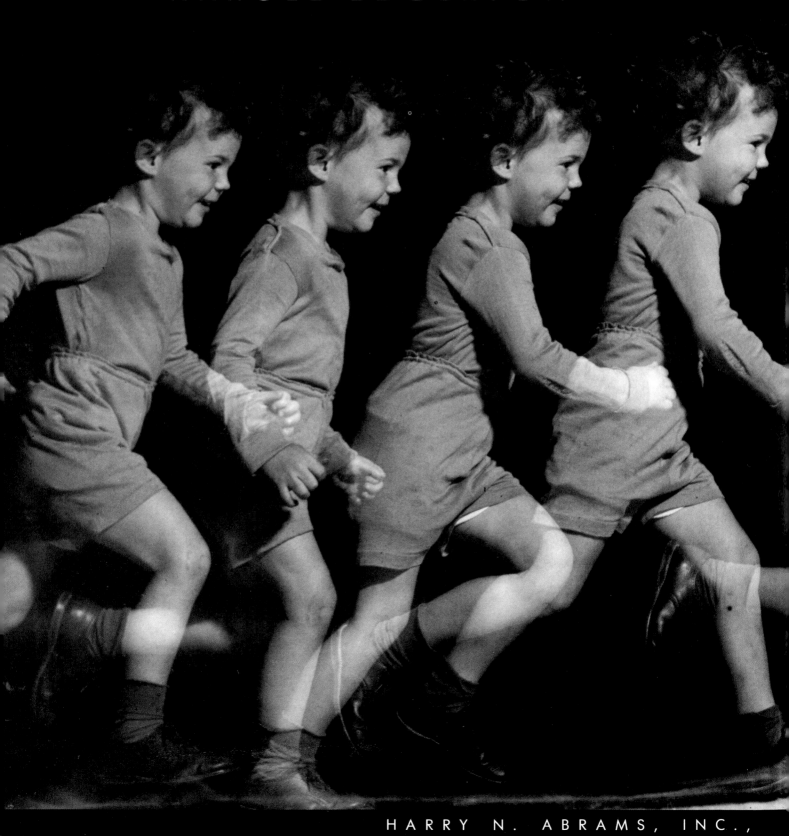

HARRY N. ABRAMS, INC.,

THE PHOTOGRAPHS OF
HAROLD EDGERTON

TEXT BY
ESTELLE JUSSIM

EDITED BY
GUS KAYAFAS

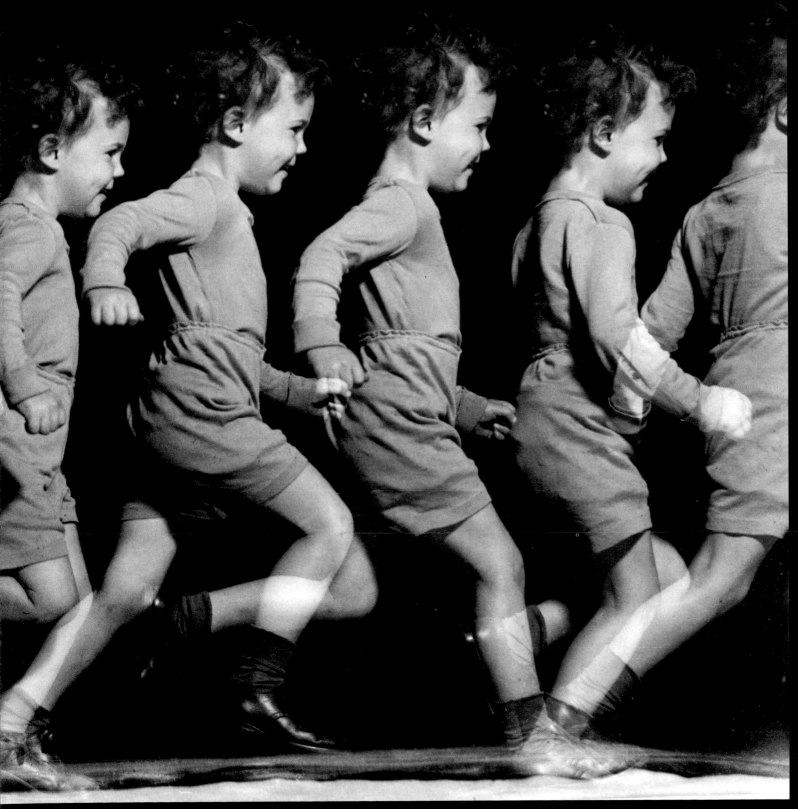

PUBLISHERS, NEW YORK

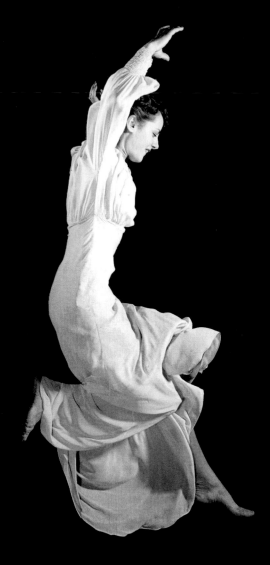

A GRACEFUL LEAP. 1938.

(preceding page) *CHILD RUNNING (BOB EDGERTON).*
1939.

Library of Congress Cataloging-in-Publication Data
Edgerton, Harold Eugene, 1903–
 Stopping time: the photographs of Harold Edgerton.
 "Complete bibliography of books and articles by
 Harold E. Edgerton": p. 162
 Bibliography: p.
 1. Photography—High-speed.
 2. Photography—Scientific applications.
 3. Edgerton, Harold Eugene, 1903-
I. Jussim, Estelle. II. Kayafas, Gus. III. Title
TR593.E34 1987 770'.92.4 87–1064
ISBN 0–8109–2717–9 (pbk.)

Editor: Charles Miers
Designer: Bob McKee

Ansel Adams quotation reproduced courtesy
of the Trustees of the Ansel Adams Publishing
Rights Trust. All rights reserved.
Copyright © 1987 Harold Edgerton

Paperback edition published in 2000 by
Harry N. Abrams, Incorporated, New York.
All rights reserved. No part of the contents
of this book may be reproduced without the
written permission of the publisher.
Printed and bound in Japan

(front cover) *SHOOTING THE APPLE.*
1964.
(back cover) *GOLF TEE-OFF.* 1962.
(this page) *GRACEFUL LEAP.* 1938.
(preceding page) *CHILD RUNNING
 (BOB EDGERTON).* 1939.

Harry N. Abrams, Inc.
100 Fifth Avenue
New York, N.Y. 10011
www.abramsbooks.com

CONTENTS

BACK DIVE. 1954.

Multiflash reveals the magnificent geom-
etry of motion, as a talented diver, Burt
West, flips backward in a procedure that
lasted less than half a second. West was
preparing a manual for divers and enlist-
ed Edgerton's willing aid.

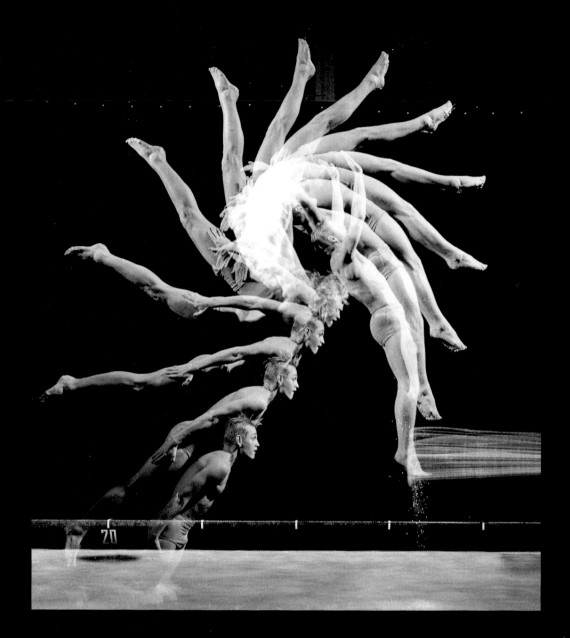

ACKNOWLEDGMENTS

A little more than twenty-one years ago, I sat in on a freshman seminar given by Doc Edgerton. I had come to MIT to study physics and to learn how the world worked. When I discovered in that first year that the certainties I had hoped to find did not exist, I was shocked and somewhat depressed. However, Doc's contagious excitement for simple discoveries, sometimes just for how something looked, was a focus for very real experience and inquiry that seemed missing from most of the other courses in which I was enrolled. I have since discovered that Doc has always provided that kind of focus to the MIT community and to the public that knows him and his work. The pictures in this book, like the lectures I attended, spark tremendous curiosity about the physical world.

I want to thank Doc for his pictures, his cooperation and friendship, and his example. His wife, Esther, and his assistant Jean Mooney provided insights and information otherwise unavailable. My wife, Arlette, encouraged me and always patiently gave me advice. Estelle Jussim wrote a marvelous essay and taught me much about writing. Marie Dagata found more in one summer of research than I had dreamed existed. In preparation for this publication, the staff at Palm Press helped produce the best Edgerton prints ever made.

At Abrams, I am grateful to Bob McKee, who designed the book with a true appreciation for the pictures, and Charles Miers. Charles's interest, prompted by an article in the *International Herald Tribune*, led him to contact Doc and me with the proposal to explore the possibility of this book. Sharing with him the excitement of what Edgerton has done reminded me of my own renewed sense of wonder when I am with Doc. Charles brought the project from an idea into reality, and I thank him for making me work harder than I have ever worked.

Gus Kayafas
Palm Press

FOREWORD

One of my first memories is of designing and building a searchlight on the porch roof of my parents' home in Lincoln, Nebraska, when I was about ten years old. It consisted of a one-gallon tin can mounted on an adjustable gimbals on a wooden post (details of the lamp and cords I have long forgotten). I soon found out that a narrow, tight beam of light cannot be formed without some proper optics, but I considered my first experiment a tremendous success. I discovered that I was limited in what I could accomplish, and that I must learn from the actual results rather than from my expectations.

In 1914, my family moved to Aurora, Nebraska, a town of about three thousand people. I was in junior high school. One of my friends had a large collection of ham radio equipment and had become disillusioned with it. Would I be interested? Well, maybe so. We did a lot of haggling, and eventually he unloaded his entire collection for a U.S. Liberty Bond I had recently bought.

I purchased a camera to record my new radio station and the antenna I built for it. Why not a large-format camera? So I picked out a postcard folding model from a mail-order catalog. It came promptly, and I went down to get a film at the drugstore, where I learned that a big camera costs more per picture than a smaller one. Also, I learned that a roll of film had eight or twelve pictures that all must be taken before the film could be processed. There was a crisis at the drugstore: the thirty cents in my pocket could not get me the fifty-five-cent roll of film, and I had to go home to get more money.

I tried to get a photo of myself at the radio set in the house, but I needed light! The first pictures were badly underexposed; only the whites of my eyes showed. So I was quickly impressed when I learned of photographers who illuminated their subjects by the use of flash powder, although after the first picture there was a lot of smoke. I never used flash powder. The chemical flashbulb with wire or foil contained in an oxygen atmosphere superceded flash powder, but like its predecessor the flash duration was too long to stop action and required a fast shutter to shorten the camera's exposure time.

About 1928, I made my first electrical flash lamp. It was a mercury arc lamp (actually a controlled rectifier for use as a circuit element). I had to use what was available. The tube was a complicated glass bulb with a liquid pool of mercury at the bottom. I had to build a holder out of two-by-four-inch wood parts to keep the mercury arc tube close to the subject since the flash was very dim. The spark was so short that a shutter was not needed to control exposure. The lab would be darkened and the shutter of the camera left open until the flash fired, and then it was closed. However, as mercury vapor heats up with use it becomes difficult to control. My colleagues and I recognized that an inert gas such as argon would be better. Soon, xenon was tried; it is now almost universally used because of its

electrical and optical properties. Today, I marvel at the small, efficient xenon flash units that are so commonly used in modern amateur cameras. Electronic flash has come a long way from the mercury arc lamp.

Many is the time that I took my classes of students in electrical engineering down into the laboratory to see the experiments with flash lamps. Although the devices were primitive (especially the tubes they each blew and filled with gas themselves), the ideas were there to see and experience. Visualization in education is a tremendous asset.

I also strongly believe in hands-on experience and experimenting with phenomena in the real world. More often than not, the experimenter is exposed to ideas that may lead to a new field of endeavor. A good experiment is simply one that reveals something previously unknown to the student. Some students expect the results to prove the initial assumption, but I have always empathized with the student who sees new discoveries and knowledge that were not anticipated flowing from the laboratory. There is no such thing as a "perfect" result or a complete study of a phenomenon. For example, although I've tried for years to photograph a drop of milk splashing on a plate with all the coronet's points spaced equally apart, I have never succeeded.

In many ways, unexpected results are what have most inspired my photography. I remember trying to discover what happens when a .30 caliber bullet goes through an electric light bulb. The timing microphone that triggered the strobe was moved for each photo to show the activity at different stages. Of special interest is the photograph in the sequence where the bullet is completely concealed in the bulb (pages 124–5). Cracks in the far side of the bulb are formed by the concentration of the shock wave in the glass, which travels many times faster than the bullet. Thus, the glass is broken "before" the bullet arrives. The experience of seeing the unseen has provided me with insights and questions my entire life. It seems to have struck a responsive chord in many others as well. For nearly sixty years, I have found wonderful audiences for these pictures: be they my colleagues, museum-goers, or elementary school students, their interest and wonder have been a true pleasure and inspiration to me.

This book and many of my exhibits over the past ten years are largely the results of efforts by Gus Kayafas, a former student and currently a research affiliate in the MIT Stroboscopic Light Laboratory. I would like to acknowledge his work and thank him for all he has done.

Harold E. Edgerton
Massachusetts Institute of Technology
January 8, 1987

ASTONISHMENTS AND MARVELS: THE PHOTOGRAPHS OF HAROLD E. EDGERTON

THE FIRST DECADE

On January 14, 1932, when the worldwide depression was at its worst, a young electrical engineering instructor from the Massachusetts Institute of Technology visited the Boston office of David Rines, Patent Attorney, and calmly admitted that he was broke. Unable to pay for his services, he believed nevertheless that Rines might be willing to undertake the work of applying for a patent for his invention: a stroboscopic light that would have wide applications for industry and the potential to revolutionize photography. Someone had guided Harold E. Edgerton to the right person: impressed by both the young man and the invention, Rines accepted the challenge without suspecting that the patent litigation would be so long-lived that Edgerton would never see a penny. If Edgerton's next forty inventions—which include a special sonar and other deep-water probes used by eminent underwater explorers, from Jacques-Yves Cousteau to the team that recently found the wreck of the *Titanic*—would eventually prove to be more financially successful, it was that first highly powerful, very fast, reusable flash lamp that established him as one of the most extraordinary inventors of the twentieth century and a giant in the history of photography. It was the fulcrum of a lighting and timing system that enabled Edgerton to photograph ultra-high-speed events and multiple-action sequences and to reveal with remarkable precision aspects of reality hitherto unseen.

Out of the enormous number of photographs produced during the last fifty years, only a very few pictures have the unique qualities of being recognized almost universally and remembered from decade to decade. Some examples are Dorothea Lange's portrait of a migrant mother, Ansel Adams's *Moonrise over Hernandez*, the news photo-

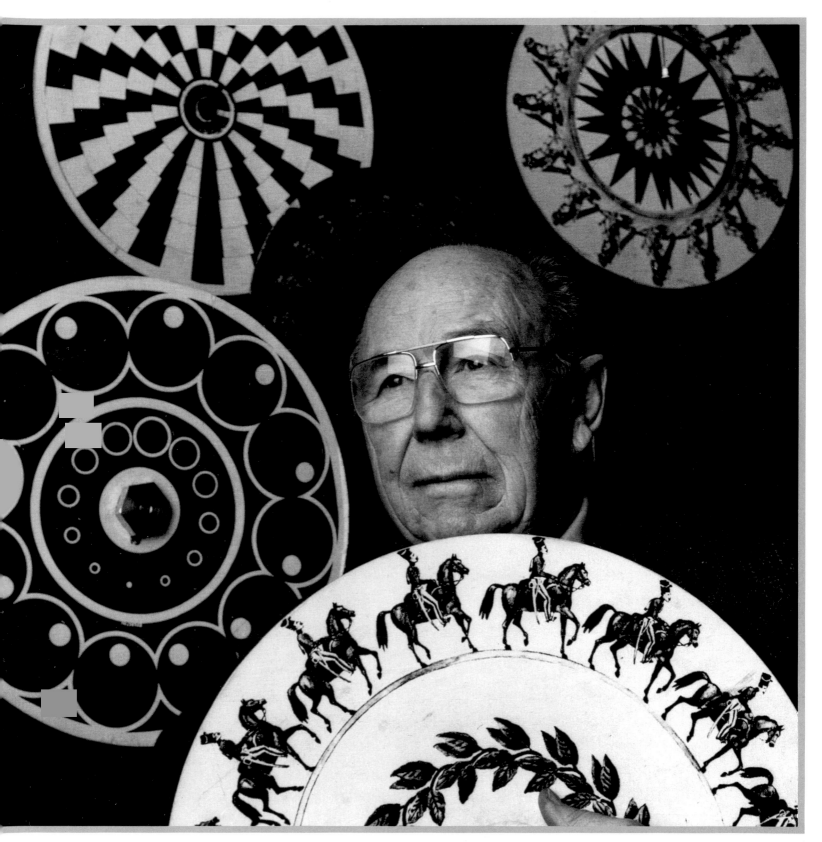

ABE FRAJNDLICH. *PORTRAIT OF HAROLD EDGERTON AT THE MIT STROBOSCOPIC LIGHT LABORATORY.* 1986.

As part of his early investigations into the effects of the stroboscope, Edgerton—like Etienne-Jules Marey before him—designed his own whirling disks. Seen rotating under the flickering light of the stroboscope, the patterns produce optical effects, which vary according to the speed of the rotating disk and the rate of the flashing lamp. Students in Edgerton's lab have to design such disks in order to better their understanding of the function of the stroboscope.

graph of the *Hindenburg* disaster, and the first pictures of the victims of Nazi concentration camps. These remain in our collective memory. Once you have seen an Edgerton photograph, you can't forget it either: the apple pierced by a bullet, the coronet formed by a milk drop, the football kick, the crystallized column of faucet water, and the astonishing multiple-flash pictures of tennis players, golfers, fencers, and divers, all caught in action sequences that resemble the depictions of motion in Futurist paintings. Those amazing Edgerton pictures taken during the first decade of strobe—the 1930s—resonate a masterful scientific realism touched by wit. Reproduced again and again, in *Life* magazine, in the major histories of photography, in basic science textbooks, in advertisements and posters, they have become part of the cultural history of our era.

Edward Steichen, himself a widely respected photographer and the organizer of the first blockbuster exhibition of photography (*The Family of Man*, at New York City's Museum of Modern Art), wrote: "How well I remember my excitement on seeing the succession of exposures of the one stroboscopic light photograph of a man swinging at a golf ball [page 43]. It not only opened a new vista from the scientific standpoint but they [*sic*] were also a new art form." Steichen was by no means alone in his enthusiasm. Beaumont Newhall, a pioneering photographic historian, included Edgerton's strobe image of the milk-drop coronet (see page 127) in the very first exhibition of photography at The Museum of Modern Art in 1937. He later told Edgerton, "Through your perfection of the electronic flash, mankind has seen phenomena never before visible or even imagined." The present curator of photography at the museum, John Szarkowski, who in 1967 assembled the exhibition *Once Invisible*, observed that Edgerton's photographs "have hung on our museum's walls almost as consistently as Picasso's [paintings] have," and they are probably as familiar to most visitors as that artist's *Guernica*. Steichen was so inspired by Edgerton's impact on news and sports photography that he organized the 1949 exhibition *The Exact Instant*, which featured a mural measuring thirty feet wide by fourteen feet high of Edgerton's pictures of an atomic bomb explosion microseconds after its detonation.

Today's photographers are so accustomed to the sophisticated and portable high-speed flash units that accompany their complex cameras they may overlook the fact that it was Edgerton who made all of this possible. For decades, the taking of indoor pictures had required the

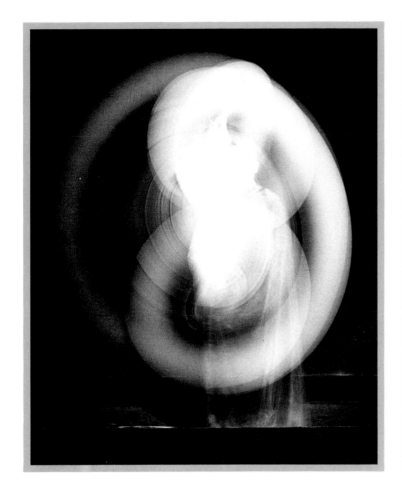

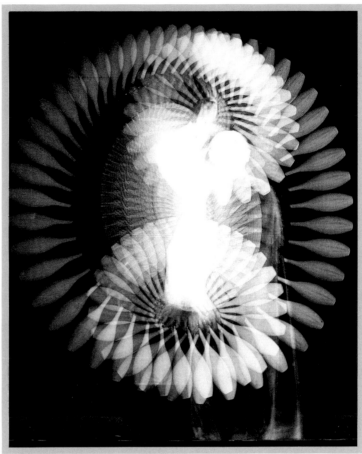

heart-stopping explosions of flash powder, a dangerous magnesium compound which as often as not singed hair, hands, and face. It also, as one newspaper account put it, "inflicted untold damage to the nervous systems of unsuspecting subjects." Flash powder was perfected by two German scientists in 1887. Scientists in Germany continued to experiment, but that unreliable pop-light, the flashbulb, which could only be used once and then had to be discarded, did not arrive until 1930, at about the same time that Edgerton was developing the invention that would make such puny lamps obsolete. For a variety of reasons, including the considerable weight and immobility of the early equipment, Edgerton and his assistants did not publically display their new strobe lighting, or "speedlight" as it was frequently called, until 1937 or 1938. In 1939, Edgerton published *Flash! Seeing the Unseen by Ultra High-Speed Photography*, showing an amazed public the results of his work. With a text written by James R. Killian, Jr., who later became president of MIT, *Flash!* was an exuberant demonstration not only of the remarkable possibilities of a new way of seeing but of the new technology that would now supplant all others. The new technology would also stimulate a new kind of journalism.

INDIAN CLUB DEMONSTRATION. 1939.
Probably no other pair of Edgerton photographs demonstrates more dramatically the precise difference between his multiflash pictures and those taken in ordinary light. On the left, an exposure was illuminated by several seconds of bright light, so the action is seriously blurred. On the right, by contrast, Edgerton's high-speed light, flashing 100 times per second, sharply delineates each moment of the sequence. The great Bauhaus artist László Moholy-Nagy was so intrigued by this example of The New Vision that he traded prints with Edgerton at a Chicago lecture in 1939.

In February 1940, a journalist for a Boston paper photographed Walter Brown, promoter for the Garden-Arena Corporation, posing with Professor Edgerton of MIT, "inventor of the new high-speed camera, used for [the] first time in any sports or news events at the Boston Garden." Brown was in a tuxedo, and decked out with the pomaded hairstyle popularized by Hollywood gangster movies of the 1930s; Edgerton, by complete contrast, was wearing the same kind of staid three-piece business suit and striped tie he still favors. Slightly balding, feet planted firmly apart, and holding the press photographer's favorite piece of equipment, the Speed Graphic camera, Edgerton smiled faintly in a boyish display of confidence. He knew very well what would happen that evening in the arena. As the newspapers reported, "Photo after photo of the athletes taken at full speed virtually stopped their motion so completely that photographic details never before possible were clearly evident." They were the first sports events ever photographed by Edgerton's revolutionary flash. The results were sensational.

George Woodruff of International News Photos and King Features had helped Edgerton set up the equipment at the Garden. On March 10, 1940, writing from New York City, Woodruff detailed the hubbub the new process was creating: "Your apparatus is the topic of conversation and argument among all the lensmen at the moment, their amazement and varied beliefs are truly interesting, some even believe it is some kind of trick and can't quite grasp the simplicity of operation." Quickly persuaded that such new tricks were vital necessities to the competitive photojournalism profession, Woodruff's colleagues at INP insisted on renaming the Edgerton process the "Speed-Ray." This magical light had been used by Edgerton on February 10 to photograph the elusive Sonja Henie, then reigning queen of the ice-skating rink and star of Hollywood "B" movies. She had banned photographers from her performances on ice since the time that a ringside camera fan had exploded a flashbulb in her face as she was racing by. The ensuing flash had so startled her that she fell and injured herself. Edgerton was determined to photograph her. With typical adroitness, he promised the manager of the rink where Henie was skating that evening that neither she nor anyone in the audience would ever notice his presence. Among the copious notes in his laboratory books for that month, he recorded that "a single lamp was hung from above; about 50 feet off the ice. A trip cord 150 ft. long was dropped at the side for the camera." With the

strobe triggered to flash for the unimaginably short time of 1/30,000 of a second, Sonja Henie never even blinked. Edgerton came away with enough pictures to fill a full page of the *Boston Herald* with delightful shots of Henie's troupe and the queen of ice herself in smiling flight.

As if to prove beyond any doubt that his Speed-Ray process could capture action anywhere, Edgerton continued in those early days of 1940 to photograph as many different types of events as he could find, including the ballet and prizefights. One such event caught the attention of the Ripley cartoon feature, "Believe It or Not," which presented him as "THE WORLD'S LUCKIEST MAN! Prof. Harold E. Edgerton . . . was the closest man to the [Joe] Louis–Conn fight and he didn't see it! He sat directly under the ring within 2 feet of the contestants as he supervised operation of the ultra-column, high-speed light for I.N.P. Photos." Portrayed in business suit and striped tie once again, Edgerton was represented as a slightly mad scientist fiddling with a switch. Yet, until his ultra-high-speed light "froze" action, no audience could really study the violent grimaces of pugilists. Using Edgerton's equipment at another fight, Joe Costa of the New York *Daily News* provided a famous visual shock when he captured the surprising ferocity of Joe Louis smashing a left uppercut into the jaw of Arturo Godoy. Such intimate glimpses of pain and rage thrilled the public and became the ideal of sports photographers everywhere.

All this public attention was hardly what had motivated Harold Edgerton to invent the electronic flash, although he had been interested in photography since his early teens. Born in Fremont, Nebraska, on April 6, 1903, and raised primarily in Aurora, Edgerton frequently visited a favorite uncle in nearby Iowa who happened to be a photography enthusiast. Soon, the young boy had learned the tricks of the darkroom well enough to set up his own in his mother's kitchen. By the time he was fifteen, he had scraped together enough money to buy a postcard folding camera, a Kodak. Photography remained an enduring but secondary interest through high school, when he worked summers for the Nebraska Power and Light Company in Aurora. There, he became fascinated by the mammoth generators and decided to pursue a career in the still-young field of electrical engineering. After receiving his bachelor of science degree at the University of Nebraska, he was fortunate enough to find employment at the huge General Electric plant in Schenectady, New York. By 1926, Edgerton was a student at the Massachusetts Institute of Technology in Cambridge, where in quick succession

he earned his master of science (1927) and his doctorate (1931). His brilliance in his chosen field, as well as an innate gift for teaching, earned him a steady rise in the academic hierarchy. Today, he possesses the rare title of Institute Professor. At MIT, his home since 1926, the institute's emphasis on practical outcomes of research has suited Edgerton's down-to-earth character and essentially modest personality. He was, and still is, intensely practical. Gjon Mili, one of his most famous photography students, described him as "a most compelling teacher; also, an American original, which is to say, an irrepressible pragmatic idealist."

Edgerton's pragmatism is revealed on every page of his laboratory notebooks. Even while the Speed-Ray was exciting the INP photographers, Edgerton was applying his ultra-high-speed light to the examination and testing of rapidly turning motors—his first impetus for developing the system—as well as to the regulation of weaving looms in the clothing industry. A logical application was the testing of automobile engines, which even today are examined by means of an Edgerton device. Eventually, landing lights for airplane fields were synchronized by Edgerton's genius, and the swiftly flashing warning lights atop tall industrial towers, chimneys, and skyscrapers are also Edgerton applications. The multitude of uses for ultra-high-speed and synchronized light persuasively establish him as one of the most imaginative of engineers.

His imagination has never ceased to be at the service of photography as well. The famous portraitist Fabian Bachrach wrote to Edgerton: "Speaking for the portrait photographic industry, I feel your contribution in the development of stroboscopic light is one of the greatest milestones in the history of photography. You have given us a light source which is as good as daylight at its best and better than daylight most of the time, because your light is always constant. . . . You have made it possible for us to capture spontaneous actions and emotions never before attainable." Clearly, the high-speed lamps freed photographers from the onerous task of keeping their subjects still. The fact that Edgerton's lights were of sufficient intensity to permit *indoor color* photography was also considered a great boon not only by portraitists but by all commercial photographers.

Edgerton had taken the very first studio flash picture in color: a 1937 football-kick photograph (page 53). He thought color was a miracle, and so it was when his ultra-high-speed, high-intensity light overcame

the slowness of the newly invented Kodachrome color film, which had a low ASA of 8 that normally permitted only outdoor subjects to be photographed properly. Studio lights had been so inadequate for this early color film that advertising photographers who had to prepare the following summer's fashion catalogs in midwinter usually transported models, fashions, equipment, and assistants out to the bright light of Arizona. With the prospect of being able to stay in their studios all year, commercial photographers besieged Edgerton for new concepts in studio-lighting design. As was so often the case during his illustrious career, his impact on this branch of photography was immediate, widespread, and lasting.

Edgerton had not worked alone to perfect the electronic high-speed flash system. Two former students of his, Kenneth Germeshausen and Herbert E. Grier, who both eventually teamed up with Edgerton to form the company known as EG&G, assisted him on lamps and circuits. In the late spring of 1940, undoubtedly as a result of the attention Edgerton was receiving for his startling sports pictures, he and his assistants were invited to the MGM studios in Hollywood. There, they collaborated on an amusing film with Pete Smith, a popular host of specialty feature shorts. *Quicker than a Wink* won an Oscar that year. The inventor was able to film lively demonstrations of a rattlesnake's strike, cats landing on their feet after gracefully arcing through the air, smashed teacups spurting milk, and other revelations of hitherto unseeable details from everyday life. It was quintessential Edgerton, the born showman always loving to display his work with enthusiasm and the born teacher delighting in bringing his findings to as wide a public as possible. Simultaneously, he was the practical engineer, who not only revolutionized slow-motion filmmaking with his strobe system during his stay at MGM, but who also conceived a new way of making motion picture stills that could be shot while the actors were performing, rather than being posed later. This procedure saved precious minutes in an industry where time is money and preserved the actions of performers at the height of their emotions during an actual scene.

It would probably be impossible either to detail all of Edgerton's inventions during that fecund first decade or to recapture the mood of that period. There was still a lingering tinge of the Art Deco style in the art of the time: the Empire State Building had been constructed with Art Deco motifs shaping its every ornament, and there were flattened eagles plastered on the corners of every post office. Yet, thanks to Franklin

JUDY GARLAND AND MICKEY ROONEY AT MGM STUDIOS. 1940 (Original in color).

While working at MGM with Pete Smith on an Oscar-winning short entitled *Quicker Than a Wink*, Edgerton photographed many of the young hopefuls in the studio with his amazing "Speedlight." The candor and spontaneity of such portraits were first made possible by Edgerton's electronic flash, prompting the society photographer Fabian Bachrach to praise Edgerton's extraordinary contributions.

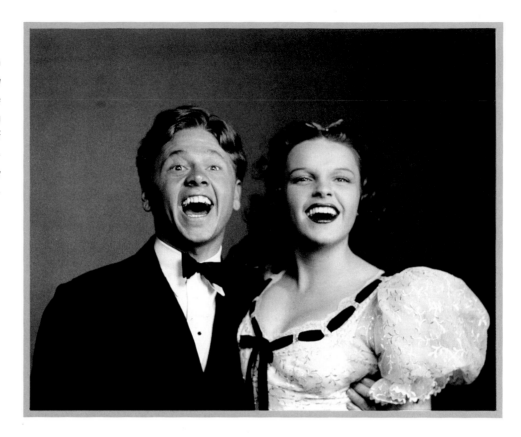

Roosevelt and the Works Progress Administration artists, there was also a decided turn toward proletarian and realistically heroic art after 1932. The country had been sobered by the Wall Street crash. It was a time for people to return to the celebration of everyday events, small homey things, and to search, through science and technology, for miracles to come. Edgerton's pictures of the small truths of nature—how a milk drop looks when it makes its diadem splash, what happens when a tennis racket hits a ball, how the bubbles of a soda-maker's spritz bounce into a highball glass—precisely reflected a turning away from grandiosity toward the simplicities of existence. As one admirer suggested, Edgerton "exemplified the man William Wordsworth had in mind when he wrote over a hundred years ago: 'Come forth into the light of things, Let Nature be your teacher.' " The secrets of nature, in Edgerton's mind, could best be revealed through technology.

THE NATURE OF THINGS

Edgerton's images are embedded in our visual consciousness, yet if it is suggested to him that he is not only a scientist but an artist, he pleads: "Don't make me out to be an artist. I am an engineer. I am after the facts. Only the facts." But facts, like the beauty of perfected mathematical formulas that the nineteenth-century mathematician Jules-Henri

Poincaré praised, can be amazingly aesthetic experiences. Johann Wolfgang von Goethe, a visual theorist as well as a poet and playwright, once observed, "Beauty is the manifestation of the secret laws of nature which, were it not for their being revealed through beauty, would have remained unknown forever." It is the singularly aesthetic quality of Edgerton's discovery of facts that is so astonishing. A diver somersaulting through perfect geometric patterns before slicing into the water (page 6) or a drum majorette's mysterious gyrations of the baton (page 104) are both demonstrations of some of those immutable laws of nature—laws whose harmony and logic are breathtaking when made visible by Edgerton's genius.

Edgerton's images appeal not simply because they are uncanny revelations of the laws of nature, but because they arouse profound philosophical speculations about art and reality. To stop motion, to analyze motion, to grasp the laws of motion, were ambitions that achieved an almost compulsive intensity among artists, scientists, and writers of the nineteenth and early twentieth centuries. Photography, a viable invention by the 1840s, seemed to offer technology capable of studying and analyzing motion. Even earlier, however, Sir Charles Wheatstone had predicted the magic of the stroboscope when he wrote, "A rapidly moving wheel or revolving disc on which any object is painted, seems perfectly stationary when illuminated by the explosion of a charged jar." The inventor of negative/positive paper photography, William Henry Fox Talbot, in 1851 actually patented a device to take high-speed photographs, utilizing the flashing sparks of charged Leyden jars—an early form of capacitor used to generate electricity—to illuminate subjects. At the outset of his career, Edgerton learned about Talbot's device, suited only to laboratories, and wrote to the Royal Photographic Society, then in London, for details of Talbot's experiments. As a result of this exchange, the society frequently included Edgerton's photographs in their annual exhibitions after 1933. It was duly noted that Talbot's device had eventuated in Edgerton's sophisticated electronic strobe.

In Edgerton's own words, "The stroboscope is an instrument that employs intermittent light to permit the visual observation of rotating or vibrating objects." Typically, he makes everything sound simple. He is talking, however, about the intermittent light he developed that is capable of flashing at one-millionth of a second, on command and under complete control of the operator. One of the earliest pictures of Harold Edgerton with his invention shows him examining a rotor that was turn-

ing at a rate corresponding to a linear speed of ninety-eight miles an hour. To permit visual inspection of the rotor, the light of the strobe had to flash at precisely the same rate as the racing motor. If he could achieve that simultaneity, the motor would seem to be standing still. His early attempts succeeded, and he used photography to record his findings. Edgerton managed to take stroboscopy out of the laboratory, with its unpredictable electric sparks and Leyden jar condensers, into the work environment. Moreover, exposure for photographs was now to be governed by the length of time of a flash, not by the aperture of a lens.

While Edgerton's technical contributions in the 1930s were devoted to the development of the strobe light, his technique in photographing the milk splash (page 127), for example, was also unique. In April 1932, *Technology Review* published the following account:

> A Falling Drop of Milk—Caught in the Act by a
> New Method of High-Speed Photography
> 44 successive splashes of a globule of milk dropping into a puddle of milk. When the drop strikes the surface of the puddle a crater is formed. . . . There next occurs a conical growth in the center of the crater which resolved into small droplets bouncing upward as pictured. . . . This phenomenon is not observable by the eye, since it takes place too rapidly.
>
> The pictures which reveal it were taken at a speed of 480 exposures a second or nearly 30,000 a minute. Each row of 11 pictures represents a time interval of about 1/45 of a second, and the entire sequence shown above an interval approximately 1/10 of a second.
>
> *The camera which was used has no shutter nor any clawing mechanisms. The film is simply run through it continuously without stopping for each picture as ordinary motion picture cameras do.* The drop being photographed here is illuminated by a powerful stroboscopic or intermittent light which lasts 1/100,000 of a second or less for each flash. [Italics added.]

By vastly increasing the number of frames that could be photographed per second, Edgerton made it possible to study events in extremely slow motion. Hollywood had also invented clumsy, ponderous equipment for slow-motion films, but nothing like his continuous-motion cameras had ever been thought practical. The trick was to avoid using the sprocket holes on the film in making the movie, yet not to injure them

or prevent them from being used afterward for the projection of the movie. Edgerton had invented a method whereby it became possible for film to be drawn continuously through a camera while the flashing strobe articulated exposures—what would ordinarily be considered "frames." His camera pulled the film through in one smooth motion at one hundred feet per second. When the first units failed to separate individual images sufficiently, Edgerton quickly devised a method whereby the strobe was synchronized with every fourth sprocket hole to ensure absolute clarity. As a normal two-hour film contains 172,800 frames, Edgerton created an extraordinary opportunity by making it possible to photograph as many as 6,000 frames per *second*, compared with the 24 frames per second of normal movie projection. Projected at that normal speed, Edgerton's images were a revelation of phases of motion in events otherwise too minute to be monitored. A colleague of Edgerton's at MIT, Charles Miller, has called this exceptional breakthrough in the depiction of high-speed motion "just another example of Edgerton's rampant imagination."

Edgerton's inventions would have obviated all the work of the photographers who struggled so valiantly in the nineteenth century to record motion phenomena, especially the phases of human and animal locomotion. He put his inventions to work in six basic ways: (1) the "freezing" of high-speed motion in a single flash, as in pictures of a football player kicking a ball or a bullet eviscerating an apple (pages 52 and 126); (2) the superimposition of successive phases of action on a single frame, as in pictures of Gussie Moran serving a tennis ball or a ballerina executing a pirouette (pages 83 and 99); (3) high-intensity photography, as in the eerie view of Stonehenge (page 76); (4) close-up microphotography, as in photographs of the circulation of blood through a human eye; (5) cameraless strobe photographs, including shadow pictures of bullets and details of microscopic sea life (pages 147 and 149); and lastly, (6) underwater images taken at immense depths (page 158).

In developing the single-flash concept, Edgerton built on the experimental foundations of his predecessors, including the scientist A.M. Worthington, whose 1908 book, *A Study of Splashes*, revealed some of the beauties and surprises of droplets photographed in darkness with the aid of an open-air spark generated by cumbersome laboratory equipment. Ernst Mach, who gave his name to the measurement of speed as it relates to sound, achieved silhouette photographs of speed-

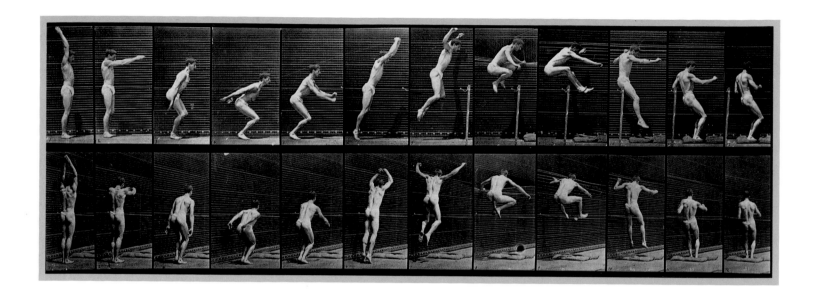

EADWEARD MUYBRIDGE. *MAN JUMPING HURDLE.* 1887.
COLLECTION GUS AND ARLETTE KAYAFAS

Muybridge, renowned in the nineteenth century for his photographic studies of animal and human locomotion, used a complicated series of trip wires and a battery of cameras to make individual pictures during the course of an event. The hurdler tripped a series of strings that released the camera shutters. Edgerton's multiflash system was able to record multiple phases of an entire event in a single picture. His exposure duration was much shorter than Muybridge's and stopped action more precisely and with greater detail, allowing a clearer understanding of the flow of movement.

ing bullets as early as 1881. These were shadow pictures produced by the passage of a bullet between the light of a flashing electrical spark (whose duration was difficult to control) and the photographic film. While these pictures were useful to scientists and technologists of the time, control over such procedures had to wait for Edgerton's inventions.

As for the study of human and animal locomotion, Eadweard Muybridge is probably Edgerton's most famous predecessor. His electrical shutter records of the invisible mysteries of a horse's movements in full gallop so astounded artists such as Jean-Louis-Ernest Meissonier that the entire enterprise of painting moving animals was altered forever. Yet, despite Muybridge's immense influence and secure place in the prehistory of the motion picture, Harold Edgerton dismisses him—and with good reason. "Anyone can do that," he protests. "That's easy. What I do isn't so easy." What had Muybridge done that could be dismissed? He had succeeded only in capturing *individual* instants of motion on separate plates, one instant per plate. Each image in the successive phases of human or animal motion was separate, boxed off from the next (page 22). Such information might suffice perhaps for an artist who wished to paint that specific part of the overall motion, but not for anyone who wanted to study the entire gesture, the complete movement from start to finish.

This was the great riddle. In the 1850s, Oliver Wendell Holmes, writing as a photography critic for *The Atlantic*, noted in his examinations of more than one hundred thousand stereographs that the camera was, indeed, capable of freezing motion. This led him to wonder about the

nature of motion: was it merely a series of steps along a continuum, as the Greek philosopher Zeno had postulated centuries before? Zeno's paradox, as it became known, stated that as an arrow flies through the successive points of a trajectory, it must be said to be at rest at each of those points; therefore, the arrow could be said not to move. This was arrant nonsense, of course, but it required mighty argument by the nineteenth-century French philosopher Henri-Louis Bergson to abolish the notion that there are stops of any kind along movement paths. Movement is a continuity, not, as Holmes or Zeno imagined, a series of frozen stops. The stroboscopic photographs of Harold Edgerton in multiple exposure, or "multiflash," allow us to ponder both sides of this issue.

In still photography, unlike motion pictures, we can see only the discrete steps of any action. Looking at Edgerton's image of a girl skipping rope in continuous motion (page 92) satisfies us that the motion is, in fact, continuous; yet, no single still photograph can actually show us motion. Indeed, one of the curiosities about so-called motion pictures is that they are made up of separate still photographs pulled through a projector at a speed fast enough to take advantage of what was commonly called "persistence of vision." Of all attempts to mirror motion in still photography, Edgerton's undoubtedly comes closest to revealing the patterns of motion, if not motion itself.

Muybridge had ingeniously arranged rows of trip wires, each attached to an individual electric shutter on an individual camera, so that horses trotting past this battery of cameras set off a sequence of still photographs. Unfortunately, the pictures obtained in this manner could not reveal the geometry of interconnected gestures and motions, since the eye had to travel from one individual frame to the next without being able to see the integration of the movements. Edgerton had only one predecessor who recognized that much more was needed: Etienne-Jules Marey.

Marey, a professor at the Collège de France, had already devoted years of research to the study of movement when he saw Muybridge's achievements published in *La Nature* in the fall of 1878. Marey had also attempted to solve the riddle of whether a horse actually lifts all four feet from the ground at full gallop. The moment that Marey saw Muybridge's work, however, he completely altered his methods. Of most importance, he decided that he might prove far more about the secrets of nature if he recorded the successive phases of motion on a single plate and from a single point of view, rather than only individual instants

ETIENNE-JULES MAREY. *LOCOMOTION STUDY.* c. 1880.
Like Edgerton, Marey was a scientist interested
in studying human and animal locomotion. Pho-
tography was one of many methods he used to
record motion. The apparatus in the illustration
emitted a signal each time the man's foot
touched the ground. Such timing mechanisms
laid the groundwork for his later photographic
studies.

of that motion. Marey proceeded to invent several methods of record-
ing phases of movements. While the best known of these is his photo-
graphic "gun"—a riflelike device from which the idea of "shooting" a
photograph was derived—not until 1882 was Marey able to perfect
what he called "chronophotography." His equipment included a true
stroboscope—the word meaning "whirling watcher"—utilizing a single
large photographic plate that was exposed to light only through the slits
in a revolving wheel. The "Marey wheel," as it was called, contained
twelve slits through which fairly rapid exposures could be made. Thus,
Marey recorded the leap of an athlete over a hurdle, a pole-vaulter,
boxers, swordsmen, birds in flight, the ponderous geometry of an ele-
phant's walk, all seen in continuous action on a single photograph
(page 26). Marey also foretold Edgerton's superlative investigations
into the motions of gases, liquids, and the interaction between materi-
als, and he left photographs of his successes. These Marey pictures
were all fascinating, but often only a pale indication of the precision and
clarity that Edgerton achieved by controlling exposures not through a
whirling wheel, but through the new idea of the stroboscope—an ultra-
high-speed flashing light linked to a stationary camera. Marey was at
his most prophetic when he wrote, "Art and science encounter each
other when they seek exactitude." That encounter would be demon-
strated in the photographs of Harold Edgerton.

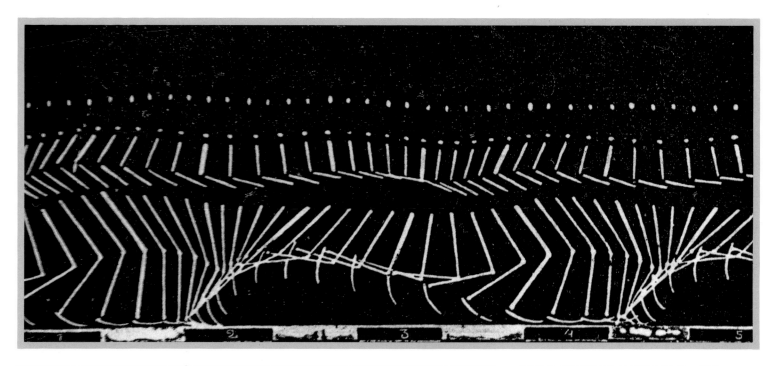

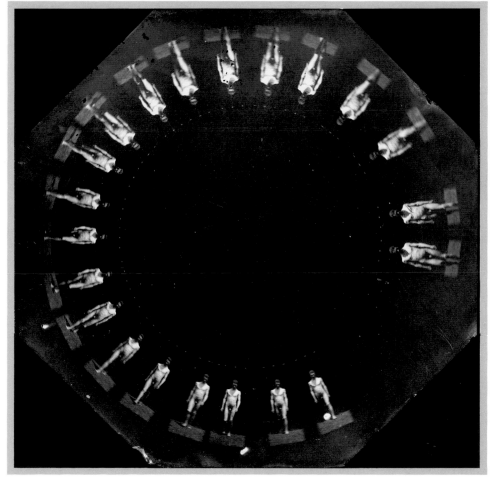

ETIENNE-JULES MAREY. *MAN RUNNING.* c. 1880.
CHRONOPHOTOGRAPH.

After Marey met Muybridge in Paris and studied his methods, he ingeniously devised various ways of capturing a sequence of motion on a single plate. He constructed plates that rotated inside a camera, moving-disk shutters, and cameras that were attached to wagons that tracked moving subjects. He even used high-speed spark-flash exposures. In this early experiment, a man wearing a black suit with a white stripe painted on it was recorded as he ran past the open shutter of Marey's camera.

THOMAS EAKINS. *MAREY WHEEL PHOTOGRAPHS OF J. LAURIE WALLACE (?).* 1884. FRANKLIN INSTITUTE SCIENCE MUSEUM. PHILADELPHIA.

Eakins, the renowned American painter, constructed his own equipment to record motion, following his discovery of Marey's principles. The "Marey wheel" he built rotated inside the camera and was capable of quickly capturing multiple exposures on a single plate.

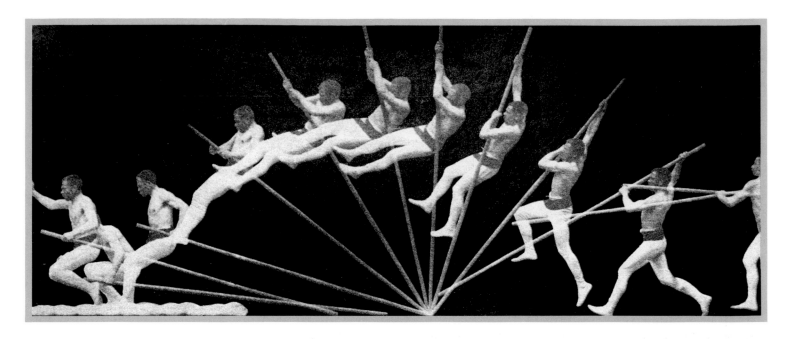

ETIENNE-JULES MAREY. *MAN POLE VAULTING.* c. 1884.
MUSÉE MAREY, BEAUNE, CÔTE d'OR, FRANCE.

In the early 1880s, Marey—and Eakins there-
after—was able to record a procession of
movement with a disk shutter and moving plate.
However, because his devices were mechanical
and his exposures usually dependent on natural
light, he was never able to achieve the speed,
control, or detail that electronic flash affords.

THOMAS EAKINS. *POLE VAULT.* c. 1885.
THE METROPOLITAN MUSEUM OF ART,
GIFT OF CHARLES BREGLER.

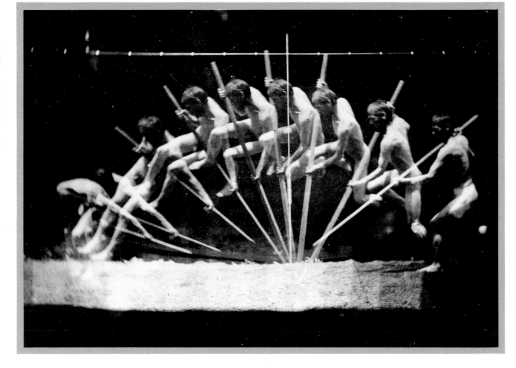

Edgerton's multiflash photographs inevitably evoke comparison with the goals of the pioneers of modern art. Even Marey could not have anticipated his own impact on early twentieth-century painting, especially on Cubism and Futurism. The Cubists wanted to shatter the limitations of representing linear time by showing the spectator many dimensions of an object or moment simultaneously. The Futurists wanted to reveal the interpenetrations of time and space and to capture the exciting characteristics of the newly invented, fast-speeding airplanes and cars; and they claimed to worship the look of machines. Perhaps the most famous example of painterly fascination with Marey's successive phases of motion was Marcel Duchamp's *Nude Descending a Staircase*, exhibited at the Armory Show in 1913, the first major exhibition of European modern art in America. It successfully mimicked the effects of Marey's continuous phases of motion and their geometric connections. The similarities with Edgerton's multiflash pictures (pages 83–117) are striking and may explain why Edgerton became so popular in fine-art circles. He was completely in sync with modernist aesthetic and philosophic concerns.

Marey's chronophotography had been, literally, the photography of time. Conventional wisdom even today would have it that all photographs stop time. But it is not so simple, insists Edgerton. His pictures, he explains, are records of *events*. An event occurs in time and space. Although his photograph of a bullet slicing a playing card (page 122) seems to imply *Now, This Instant*, it also implies both time past and time future as we instinctively interpret changing spatial relationships between the bullet and the card. Edgerton's high-speed flash was set off by the sound of a gunshot—the gun remaining unseen but clearly present to the left of the event—that preceded by only the tiniest fraction of a second the event Edgerton's camera witnesses. The bullet must continue on its path until a barricade stops it somewhere on the other side of the picture. Even though this is a still picture, we sense the totality of the event because the human mind instinctively constructs a context for the image to recognize what has happened and to anticipate future events. This is part of the logic that maintains our sense of security and may explain one of the major appeals of an Edgerton photograph of a bullet slicing through an apple or a playing card: the picture is so logical, so clear. It also explains the excitement of the picture, for we recognize that the bullet is traveling at a tremendous speed and has been captured in the photograph only by extreme ingenuity.

While the contents of an Edgerton picture may surprise—who could have foretold that a bullet's impact on an apple (page 126) would make an explosion of matter at the bullet's entrance as well as exit?—there is a serenity about the image despite its violence. It comes, perhaps, from the fact that we sense the photographer was in perfect control of his subject at all times. Perhaps that also makes us feel as if the world is intelligible and controllable, a comforting notion in a time when events seem totally unpredictable.

THE NEW VISION

That everything might be controllable and explainable was undoubtedly what motivated many modernist artists, technologists, and scientists to worship the machine and to try to imitate the minutiae of its workings. People became obsessed with trying to grasp the present, that fleeting instant that William James called "the thickened *Now*." Analysis of motion for efficiency's sake became a dominant American preoccupation. While Marey was developing his chronophotography in the 1880s, Frederick Taylor had begun to apply the principles of "scientific management" to the precise study of motions made by factory workers during the course of their job activities. Timing their motions with a stopwatch, Taylor endeavored to maximize both the speed and comfort of a work sequence, obviously for the sake of increasing production. Taylor's disciple, Frank B. Gilbreth, also investigated the spaces occupied by each motion in the production lines of factories. Ultimately, Gilbreth adapted motion picture photography for a process called "chronocyclegraphs" that registered the paths of motion made by various parts of a human body as a specific task was completed. As these measurements became more and more precise and coherent, they led to the development of robot factories.

All these attempts to measure efficiency clearly applied not only to people but to their machines as well. Edgerton first used his strobe lamp to study the efficiency of motors. He had grown up in an atmosphere that suggested efficiency was the aim of technology; but he offered the world a new tool, an instrument as suited to the arts as to the sciences. As Rudolph Arnheim observed, "The scientist, like the artist, interprets the world around him and within him by making images." Nevertheless, the notion that art and science might share characteristics has occasioned much vehement argument. Some critics deny any similarities

whatever between a mode of investigation that claims—like Edgerton himself —to seek only "facts," and a mode of creation that seeks beauty, expressiveness, and emotional effect.

Perhaps because the nineteenth century became obsessed with factual evidence, photography was long regarded as a lowly servant of the sciences, incapable of the creativity of the arts. After all, the camera was merely a mechanical device. It delivered what the public construed as unalloyed renderings of the realities of nature. That the camera perforce lied, distorted, and misled did not diminish the belief that photography was a superbly impartial observer, the very paradigm of what the new science was supposed to be. The British, for example, insisted at first on exhibiting photographs of all types in halls of science rather than in art galleries.

It took heroic efforts by the Pictorialists, led by Alfred Stieglitz, to provide photography with the desired aura of "art," yet the gentle art studies of Stieglitz's Photo-Secession, so often imitative of Impressionist and Symbolist painting, could hardly withstand the onslaught of modernism in the early days of this century. It was not simply that the Cubists and Futurists were fascinated by time and space or motion and machines, but that the horrors of the First World War destroyed all prior sets of aesthetic judgments. Traditional approaches to artistic activity seemed suddenly like shopworn ideologies completely out of tune with modernity. What was needed was a new vision, a new aesthetic. Motion, rhythm, and machine forces took precedence over the traditional harmonies, the golden mean, and established compositional values. What was to be treasured now, as László Moholy-Nagy and the Bauhaus would define it, was The New Vision.

Quintessentially Germanic in its origins, *Die Neue Sachlichkeit* (The New Objectivity or New Vision) was essentially a new kind of realism supported by strong formal compositions with unorthodox perspectives. It offered the world a photography as coolly objective as the Pictorialists had been romantic. Moholy-Nagy and Albert Renger-Patzsch were the guiding spirits of a new aesthetic for photography. It would include an almost clinical examination of everyday things, as the artist Gustaf Stotz reported in May 1929: "Today things are important that earlier were hardly noticed: for example shoe lasts, gutters, spools of thread, fabrics, machines, etc. They interest us for their material substance, for the simple quality of the thing-in-itself [that is the translation of *Sachlichkeit,* "thinginess"]; they interest us as a means of creating

space-form on surfaces.'' Renger-Patzsch had a profound belief in re-
cording reality in minute detail. As Van Deren Coke (one of today's
leading photographic historians) noted about Renger-Patzsch, this ide-
alistic realist believed that photographing both ''small organisms in na-
ture as well as...products of technology would reveal that man's
designs and nature's designs were often analogous.'' The sentence
could be a prescription for Edgerton's photographs. For Edgerton, that
''irrepressible pragmatic idealist,'' shared the zeitgeist: nature would
reveal her secrets to those who believed in the fundamental unity of all
creation. It was a sentiment espoused by master photographer Edward
Weston, for example, as early as the 1920s. Weston monumentalized
shells, bits of flotsam, peppers, and other small natural objects, guided
by the theory that there was one spirit uniting all aspects of nature, from
rocks to humans. Certainly, the idea that technology and machines had
affinities with natural geometries was brought to MIT by Edgerton's col-
league Gyorgy Kepes, who taught in the institute's architecture depart-
ment from the early 1930s until the 1970s, and who was also a
photographer of abstractions. In the 1920s and 1930s, one of the most
influential American photographers, Paul Strand, was wholly in tandem
with this realistic, formal idea, and when he began to photograph the
mechanical innards of his own motion picture camera, he could be said
to epitomize the new hard-edged, machine-worshiping aesthetic.

In his own way, Edgerton can be regarded as pursuing the same
ultimate realities that Edward Weston sought so pertinaciously. For
Weston, it was the idea of ''quintessences,'' the fundamental nature of
things. For Edgerton, it is ''facts,'' and the secret laws of nature. Among
these secret laws are those of optics and human perception. Marcel
Duchamp, for example, sought to make art out of the revelations pro-
vided by the new science of optics. He was influenced not only by
representations of motion discovered by Marey but by a lively history of
illusions of motion that derived from scientific experiments in the pre-
vious century. Like Edgerton, Duchamp was enchanted by Joseph An-
toine Plateau's experiments in the 1830s with the phenakistascope, an
instrument that paralleled the development of the ''whirling watcher''
stroboscope in its early forms. Plateau, often cited incorrectly as a direct
predecessor of Edgerton, also experimented with disks painted with
spirals. When these are rotated clockwise, the spirals seem to expand;
rotated in the opposite direction, the spirals appear to contract (page
10). Basing his own work on similar illusions, Duchamp constructed a

series of Roto-disks, which he used in his 1925 film, *Anèmic Cinéma.*

What Plateau, Duchamp, and Edgerton studied was what are called "stereokinetic" effects. Two-dimensional images, such as the Duchamp and Plateau spirals, can acquire through motion an illusion of three-dimensionality. It is the same stereokinetic effect that makes movies seem so real, translating the essentially two-dimensional light projections on a flat surface into living three-dimensional experiences. Small wonder that Edgerton was so eager to expand the potential of motion pictures: they were an integral part of and important influence on The New Vision. Edgerton's work combines optics, technology, and a sense of wonder at the revelations of the strobe. It has been observed in art circles that if Marcel Duchamp had been able to use Edgerton's stroboscope back in the 1920s, he would have gone far beyond the Roto-disks into a mad collision of light and matter. The New Vision reveled both in facts and in the illusions created by juggling the secret laws of nature.

In his pioneering *History of Photography*, Beaumont Newhall observed that The New Vision delighted in "what the unaided eye cannot see, but what has ever existed; as more powerful tools for observation are built, new worlds of form are revealed." The New Vision was at its most influential when it revealed what had never been able to be seen before. The forms underlying the phenomenological world—the laws of nature made visible—had become much more intriguing than all the traditional canons of beauty. Surprisingly, the new inventions of technology were leading the way to an aesthetic that had little to do with the once-great truth called Beauty. Its beauty was to be of another sort, one that a scientist like Edgerton could embrace without stigmatizing himself as that stereotypical entity, the artist. In ancient times, any division of creativity into arts and technologies would have seemed absurd, for the classical world had no word for visual "art" as we know it today. What we call art was then *techne*, the equivalent of a craft or skill. In our own century, what had become the traditional definition of an artist was challenged by artists from the Futurists to the Bauhaus, who embraced racing-car designers, machine craftsmen, and power-station builders as kindred spirits.

For the generations that grew up with Kinetic Art, Op Art, Conceptual Art, Happenings, Performance Art, the separation of art from science makes no sense at all. What matters is a devotion to discovery, an awed delight in the revelations of the complexities of the physical world and the strategies of the human brain. Edgerton's invention of the electronic

strobe was not only perfect for its time, but his pictures made with that instrument retain their immense appeal. Perhaps this is because, as Beaumont Newhall decided, The New Vision, empowered by technological miracles, was essentially aesthetic. People had come to recognize and accept a new idea of the artistic. They delighted in a world that contained so many marvels and in the technology that captured them. Goethe, who had written that it was beauty's revelation of the secret laws of nature that made it possible for us to encounter those secrets, was vindicated.

THE PICTURES AS VINDICATION

Edgerton's most famous single image, the milk splash transformed into a coronet (see page 127), can serve as confirmation of Goethe's hypothesis. Brought to public attention by Life magazine in 1939—where it created a small sensation—the image reveals an unseen reality, and it is also, yes, beautiful. (Even Edgerton will permit himself use of that word. In his Nebraska drawl, he says: "Anything that moves is my game. It's always beautiful.") Yet the scale of the print and its subsequent reproductions completely misrepresent the small size of the actual event. Rather than a crown that might be even larger than the crown of England, the drop of milk actually produces a splash about one-half inch in diameter. With the unaided eye, only a single drop can be seen. With the strobe, however, and the continuous film rushing through the camera, the stages of this milky event can be followed from first impact, through the rising of a beaded-cup shape, and the spread of the crown as the beads are flung outward and upward, until the final collapse of the coronet. Seeing only the apex of the event in Edgerton's miraculous picture, with the beads rising majestically above the spikes of scattering milk, one might be tempted to think that this same photographed coronet occurs with every drop and splash of milk. On the contrary, what makes Edgerton's picture so remarkable is that the event is never the same twice. It is only when the coronet is symmetrically formed with the beads the same size around its rim—and the picture is therefore beautiful—that we think we are seeing the secret laws of nature. The fact is that the event itself is not only never the same twice, but it is not always beautiful. The picture Edgerton decided to present to the world is science, but it is also art.

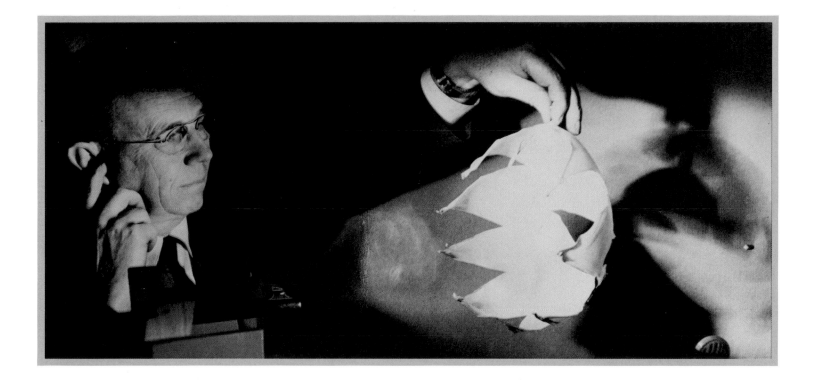

SELF-PORTRAIT WITH BALLOON AND BULLET. 1959.
A whimsical demonstration of Edgerton's ultra-high-speed flash. At an exposure of one microsecond (1/1,000,000 of a second), the bullet, balloon, and the inventor guarding his ear are simultaneously frozen.

In actuality, Edgerton repeats each experiment over and over again until he captures what he thinks is the right look. What is this look? Very simply, it is the appearance of an event that tells him that this is the way nature *should* look when all the elements of an event can be perfectly controlled. While Edgerton claims to place his trust in luck—he says that with a decided twinkle in his eye—the milk-splash coronet is no accident. He is meticulous and his own most severe critic. Dozens of pictures of imperfect coronets have been discarded. He seems to be seeking a visual perfection that is akin to the painter's search for the perfect way to express an idea. Those secret laws of nature, surprisingly, do not reveal themselves without considerable assistance. They require not only skillful techniques to make them visible or apprehensible in one form or another but also a mind that can conceptualize the necessary implementation as well as instinctively anticipate the result. Documentation of this exquisite kind is not unlike the responses Conceptual artists produced to questions like *What if—? How does—?* and *Under what circumstances—?* Edgerton's flash and strobe pictures are his answers to similar questions.

Edgerton tells a story about his first flash pictures of speeding bullets, which required exposures of one-millionth of a second to prevent blur. A skeptic scoffed that Edgerton had merely hung his bullet on a string and retouched the photo to eliminate the string. Said Edgerton, "Well, then, I'll just have to show the bullet passing through something." Thus began

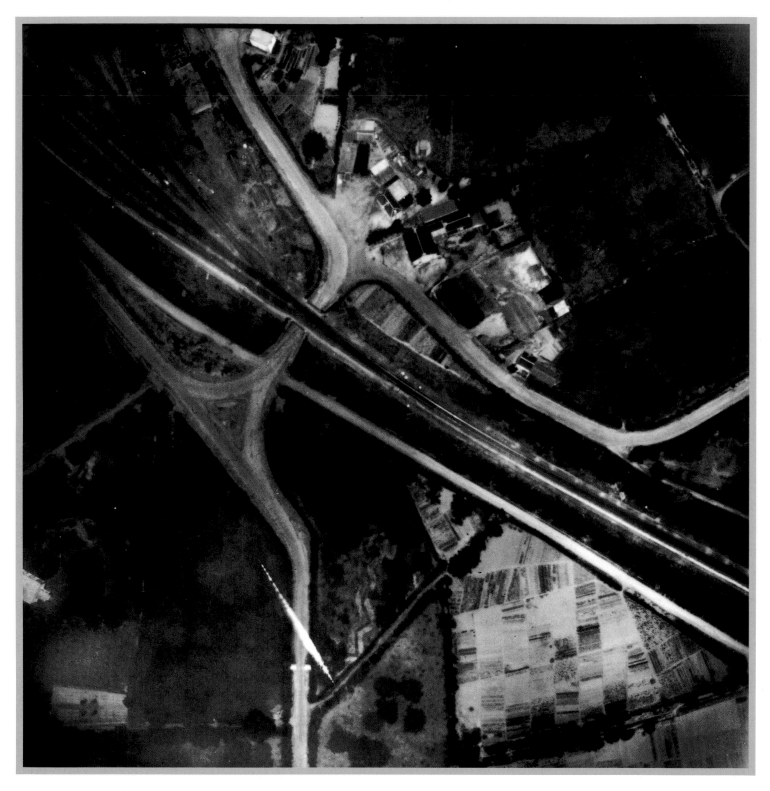

JUNE 6, 1944, OVER FRANCE. 1944.

One of the many nighttime photographs Edgerton and his trained plane crews made over enemy territory using high-powered strobes. This picture was made specifically to determine if there was surreptitious troop movement the night before D day. Notice the tracer bullets at the bottom of the frame.

the series of photographs showing the passage of bullets speeding through apples, bananas, soap bars, bubbles, gases, liquids, and, most astonishingly, through the edges of playing cards. In western movies, the cowboy hero sometimes had to display his prowess with a gun by shooting out the eye of a playing-card jack. Edgerton did him one better by turning the card sideways, lining up his rifle, and severing it neatly—"cutting the card quickly," as he likes to put it. Many of these pictures seem more like the work of a magician than of a scientist. Yet, because we know they are not tricks, the images have immense power. They are macho pictures and tough-minded.

THE WAR

The United States government certainly considered Edgerton a magician for his achievements in nighttime photography during the Second World War. Edgerton was able to produce high-powered strobe lamps that allowed the Allied forces to keep track of enemy movements at night. To demonstrate the effectiveness of his new high-intensity lights, he had an airplane fly over Stonehenge at night with a fifty-thousand-watt-second strobe illuminating the ground fifteen hundred feet below. With a folding pocket camera mounted on a fence post on the ground, its shutter open when the flashing light from the plane passed overhead, Edgerton captured one of the most extraordinary photographs of the megaliths ever taken. In an otherwise pitch dark night, the mysterious structure glows, making it easy to imagine that the Neolithic Britons have returned to practice their savage rites (page 76). Simultaneously, the plane was equipped with a camera that recorded the eerie circle of giant stones from the air—the first time a detailed photograph was taken at night from the air.

Once Edgerton convinced the Allied commanders that his instruments worked, his night reconnaissance systems were immediately employed to search out the German forces at the Battle of Monte Cassino, one of the Italian battlefields where American casualties were cruelly high. Edgerton's systems performed so accurately that they were entrusted with the task of scanning the Normandy beachheads on the nights prior to the D-day invasions. After many successes, some from as high up as one-half mile above various European theaters of war, Edgerton's equipment was shipped out to help in the Pacific arena. There, a captured Japanese officer, who happened to speak English, complained, "Oh, what can we do now! With his bright, blinking eyes

streaking across the dark canopy of night, the devil himself has compromised our last and now unfaithful mistress of security." The "devil"—Harold Edgerton—received the Medal of Freedom from the War Department for his efforts.

The United States government had great regard for, and even greater need of, devils like Harold Edgerton. In 1947, EG&G, Inc., helped to develop instrumentation for the Atomic Energy Commission, primarily for testing and photographing the early phases of nuclear explosions. (Today, the "*Fortune* 500" company, from which all three principals have retired, is a major technical equipment producer.)

There was only one chance to photograph each atomic test, so the photographic procedures—not strobe, this time—had to be exceptionally precise and foolproof. On a tower seven miles from the test site, Edgerton and his associates rigged a series of mirrors, telescopes, relay lenses, wire-fuse shutters, mechanical capping shutters, and other devices needed to capture the exceedingly fast early stages of the explosion. To record the microseconds after the explosion began, they had to cope with "the very large range of light intensity, the very short duration of the initial light, and the high velocity of the early phenomena." With typical Edgerton conciseness and understatement, he deemed the time of the exposure "ultrashort."

Reading the technical data for these photographs, however, can in no way prepare the viewer for the bizarre images themselves. Two of them are particularly ominous (pages 144–5). These bulbous emanations of disaster float like grotesque balloons arriving from outer space. Even if you did not know that these were pictures of atomic explosions, there is something about these shapes bursting in the night that evokes an instinctual dread, a horror that prickles the skin. Robert Oppenheimer, the father of the atom bomb, upon seeing the first test explosion aptly remembered a line from the *Bhagavad Gita*: "I am become Death, the shatterer of worlds." The EG&G photographs were unprecedented. Nothing like them had ever been seen before. Their scientific value was incalculable.

THE OCEANS

In 1953, Edgerton was asked by the National Geographic Society's research committee if he would join them in pursuing underwater exploration. Jacques-Yves Cousteau, the leader of the expeditions, visited

MIT to see Edgerton's underwater cameras. It was the beginning of a long and cordial association between the two scientists. What Edgerton came to realize as they undertook photographing some of the deepest seabeds in the world was that the murkiness of the waters would require some kind of sound system to augment his cameras. In this, he was following a tried-and-true method of the innovative scientist: if you cannot see something directly, figure out a way to record it indirectly. Edgerton simply switched from sight to sound. He deployed a type of penetration sonar—an echo sounder or "pinger"—now used everywhere by ships to measure the subbottom depths. As Edgerton explained, "Even with the clearest ocean water, the maximum distance at which an object can be photographed is about 30 meters." Sound, however, can record activity over much greater distances and can even "see" below the sea floor.

The most useful application of the echo sounder was in searching for shipwrecks long submerged in mud or sediment. To find underwater relics that projected above the sea bottom, Edgerton used a side-scan sonar about the size and contour of a hammerhead shark. Towed behind a vessel, it could scan for two hundred meters on either side. If the vessel made four knots, the scanner could explore a square mile in one hour. The timesaving benefits were enormous, and the accuracy of the sonar proved invaluable. Using a variety of sonar instruments, Edgerton helped various expeditions to locate not only the remains of the capsized USS *Monitor*, lost for a hundred years since its sinking during the Civil War, but also the wreck of the HMS *Britannic*, sunk in Greek waters during the First World War. Perhaps his most dramatic find was the famous sixteenth-century English warship, the *Mary Rose*, sunk during the reign of Henry VIII.

Edgerton's "pingers" have found dozens of uses in underwater explorations. He also created miraculous flash photography devices for French bathyscaphes and other deep-water submersibles, some diving to seven miles below the ocean's surface.

In 1986, to the inventor's infinite delight, an Edgerton-type camera, manufactured by Benthos, Inc., triumphantly secured the first pictures of the wreck of the RMS *Titanic*. Exactly where the *Titanic* was—and what its condition was—had tantalized explorers for decades, until the Woods Hole Oceanographic Institution team discovered it intact. Thanks to Edgerton's ingenious underwater devices, the mysteries of the deepest oceans are being exposed to rational exploration.

There was nothing exactly rational about the search for the Loch Ness monster back in 1976. Nessie, as the probably imaginary creature is affectionately called, is presumed to have survived the destruction of all other dinosaurs and to still swim in the chill waters of the highly convoluted depths of a Scottish lake. Powerful side-scan sonars were of course put to the test in the attempt to find evidence of the monster's existence. Edgerton himself was at lakeside and helped to assess the data as it was collected. The presence of Edgerton at such a quixotic search inspired Garry Trudeau to a series of spoofs in his famous cartoon strip, *Doonesbury*, thus proving beyond any doubt that "Doc" Edgerton had entered the American consciousness and was now a national hero (page 160). Trudeau teased him unmercifully, drawing him as a rather rumpled professorial type who, like one of the regular characters in the strip, belongs to the "Academy of Implied Sciences," which handles borderline cases. Edgerton, as his pictures suggest, has a healthy sense of humor and considerable wit and took it all in stride.

TODAY'S ENTHUSIASMS

Edgerton's underwater inventions have brought him kudos from around the world. Members of the Soviet Academy of Sciences have saluted his contributions. Yet, Edgerton's interests in underwater exploration have not been limited to the melodramatic discovery and the media sensation mystery.

In 1968, for example, he and his colleagues created a photographic system that made it possible for the first time to study underwater activities much too slow and minute to be observed within the limits of human patience and perception. Performing night and day, the system uses strobe lights for intense illumination. Thus, marine scientists can follow the indescribably sluggish movements of such creatures as sand dollars and sea urchins. Edgerton's devotion to helping others see what they need to see is reminiscent of Etienne-Jules Marey, whose stated ideal was to be "an engineer of life." Edgerton has retained a tender affection for the anonymous sea denizens, out of whose activities he has never tried to make "art." He is currently researching the multitudes of microscopic sea creatures. His enthusiasm for them is undiminished, as is his determination to continue to enlarge modes of seeing.

His new methods of photographing live brine shrimp and other minute forms of marine life will supplement the microscope, he claims:

"With the microscope, you can only photograph dead things. With my technique, you can study the living organism. That way you can really see its details." The brine shrimp, each about one millimeter long, are exposed to the flash of a strobe while floating in a glass dish on top of a sheet of film. A few moments later, crystal clear on the negative are the tiny creatures in all their featherlike dimensions, recorded life-size and alive. The detail is, indeed, remarkable, and enlargement will provide even more information (page 149).

Edgerton's strobe photographs demonstrate that he is not simply one of America's most gifted electrical engineers but also an artist of vision and an inventor so highly regarded that he was the subject of an exhibition jointly with Leonardo da Vinci at the Spencer Museum of Art in the spring of 1986. If Edgerton's laboratory notebook sketches have none of the elegance of Leonardo's, he shares with that great artist some of the same primary motivations: to *see*, to learn from every event, to recoil from nothing—not even atomic explosions—to discover what is happening at any cost, then to make it possible for others to see what he has either discovered or recorded. Since the Renaissance, Western society seems to ask of its artists and scientists to look even on the face of disaster and create images that we can tolerate seeing. In that sense, we may be asking of artists and scientists that they be the ultimate realists.

It was perhaps the realism, so long absent from visual imagery during the heyday of abstract modernism, that attracted audiences to Edgerton's photographs from the very beginning. The general public undoubtedly came to Edgerton's images with a strong sense of relief that they were uncannily physical. Their beauty was physical. Besides, with the exception of the atomic bomb tests, the pictures were often witty and fun: the antics of trained dolphins, grinning bats hurtling across space, pigeons arching into the air, all these were as enjoyable as the wild gesticulations of fencers, the soaring leaps of track athletes, and the exuberance of circus acrobats. Edgerton, who is known to have engendered fierce loyalty among his students, has also encouraged them, his colleagues, and the general public to benefit from his expertise and to supersede his accomplishments. It is obvious that Edgerton's strobe and flash have completely altered the way that photographs look and photographers work.

In *The Nature and Art of Motion*, Gyorgy Kepes—former member of the Bauhaus and teacher of The New Vision—put together a sequence of illustrations that illuminates the new interdisciplinary relationships be-

tween the arts and sciences. The sequence starts with a diagram of human movement by Etienne-Jules Marey, includes photographs of spirals in motion, aerial views, industrial and computer applications, paintings by Jackson Pollock, Robert Delaunay, Kasimir Malevich, and Piet Mondrian, as well as two photographs by Harold E. Edgerton: *Dynamite Cap Exploding* and *Stroboscopic Motion Study of a Tennis Player*. Kepes explained that the book was devoted not only to "artistic creation but the scientific comprehension of phenomena as well." The sequence of pictures is a confirmation of Marey's epigram quoted earlier: "Art and science encounter each other when they seek exactitude." Edgerton's photographs seem equally at home with the paintings as they do with computer graphics.

Exactitude is certainly one clue to any definition of Edgerton's visual accomplishments. Like Leonardo, who confessed to adoring mechanics and mathematics, Edgerton can be found to belong to both the sciences and the arts. But I would suggest that it is to yet another category that Edgerton belongs. I base this evaluation on several typical photographs: the drum majorette (page 104), the milk-splash coronet (page 127), and the column of water (page 45). In these marvels, he presents the transubstantiation of a young woman into a geometric pattern, a half-inch splash of milk into a majestic crown, and plain tap water from a faucet into scintillating glass. There is a word for people who practice such transformations: *magician*.

Ansel Adams, who frequently studied Edgerton's work to help him "get under the scaley epidermis of reality to reach the essences of life and the creative spirit," wrote to Edgerton in 1968 to congratulate him on retiring from active teaching: "You have shown us new vistas and have revealed new configurations in the infinite matrix of time and space." Edgerton is a visual magician who lets us see not only the secret laws of nature but also the beauties that accompany them.

Edgerton watches his assistant Jean Mooney tossing a baton for the multiflash in 1965.

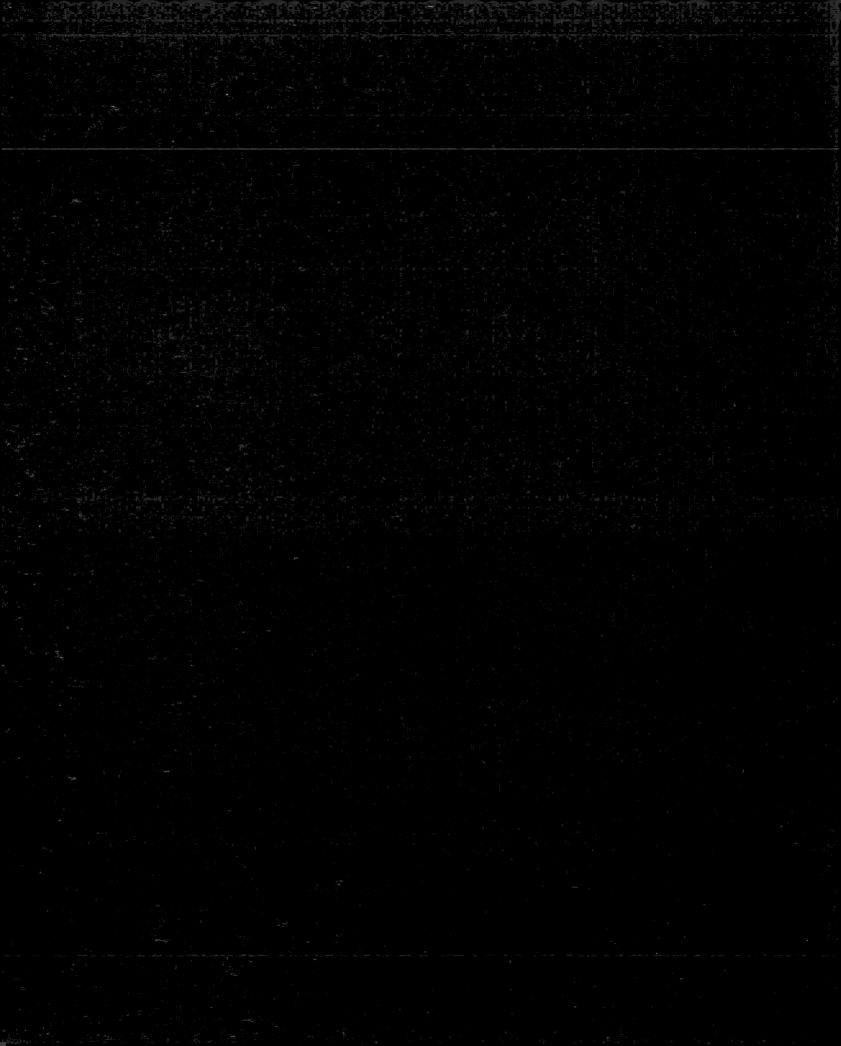

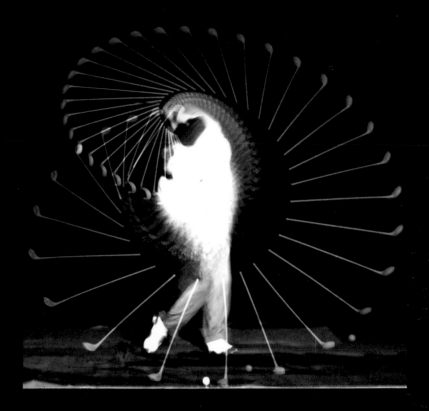

DENSMORE SHUTE BENDS THE SHAFT. 1938.

A famous golfer, well known for the style and grace of his strokes, Shute swings his driver into an Archimedian spiral—photographed at 100 flashes per second for half a second. His torso dissolves into a ghostly shape, super-imposed on itself 50 times by the flashing strobe. Note the curving of the shaft after the ball is hit.

Single-flash strobe is able to stop fast action. The electronic flash so common today has an exposure length of about 1/800 of a second, whereas Edgerton's exposures ranged from 1/3000 to 3/10,000,000 of a second in duration. Generally, the longer the exposure duration, the more light is emitted and the less clear the details of high-speed action become. Stopping bullets and golf balls requires very short exposures and extremely careful setup in order to expose the film correctly. In many situations, the ambient light level must be total or near darkness so the image is not overexposed. This can make the event difficult to control or even perform.

Timing the moment of exposure can be relatively simple: in this photograph, the shutter was opened (in darkness) and the flash set off manually. But it can involve more complex methods of synchronization, including (1) mechanical contact, where the action (such as a ball being kicked) physically moves wires into contact, completing an electrical circuit that fires the strobe; (2) acoustical synchronization, in which a microphone is used to pick up a sound (such as the shooting of a bullet or the sound of a bat striking a ball) and an electronic timing circuit delays the triggering of the flash for an appropriate amount of time; and (3) optical means, whereby the subject interrupts a beam of light aimed at a photoelectric cell (not unlike an "electric eye" alarm system) resulting in the release of the flash. All of these methods were used by Edgerton to synchronize the flash with various events. However, many of the photographic opportunities required hundreds of attempts before what was revealed was articulate or beautiful enough to satisfy him.

As a good scientist must, Edgerton kept open his expectations of what his photographs would reveal about the events he explored. In the best pictures, the surprise and delight are the viewer's as well as his.

WATER FROM A FAUCET. 1932.
The very first flash photograph Edgerton made that was not of a motor. Encouraged by his wife and colleagues, he tried the magic of the strobe on everyday happenings. Astonishingly, plain running water, which moves more quickly than one might imagine, is transformed into crystal by the speed of the flash.

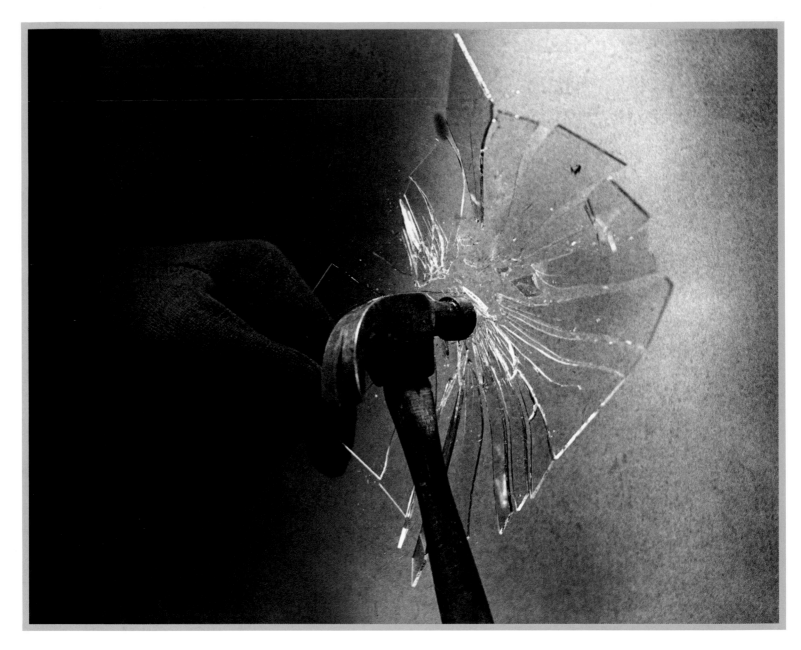

HAMMER BREAKS GLASS PLATE. 1933.
Wearing a glove to protect himself from flying fragments of glass, Edgerton's assistant smashes a pane of window glass. Unexpectedly, the knifelike glass shards shatter toward the camera.

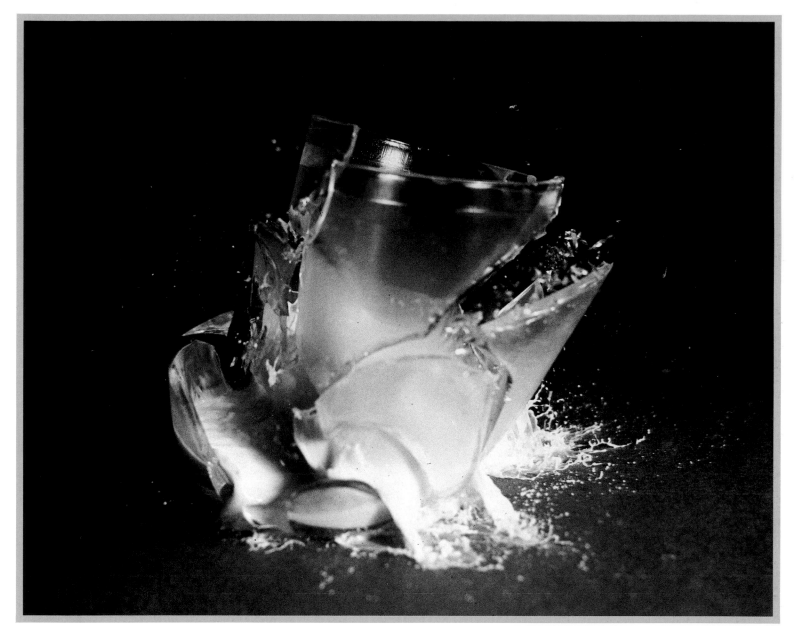

SPILT MILK. 1933.

Falling from a height of five feet onto a contact mechanism hidden beneath the piece of paper, a heavy tumbler shatters, and its impact simultaneously releases the flash. The exposure is so short that the splashing milk has not yet begun to spread.

SODA SPRITZER. 1933.

At exactly 8:31 P.M. on a summer evening, Mrs. Edgerton attempts to fill a highball glass from the soda siphon. The brief flash of Edgerton's strobe captures the jet of carbonated water and makes it resemble a winter's icicle.

WATER ONTO A CAN. 1934.

A smooth column of water hits the bottom of an overturned can and transforms itself into elegant, jeweled sprays. The charm of such simple occurrences fascinated Edgerton and captivated the early audiences to whom he demonstrated the magic of the strobe.

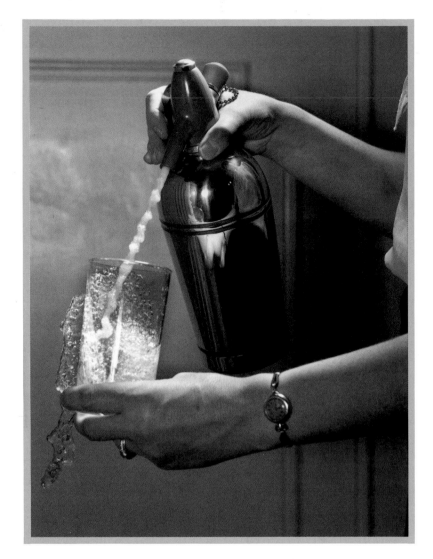

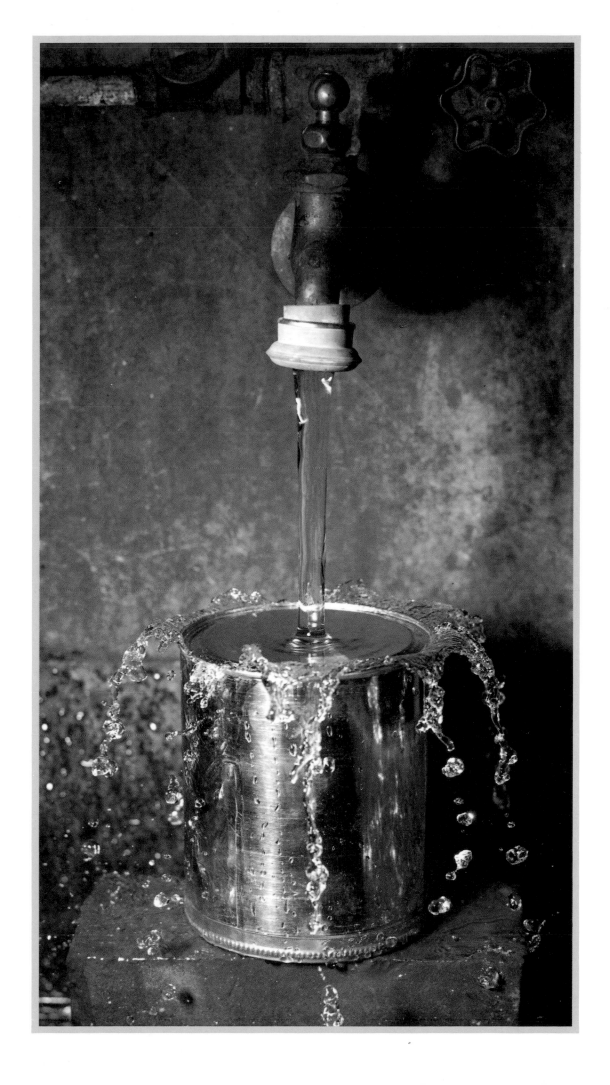

CAR THROUGH WATER. 1938.

What was especially exciting about this picture was that it demonstrated the portability of the newly developed flash equipment. Edgerton could photograph fast-moving phenomena in virtually any environment.

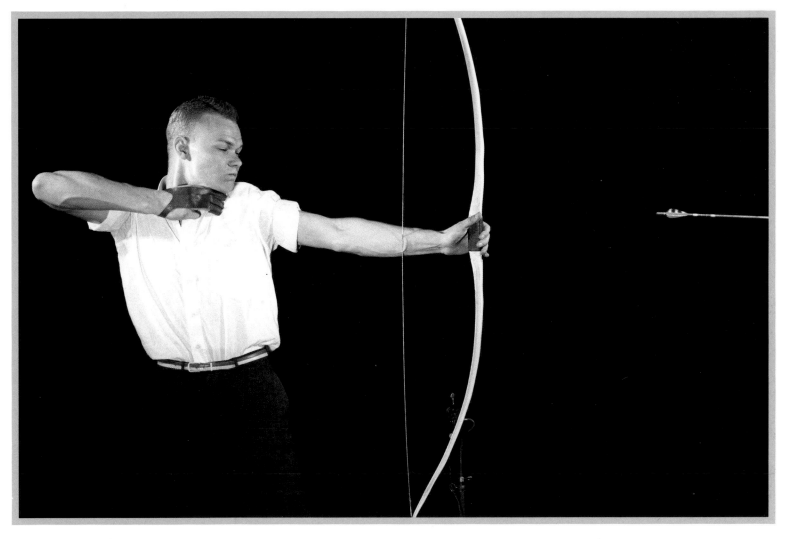

OUCH! 1934.

Photographing sports figures in an effort to capture ever-faster moments of often-observed action, Edgerton experimented with archers. Here, one of his obliging graduate students aims an arrow toward a target. The flash reveals the instant he learns how painful a bowstring can be when it is incorrectly released. Pictures made later in the session show the student wearing a forearm protector.

WES FESLER KICKING A FOOTBALL. 1934.

Using the simplest of all electrical synchroniza-tion methods, Edgerton's setup lets the football actually take its own picture. As it is kicked, it pushes two wires together to complete a circuit. The dirt that was lodged in the top seam of the football hovers by its original location just as the ball is kicked. The boot penetrates more than half the diameter of the properly inflated ball.

After this first look at what actually happens at the moment of impact, athletes in other sports were eager to collaborate with Edgerton to ex-plore the unseen moments of their own activities.

FOOTBALL KICK. 1938.

In one of the first color strobe pictures ever tak-en, a brilliantly clad athlete smashes his boot into what seems to be a stationary football. As a result of the impact, the ball will rhythmically ex-pand and contract as it tumbles through the air. The player performed his kick in the darkness of Edgerton's studio. The clenched fist reveals his total concentration and the strain of his effort.

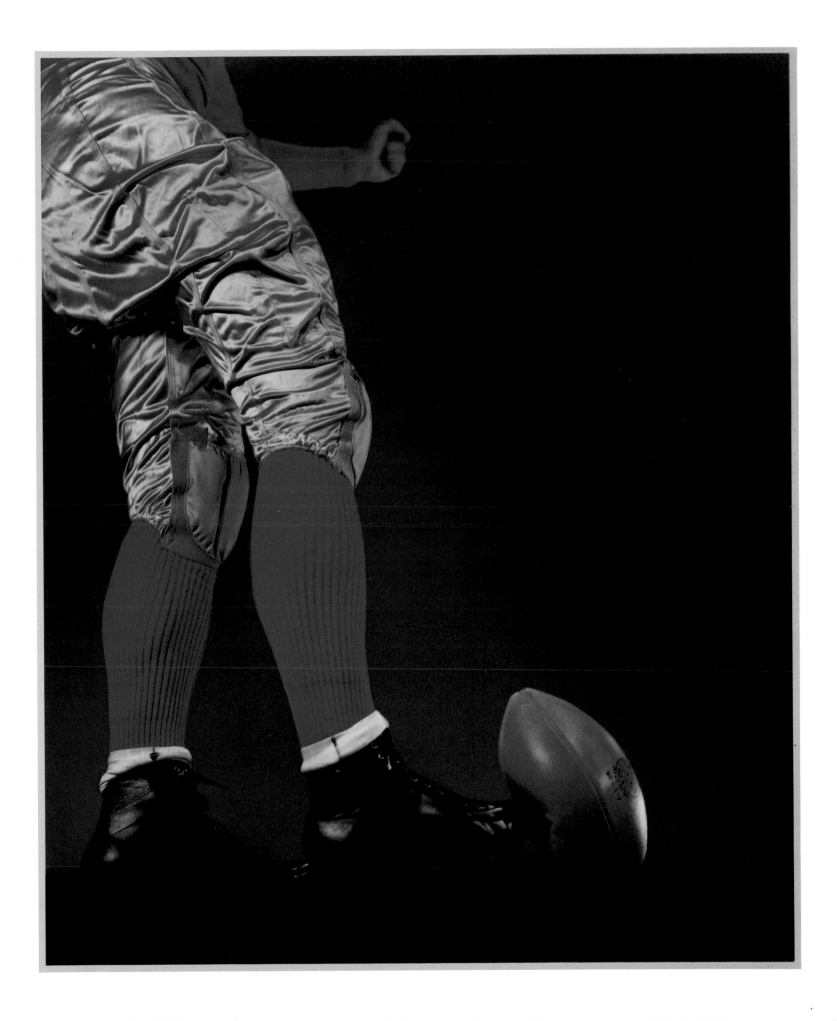

DRIVING THE GOLF BALL. 1935.

It took an exposure of 1/1,000,000 of a second to demonstrate the acute compression endured by a golf ball struck powerfully by a wood. The ball's cover momentarily crazes like old porcelain.

TENNIS BALL IMPACT. 1935.

Hitting the tennis racket as if it were a trampoline, the ball flattens dramatically. The sound of the impact set off the flash.

SOFTBALL BATTER. 1938.

The bat bends, the ball compresses. With his eye on the ball, the batter concentrates all his muscular power into the stroke. As in many of Edgerton's sports photographs involving hitting a ball, the batter swung in a darkened room, and the sound of the hit was used to trigger the flash. The microphone was just beyond the right edge of the frame of the photograph.

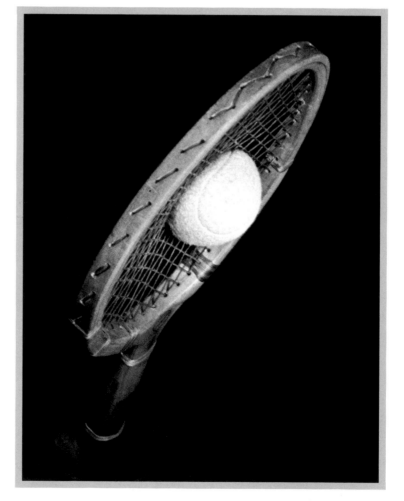

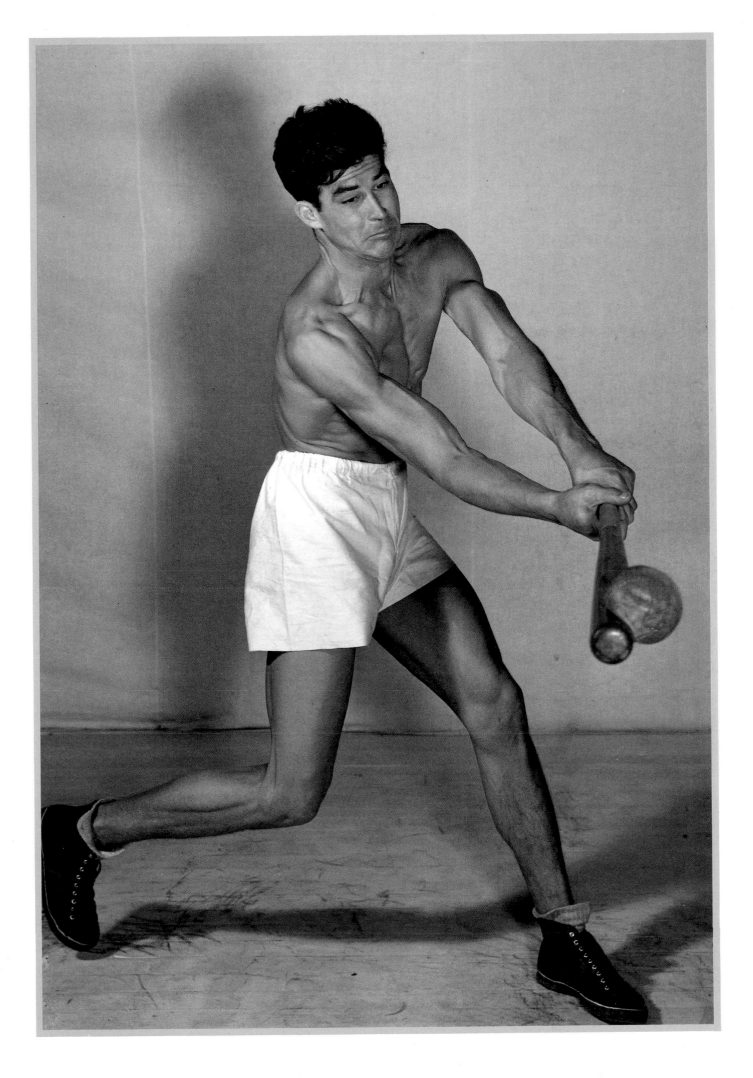

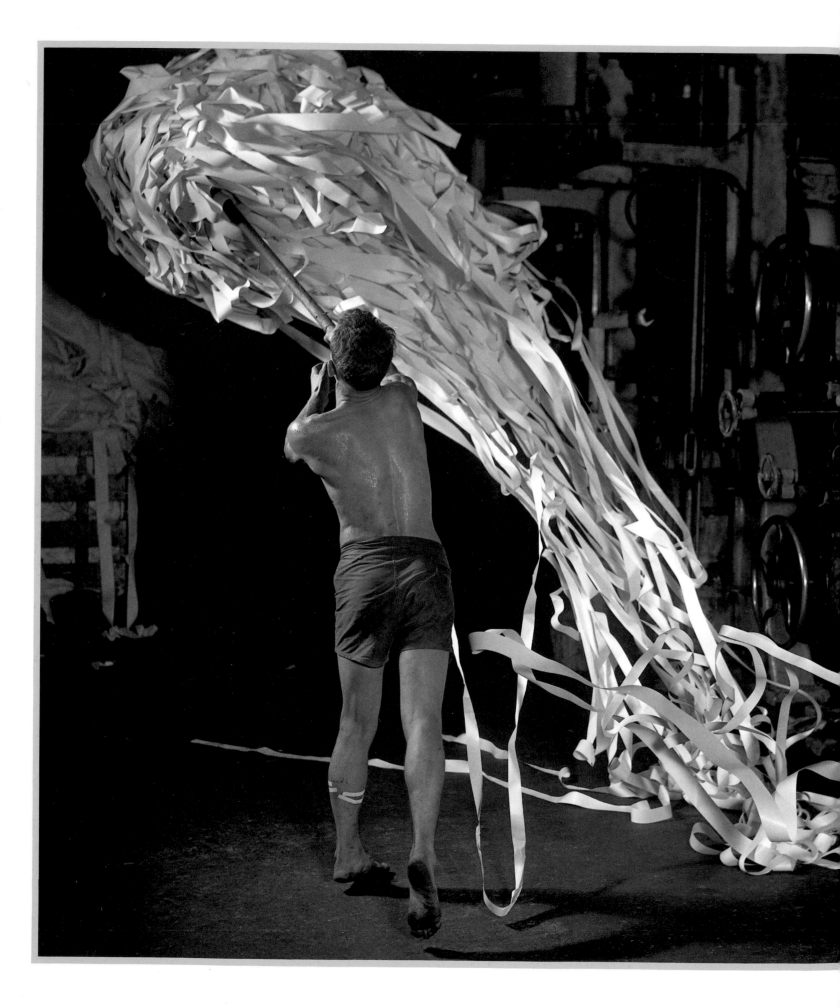

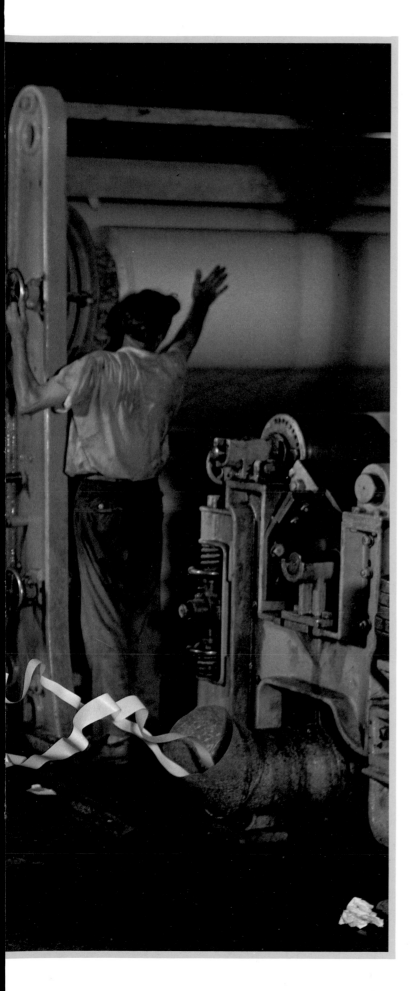

(left) *PAPER-MILL WORKER.* 1937.

While setting up and testing their equipment to study papermaking machinery, Edgerton and his associate Kenneth Germeshausen saw this worker removing a mass of the waste edges cut from large sheets of paper.

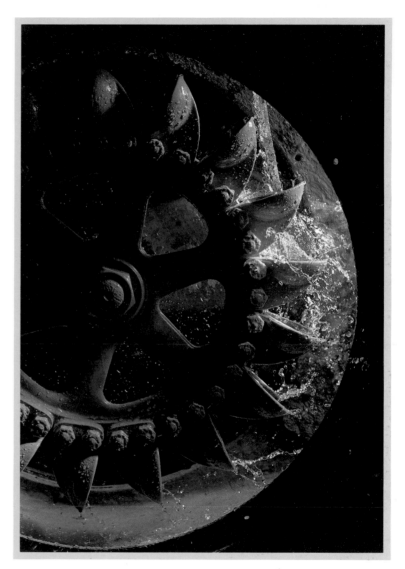

WATERWHEEL. 1939.

Water jets into the buckets of a Pelton wheel, changing the strong stream into rotary motion to generate electric power. The buckets each measure nearly two feet in diameter. Edgerton's pictures helped analyze the efficiency of the design.

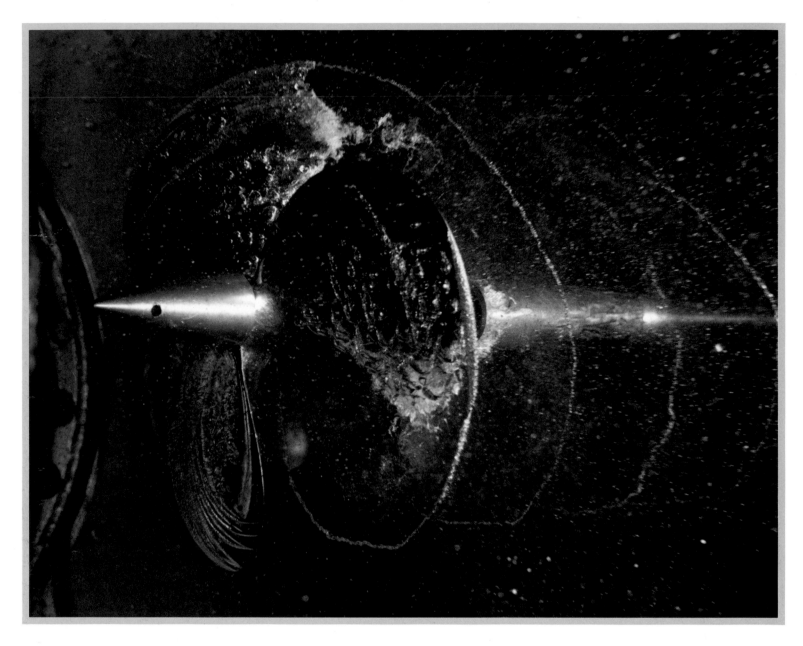

PROPELLER CAVITATION. 1938.

Cavitation is the destructive force of implosive bubbles created by the spinning of a ship's propeller in water. The speed of the outer ends of the propeller causes huge pressure differentials and boils the surrounding water. Edgerton's high-speed flash allowed analysis of the formation of the bubbles and aided in the redesign of the propeller to minimize the damage it causes to itself. As the potential of the strobe was increasingly understood, Edgerton's services were often requested by engineers and industrialists interested in studying fast-moving phenomena.

(opposite) *FAN AND SMOKE.* 1934.

One of the many pictures Edgerton exhibited at the Royal Photographic Society in London in 1934. The titanium tetrachloride smoke is forced by the whirling fan blades into spiraling vortices. Because at first the strobe caused uneven, specular reflections on the shiny metal fan blades, the blades had to be painted white for maximum clarity.

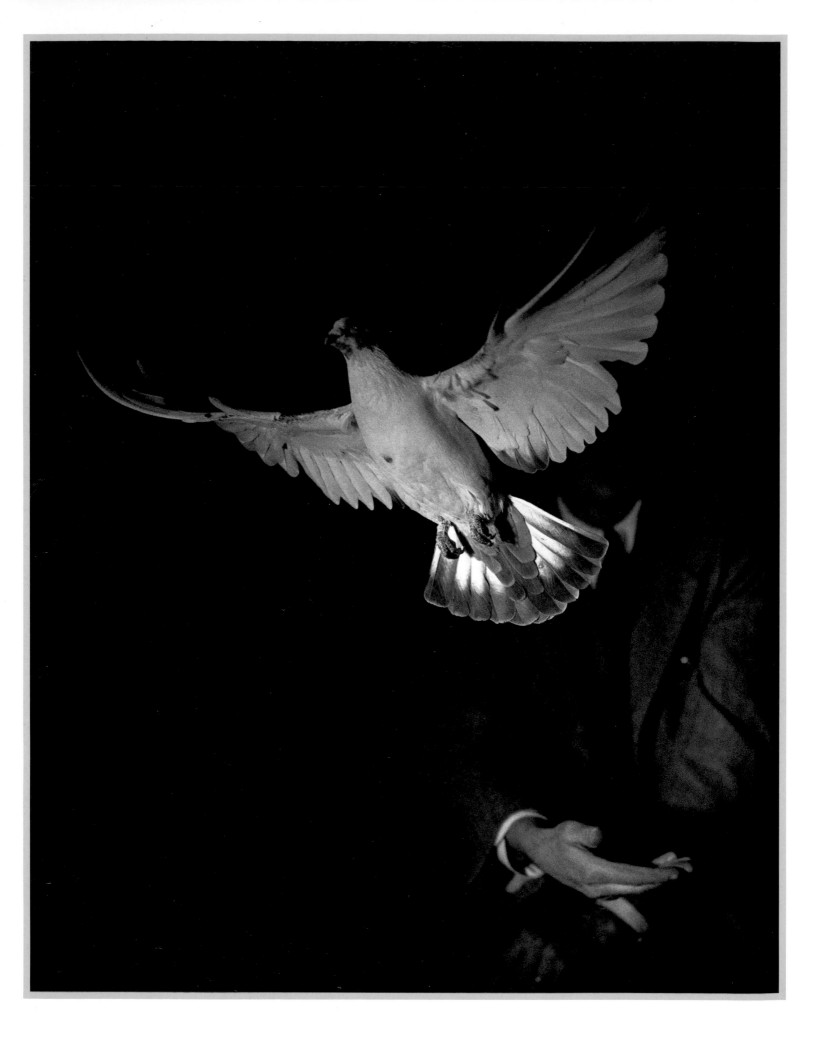

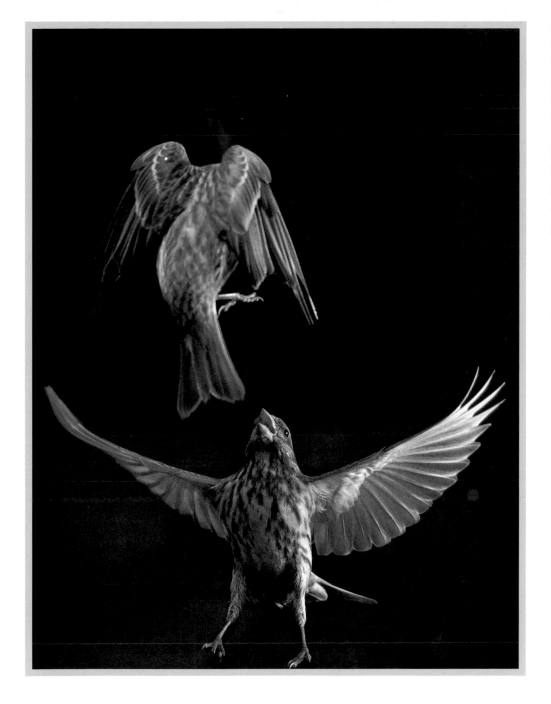

(opposite) *RISING DOVE.* 1934.

As it leaves its trainer's hands, the dove spreads its wings to their fullest extent, revealing the complexity of its plumage and the aerodynamics of the tail feathers that stabilize its ascent. The flash duration was 1/100,000 of a second. Throughout his long career, Edgerton's curiosity has been provoked especially by the movements of birds and other animals. His pioneering pictures of birds are frequently cited by naturalists and were published often in *National Geographic* magazine and other periodicals.

FIGHTING FINCHES. 1936.

Interrupted at a windowsill feeder, an angry purple finch fights off an uninvited intruder.

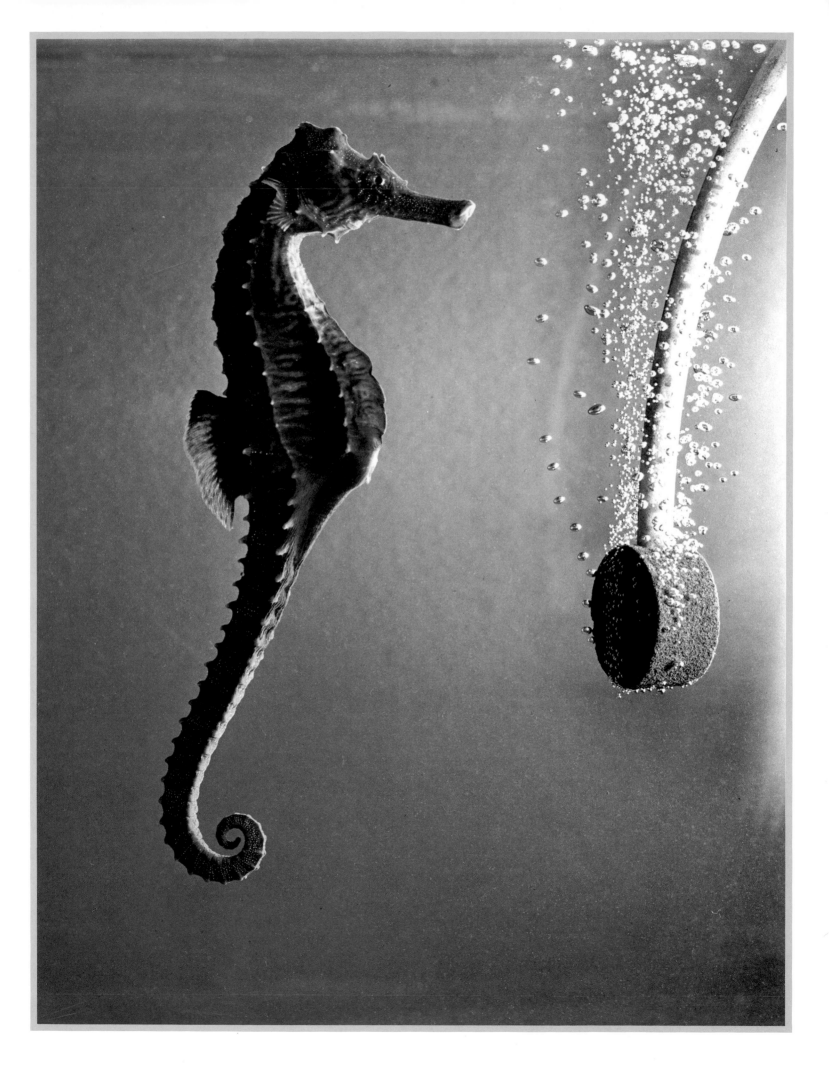

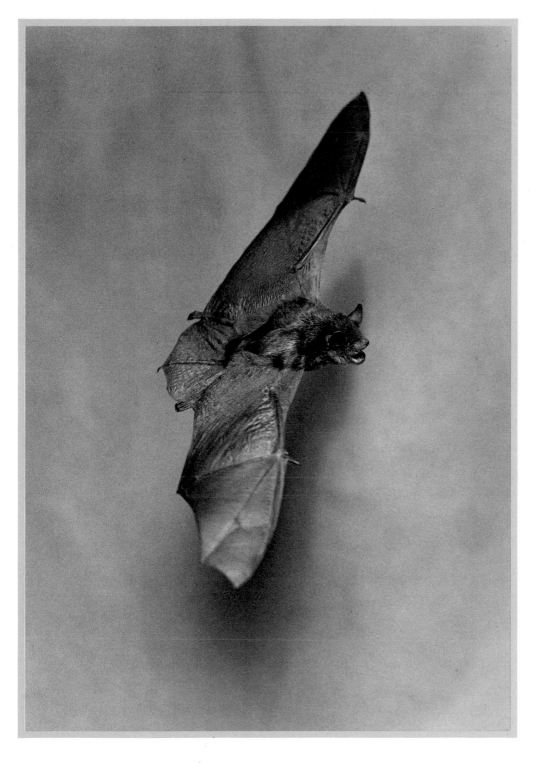

(opposite) *SEA HORSE.* 1939.

As the tiny sea horse hovers in front of the aquarium aerator, its fin fans at 35 beats per second, a blur to the naked eye. While the light from the strobe is intense, the flash is too brief for its heat to injure the delicate creature.

BAT. 1939.

Since the flight of a bat cannot be anticipated with any precision, the animal was allowed to fly freely in a darkened room. Once it interrupted a beam of light aimed at a photoelectric cell, the flash was automatically released. With this method, Edgerton caught the first detailed photograph of a bat in flight.

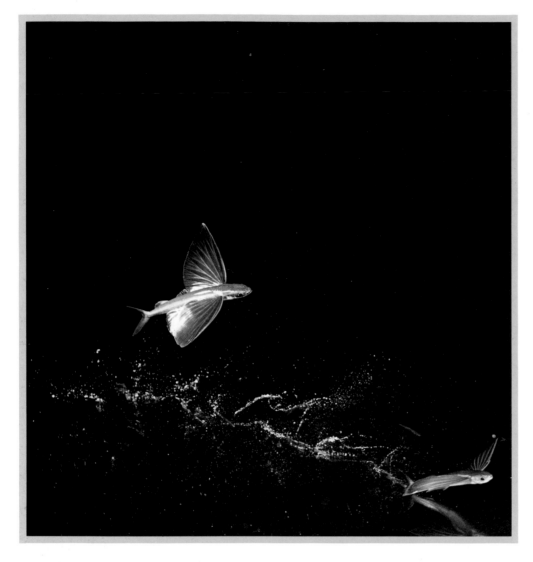

FLYING FISH. 1940.

Taken near Catalina Island, California, with the help of associate Frank Wyle, this composite photograph was extremely difficult to produce. Weather conditions had to be perfectly calm and the fish were elusive. To take off, a flying fish achieves speed with rapid movements of his tail fin. The fish glides but does not actually fly. To show the stages of flight on one image, two negatives were combined by Edgerton for this picture.

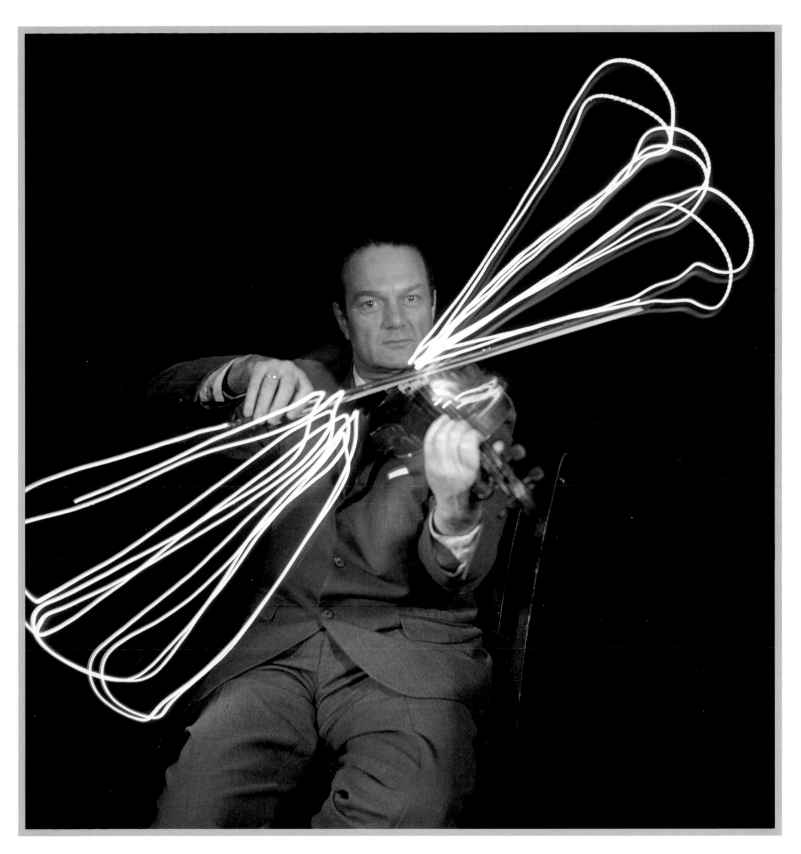

VIOLINIST. 1968.

Two tiny lightbulbs were attached to the ends of the violinist's bow as he played in total darkness while the shutter of the camera remained open.

To record his presence, the strobe was fired once, otherwise only the traces of the bulbs would be seen.

(opposite) SPRINKLER. 1939.

A nighttime picture of a lawn sprinkler creating an impressive figure eight as the water twists in regulated spirals. To capture the complete pattern of the fast-moving spray, the strobe was fired at 1/100,000 of a second.

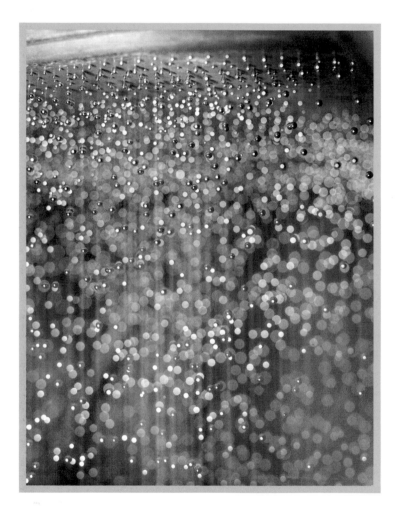

LEAD FALLING IN A SHOT TOWER. 1936.

Edgerton was asked to photograph shot-making processes to help the manufacturers analyze the efficiency of their machinery and to reveal what actually occurs at moments too fast for the eye to see and understand. Here, molten lead drips through the holes of a die, solidifying into shot as it falls.

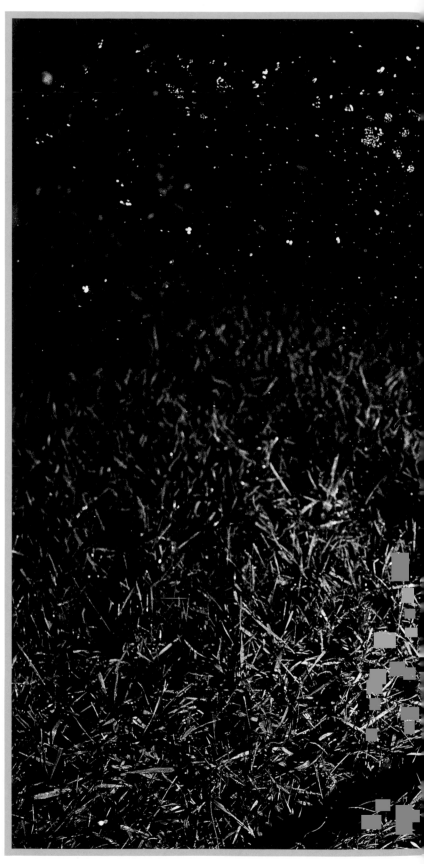

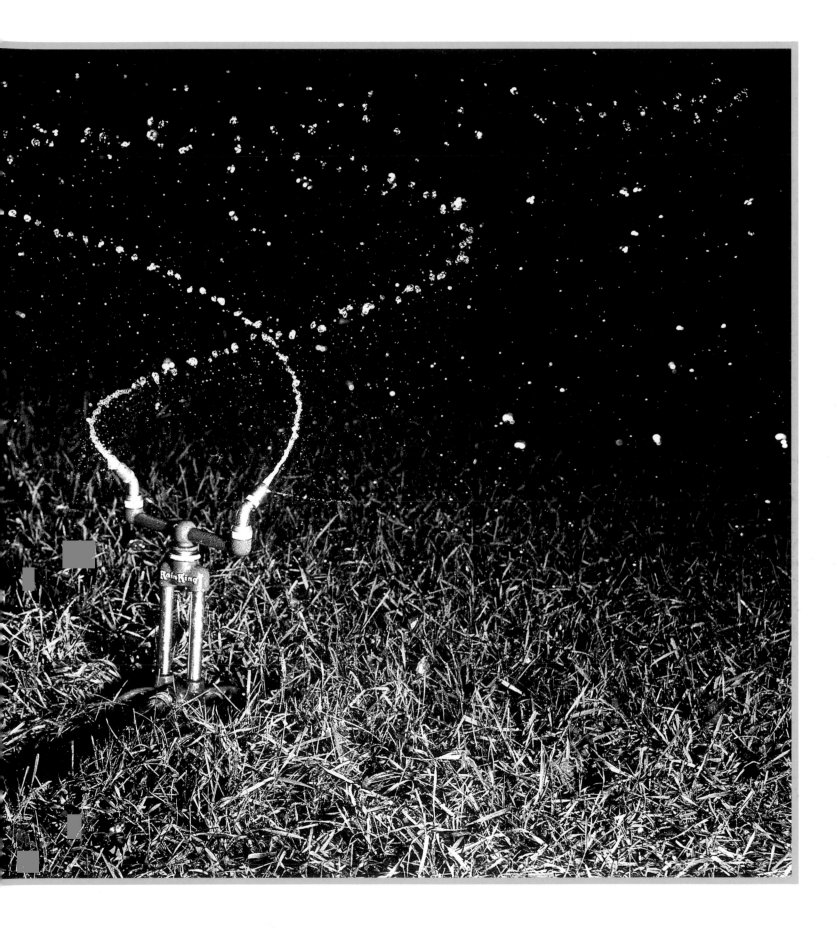

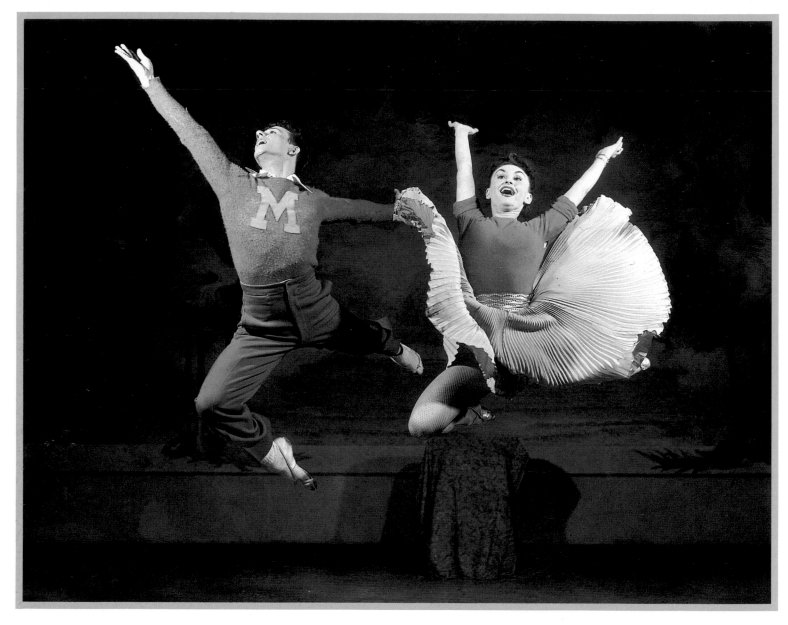

BROADWAY DANCERS. 1947.

Stymied by union regulations barring photography during live performances, Edgerton invited the cast of *Call Me Mister*, a popular revue, to perform in his lab. Nuances of gesture and expression, previously only sensed in photographs, could now be made visible.

JUMPING GIRL. 1940.

Edgerton's daughter, Mary Louise, leaps high as she skips rope in the family's living room. With the perfect technological marriage of the then recently introduced Kodachrome sheet film and his newly developed Kodatron electronic flash unit, a proud father demonstrated his invention's versatility, taking one of the first indoor snapshots decades before they became commonplace.

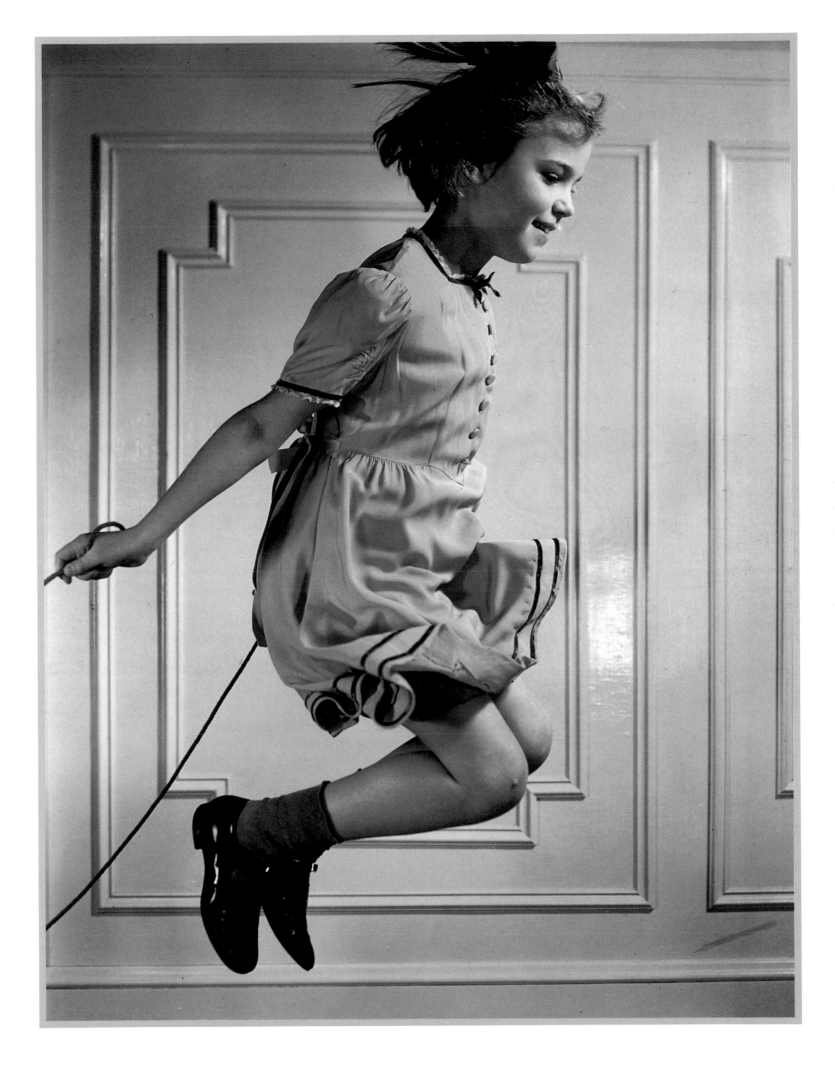

FANNING THE CARDS. 1940.

Faster than the eye; but not the flash. An expert flips the cards from hand to hand, controlling their flight with thumb and forefinger.

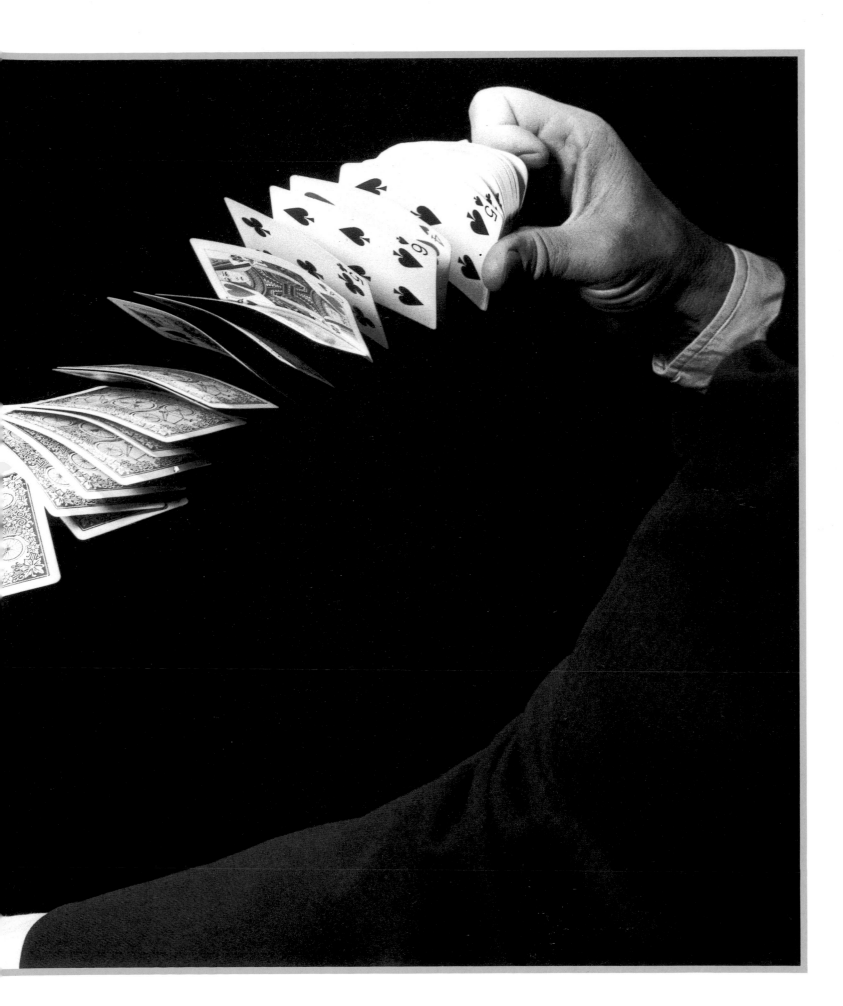

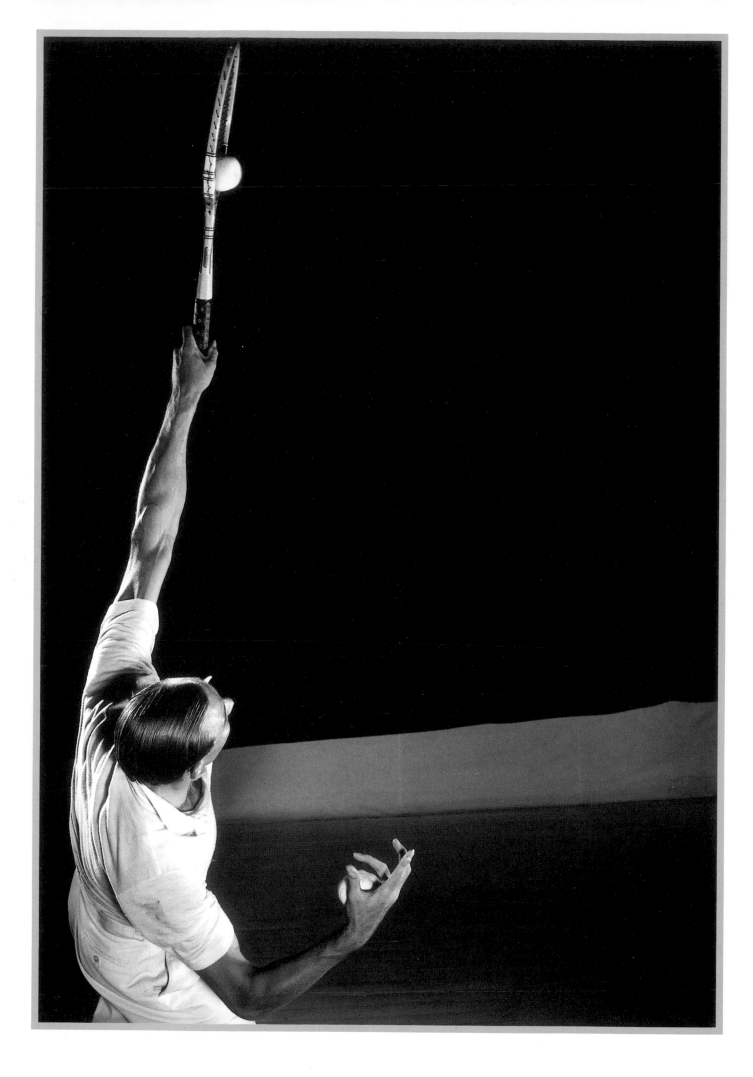

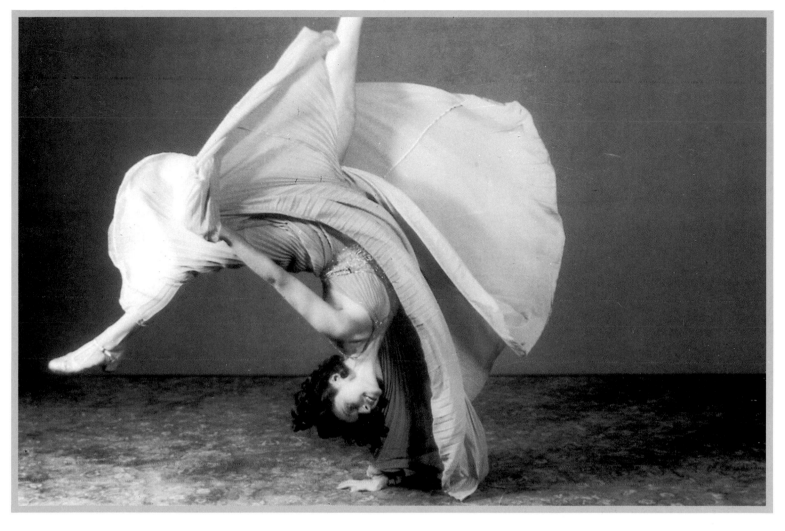

(opposite) *CHARLES HARE SERVES.* 1938.

The left-handed British tennis ace shows his form as he serves in the studio for Edgerton. The impact bends the frame of the racket. The relative simplicity of Edgerton's technique and the high-speed action he revealed for the first time, won the interest and cooperation of sports promoters and many celebrated athletes.

DANCER'S CARTWHEEL. 1940.

At a photography fair in Chicago, Kodak introduced Edgerton's Kodatron strobe with a demonstration of its ability to record rapid movement. At 1/3,000 of a second, the flash stopped the dancer's momentum in the middle of her seemingly impossible move.

By 1940, Edgerton ventured beyond his lab, with the small-scale and well-controlled environment it provided, to public and sporting events that required massive lighting on a scale never before attempted. Logistical and public relations problems new to a scientist compounded the difficulties. Edgerton's skill as a communicator and his willingness to share ideas, technical developments, and enthusiasm were as important as the photographic techniques he used. Capacitors the size of coffins and weighing nearly a thousand pounds, quartz flashtubes mounted in 36-inch searchlight reflectors that emitted bursts of light many times brighter than the sun, thousands of volts of direct current, and the smell of ozone invaded Stonehenge, Symphony Hall, and many arenas across the country.

SHOT FROM A CANNON. 1940.
Victoria Zacchini flies through the air toward a safety net 175 feet from the cannon. Below her, Papa Zacchini had activated the spring-loaded propelling mechanism, as well as the cosmetic black powder charge, by depressing a plunger. Two large reflectors housing powerful flashtubes were necessary to illuminate the action.

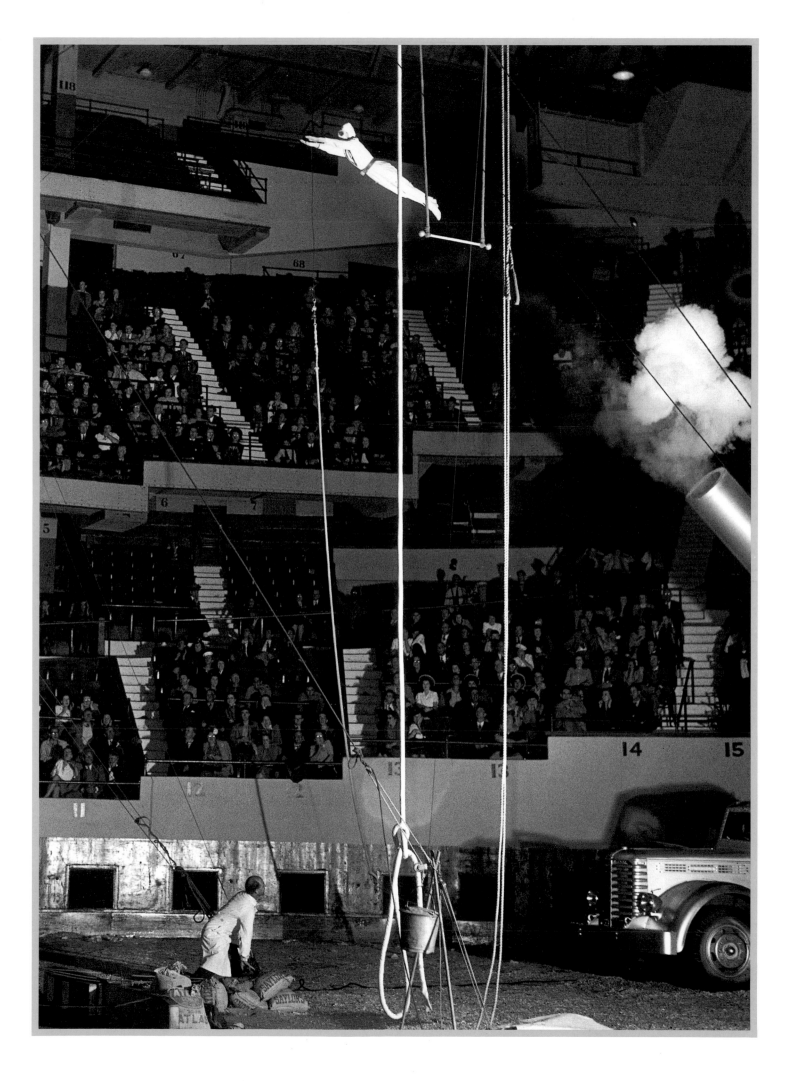

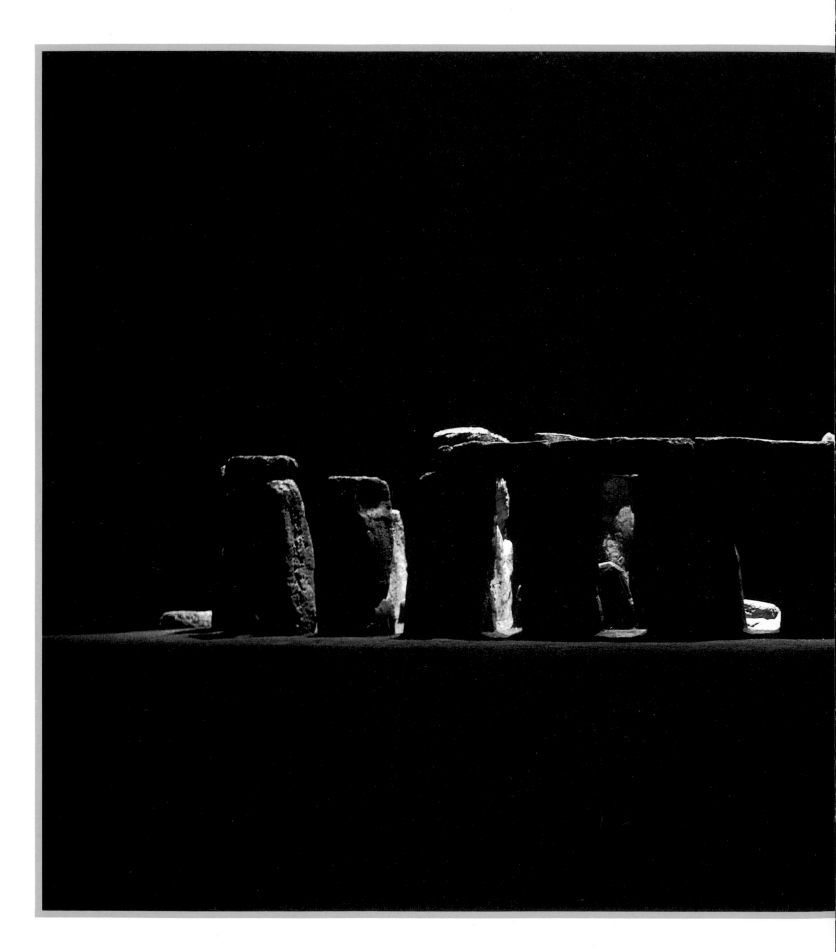

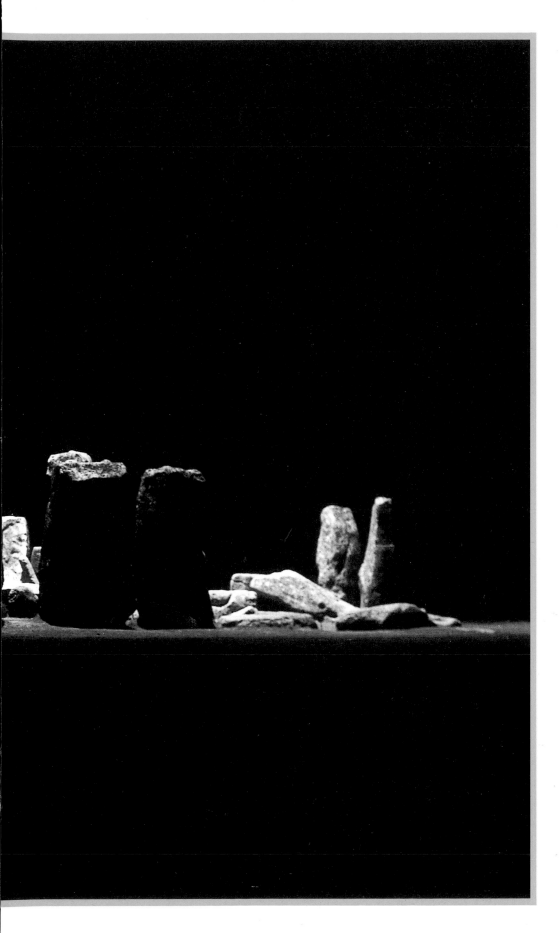

STONEHENGE AT NIGHT. 1944.

Illuminated by a 50,000 watt-second flash in the bay of a night-flying airplane 1500 feet above the ancient monoliths, Edgerton's pictures of Stonehenge served as a demonstration to the Allied commanders of the potential for nighttime reconaissance photography. Edgerton was on the ground with a folding pocket camera braced on a fence post as the plane flew overhead. Simultaneously, the monument was recorded in perfect detail by a camera in the plane. The target was chosen because it was remote enough to allow the equipment to be tested without arousing unwanted interest. Edgerton has maintained an active curiosity about Stonehenge since he took this picture, which has appeared in virtually every publication about the monoliths.

DRUM MAJORETTES AT THE CIRCUS. 1940.

A colorful apparition entering the Boston Garden. Unlike the rodeo (page 80), in which peak action occurred at random locations in the arena and therefore required a mobile reflector to follow the subject, this carefully planned parade was met with a barrage of light so strong it overpowered the bright arena spotlights.

(opposite) *FIEDLER AT THE POPS.* 1947.

Arthur Fiedler wields his baton during a performance in Boston's stately Symphony Hall. It was necessary to have separate, synchronized electronic flashtube reflectors aimed at the audience and the conductor.

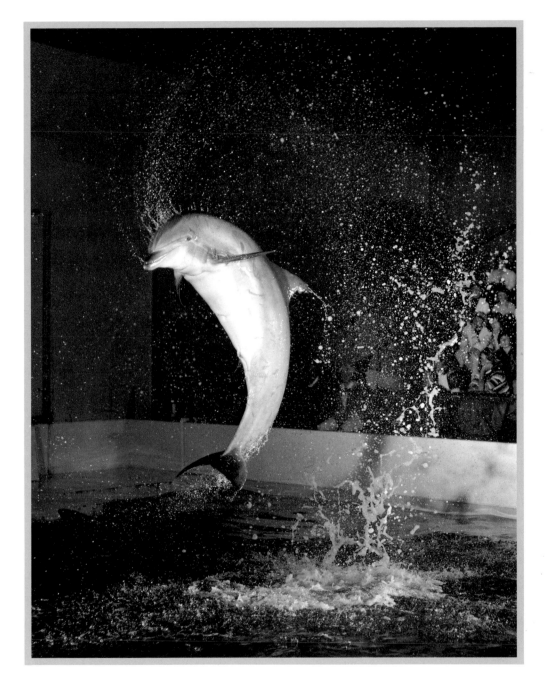

(opposite) *RODEO.* 1940.

Perched high in the rafters of Boston Garden, a graduate assistant aimed a strobe housed in a heavy 30-inch reflector to spotlight the action, so that Edgerton's camera, connected to the strobe by a 150-foot wire, could record this astonishing picture of horse and rider—separated not only from each other but from the ground as well. This was one of many sports events that Edgerton photographed to publicize his powerful, high-speed flash inventions.

DOLPHIN. 1977.

A lively dolphin performs a high leap before an appreciative audience at the New England Aquarium. The aquarium maintains the Edgerton Research Laboratory for Oceanographic Studies, in honor of Edgerton's ongoing and significant contributions to underwater research.

High-speed multiple exposures were first made effectively by Edgerton's multiflash, which is simply an electronic flash fired in rapid succession (like a stroboscope) while the camera shutter remains open. The strobe can be timed electronically to fire at regular intervals for a prescribed length of time, or it can be released manually at slower or irregular intervals if the action occurs at varying rates of speed. There were numerous obstacles to contend with during the design and operation of the multiflash. The main technical problem was to create the circuitry and tube so that the flash would fire and recycle repeatedly without stalling or overheating, melting, and exploding. One of the major photographic challenges is preventing overexposure of the areas of the image that are subjected to many flashes (such as the background or the relatively stationary parts of the body) while correctly exposing the faster moving objects (such as a ball or racket) that in any one position were caught by only a single flash. Synchronization of the flash and the action can be highly complex since the sequence of flashes must start and stop at appropriate times, and the rate of the flash must be carefully controlled in order to separate or crowd the individual exposures in accordance with the speed and rhythm of the event.

These records of the paths of movement allow an understanding of motion and the interaction of moving parts. Sometimes, the information can be literally evaluated; for example, how the space between images of a golf club is greater before the impact and transfer of momentum than after the impact, when the club slows. Other times, the insight is less specific, but certainly as clear: the multiflash is an unmerciful judge of the difference between the graceful golf swing of a professional and the awkward stroke of the duffer.

GUSSIE MORAN. 1949.
Edgerton brought his strobes and other equipment to Longwood to photograph the touring tennis stars. He was given a few minutes with each in an anteroom before they went out for their matches. Moran, an outstanding player, tossed the ball into a perfect parabola for a power serve.

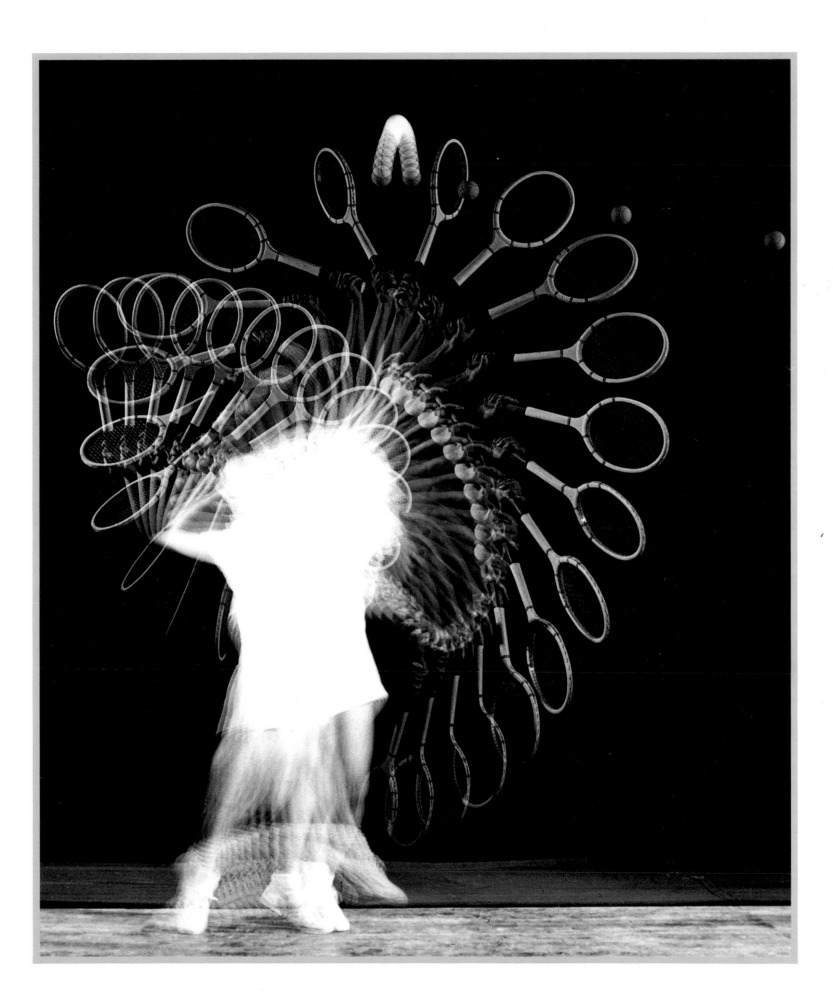

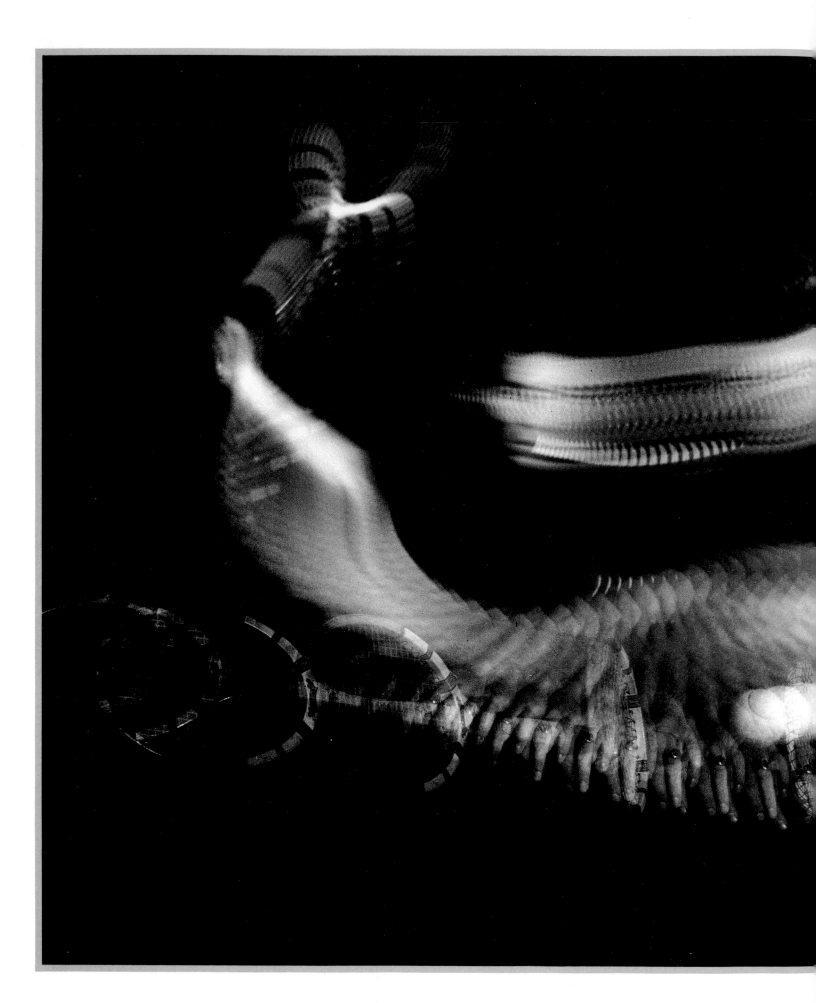

SWIRLS AND EDDIES: TENNIS. 1939.
Clothed in black, so that nothing shows but his face, hand, ball, and racket, a player keeps his eye firmly on the ball as he follows through with a forehand drive. Upon close examination, the apparent blur of the racket is actually many clearly defined, overlapping images. The rapid rate of 120 flashes per second created this effect. This photograph was selected by Edward Steichen for The Museum of Modern Art's collection.

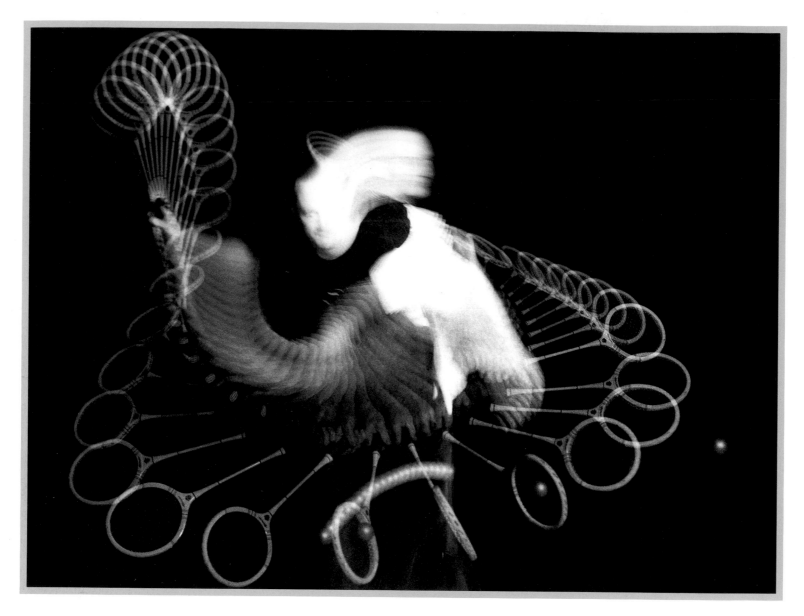

SQUASH STROKE. 1938.

Champion Jack Summers serves the squash
ball. The magic of the multiflash follows the com-
plete gesture, seemingly adding a second head
to the player as he turns with the racquet.

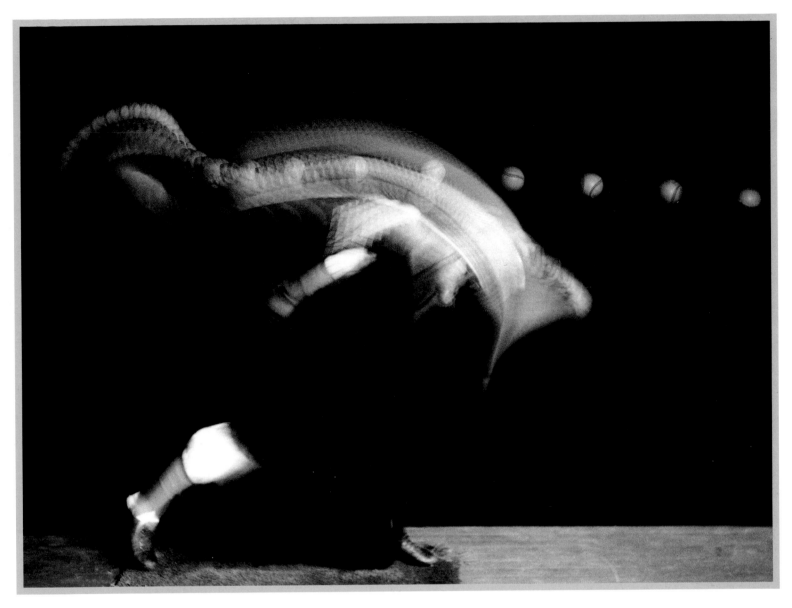

PITCHER. 1938.

With one leg peeking out from the black kimono Edgerton asked his participants to wear, Wes MacFayden of the Boston Bees delivers a hard-thrown curve ball. One hundred exposures per second obscured the pitcher's motion some-what, but allowed the rotation of the baseball to be clearly observed.

(right) *FOIL SALUTE*. 1938.

The foil salute that each fencer offers before engaging an opponent is epitomized in a classic gesture by five-time national champion Joe Levis.

(below) *TWO FENCERS*. 1938.

The rapid lunge to the neck is made visible as the truly graceful movement it is.

(opposite) *FOIL TRICK*. 1938.

The fencer boldly presses his foil to the ground. When he releases it, the foil springs upward and rotates until he catches it with one hand close to his chest. Photographing the thin blade required extremely careful exposure for the camera to pick up each reflection of the light off the steel.

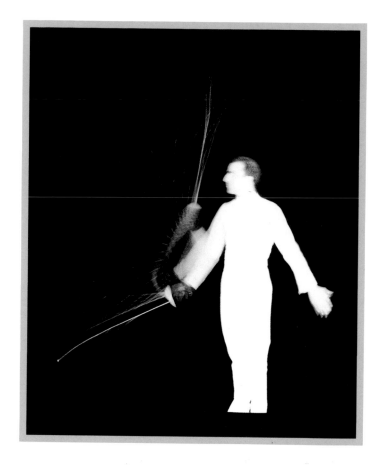

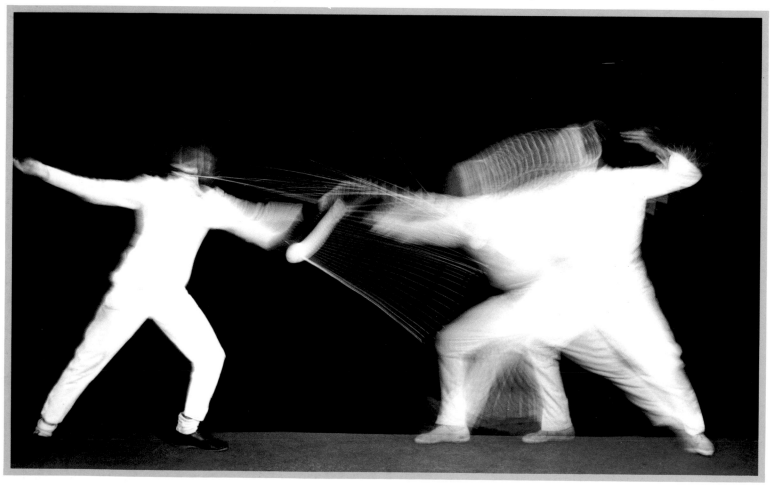

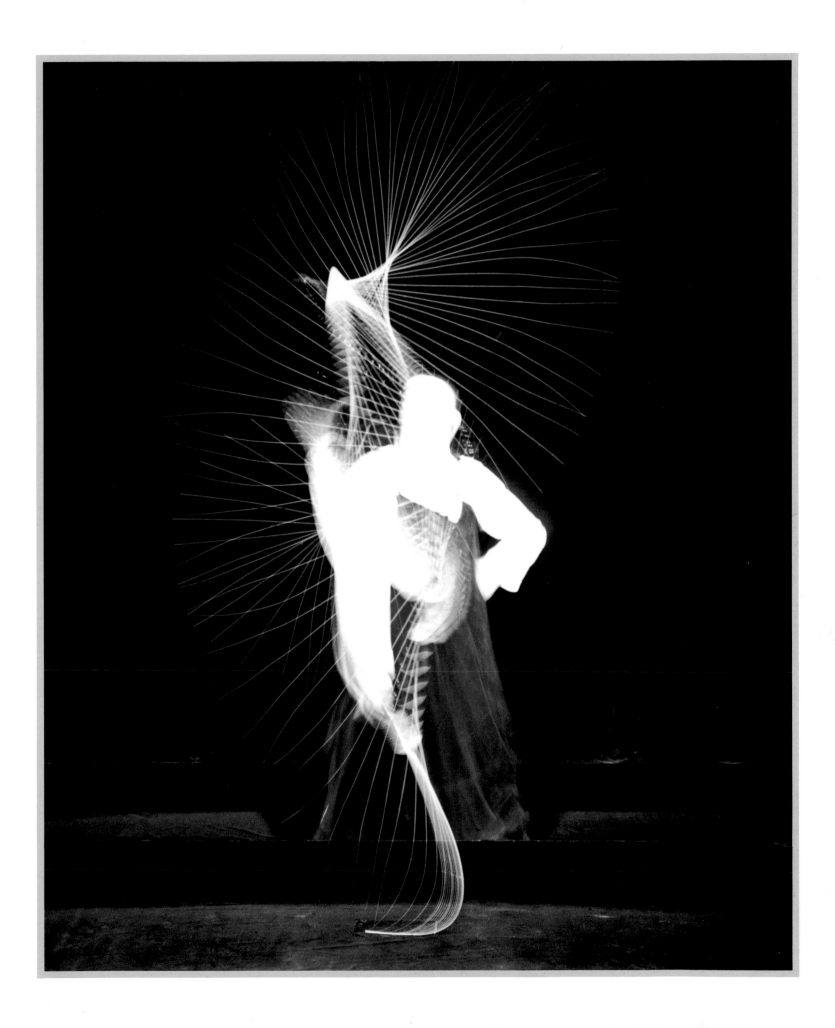

JACKIE WAGS HIS TAIL. 1948.

Looking like a subject from a Futurist painting by Giacomo Balla, Edgerton's family pet performs for the strobe with the poise of an accomplished actor.

(right) *JACKIE JUMPS A BENCH.* 1948.

Using one paw to propel himself, Jackie hurdles a piano bench. This many legged phantasm was the strobe's creation at 60 multiflash exposures per second.

Ninteenth-century physiologists were fascinated by human and animal locomotion but could never achieve the accuracy and detail that Edgerton's strobe made possible. The very short duration of his flashes stopped the action, while the large amount of light emitted allowed full exposure of each moment in the sequence.

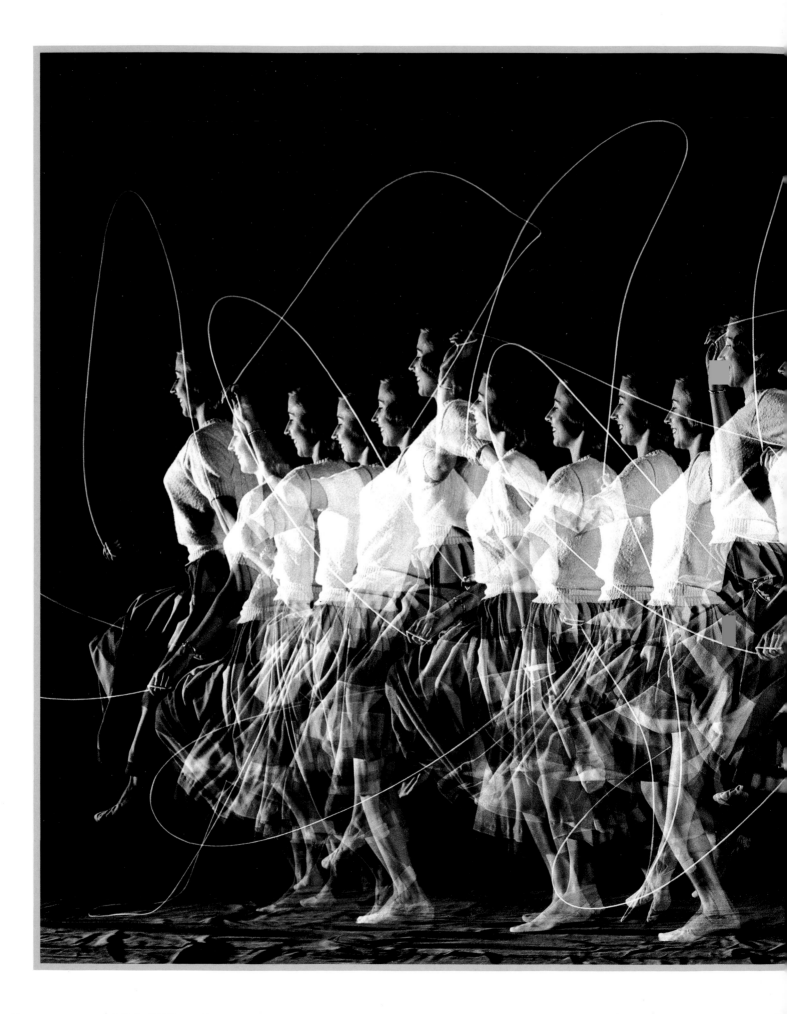

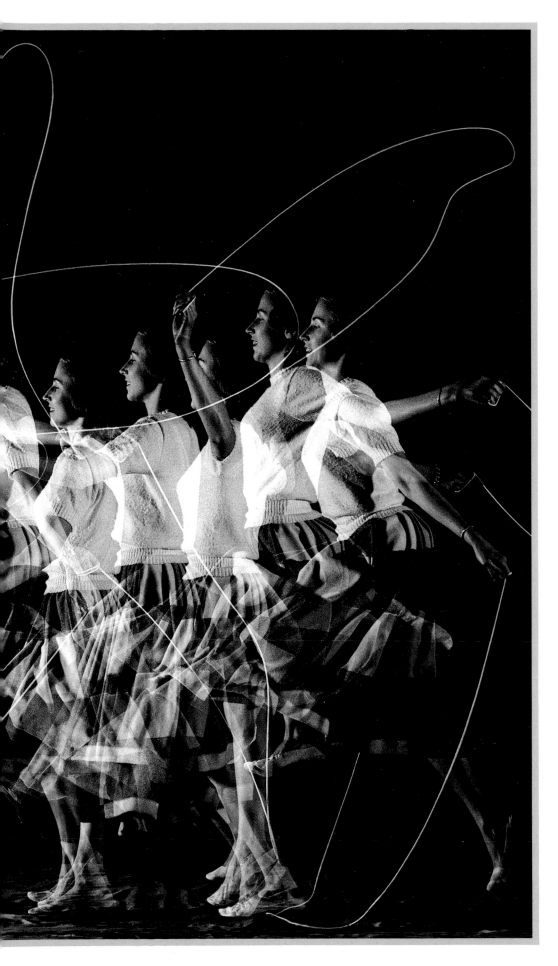

MOVING SKIP ROPE. 1952.
Fired 30 times per second, Edgerton's multiflash clearly shows the complicated and erratic trajectory of a jump rope. With obvious enjoyment, the young woman skips forward, unaware she is creating intricate patterns.

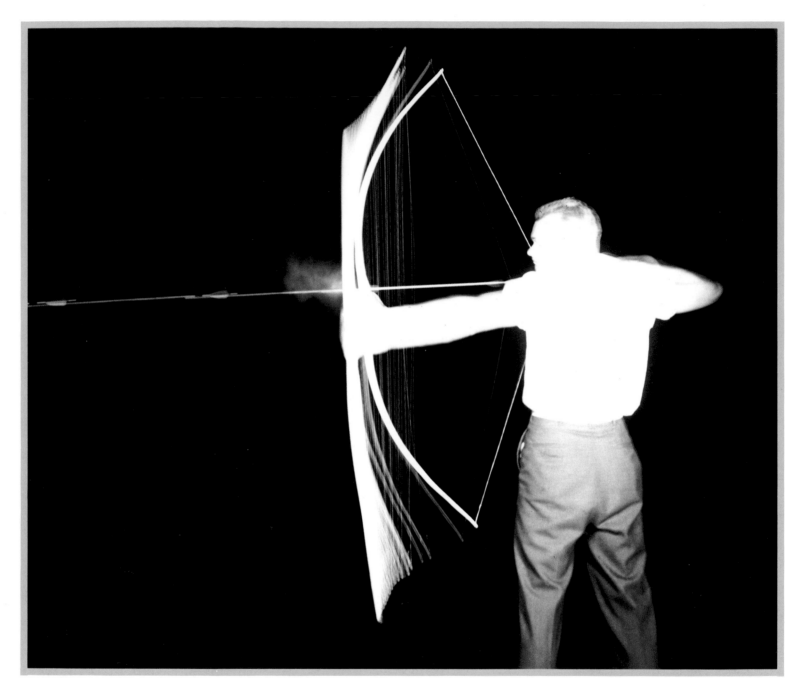

ARCHER. 1934.

In this early multiflash photograph, taken before Edgerton began draping the relatively stationary body parts of his subjects in black, the archer's body is seemingly dematerialized. The intense light of the strobe, flashing 100 times per second for nearly half a second, obliterates all detail. The flash continued to illuminate the bow and string long after the arrow, seen here three times, left the scene.

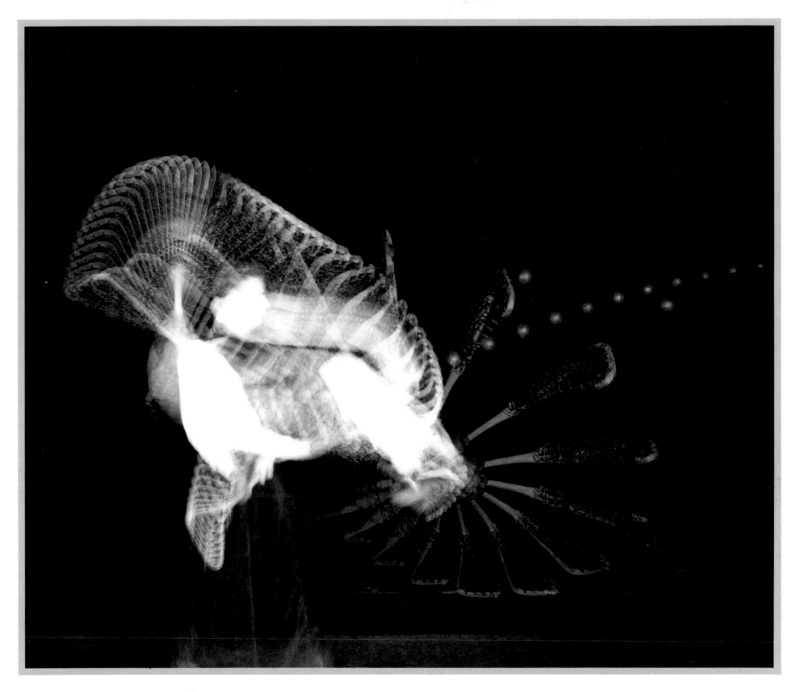

LACROSSE PLAYER. 1939.

The incoming ball is caught in the net of the la-
crosse stick, quickly rotated, and flung away at
about five times the speed it arrived. The pattern
of the net superimposed upon itself creates a
true sense of the space scooped out by the stick.

(overleaf, left) TUMBLERS. 1942.

A bizarre creation of the multiflash, the picture
follows the Martels and Mignon dance team
hurling one of their members high into the air,
where she performs a complete somersault. Ed-
gerton's three pictures of this acrobatic troupe
were among the earliest of his many images to
appear in Life magazine, whose readers re-
sponded enthusiastically to his photography.

(overleaf, right) PETE DESJARDIN DIVING. 1940.

For Edgerton to capture the detailed action with
maximum effect in this multiple-exposure (or
multiflash) photograph, Desjardin had to dive
into the MIT pool in darkness. The flash, firing
evenly at 20 flashes per second while the cam-
era shutter remained open for the duration of the
event—less than one and a half seconds—su-
perimposed his image on itself in the early part
of the dive; then, as his body accelerated, the
space he traveled between flashes increased.

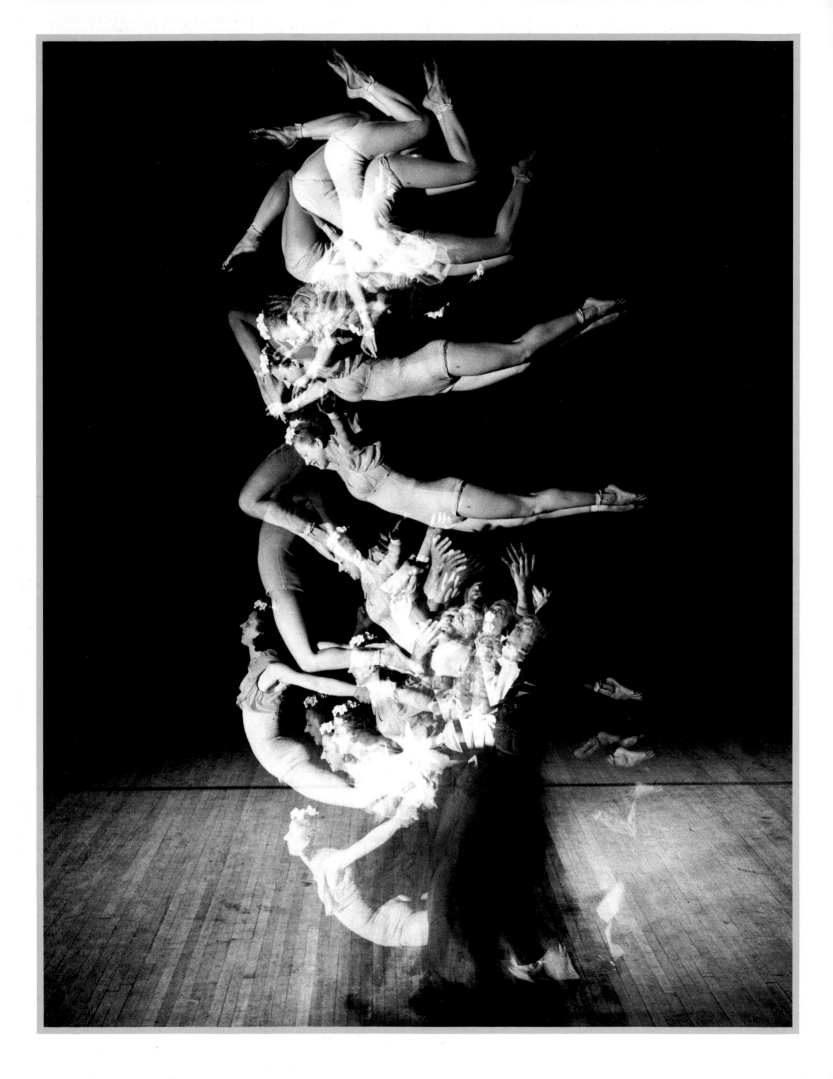

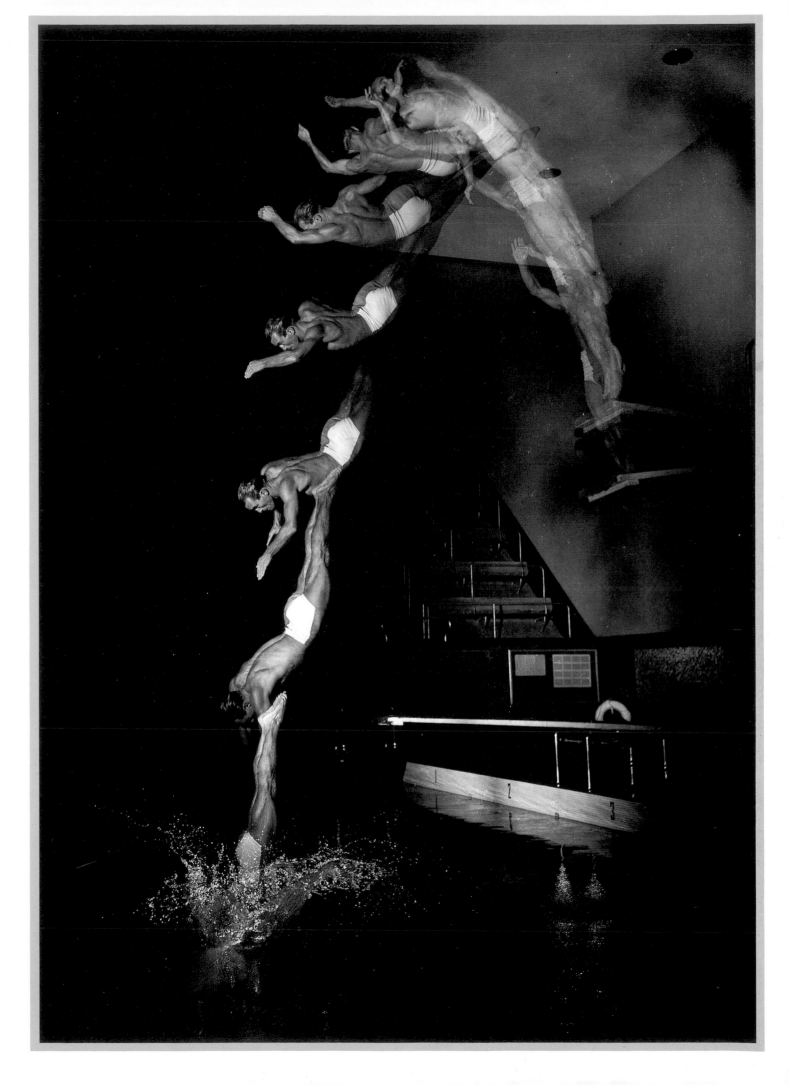

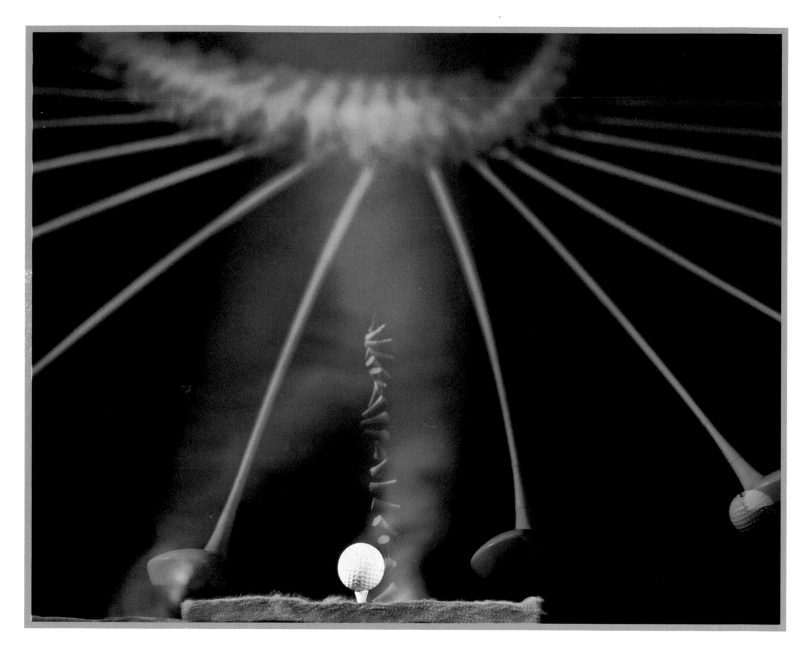

GOLF TEE-OFF. 1962.
Looking like a string of animal fangs, the golf tee
tumbles upward while the club bends from the
impact of hitting the ball.

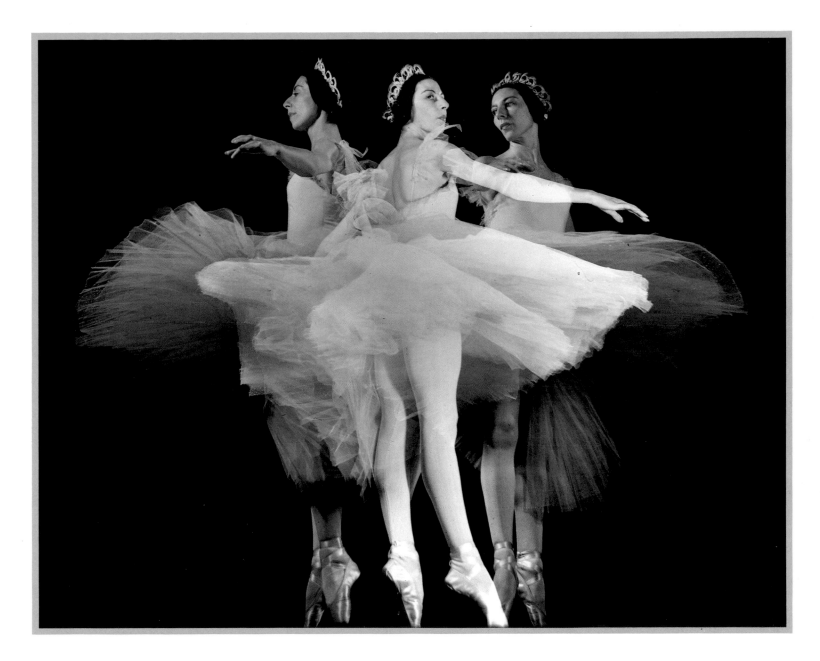

BALLERINA. 1940.

Collaborating with former classmate Gjon Mili, Edgerton photographed a famous prima ballerina executing a majestic pirhouette. Edgerton worked with Mili, who became a famous *Life* photographer after graduating from MIT, and provided him with specialized equipment.

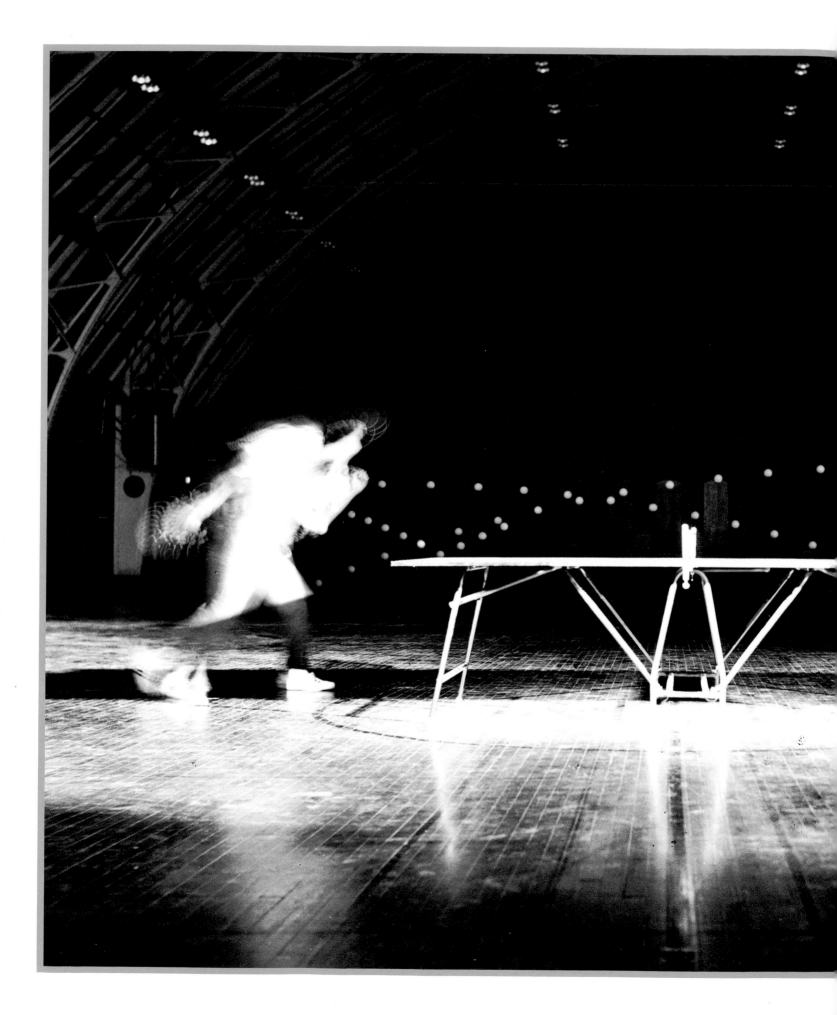

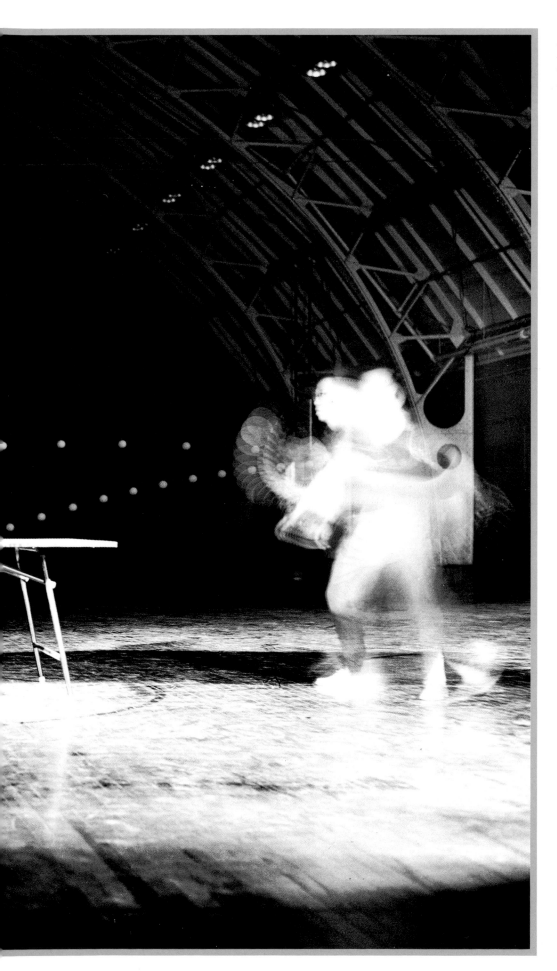

PING-PONG. 1955.
Two ferociously dedicated players rally for only one and a half seconds as the multiflash catches their actions 75 times. The Armory at MIT was often the site of spirited sport, but rarely was there such unusual lighting.

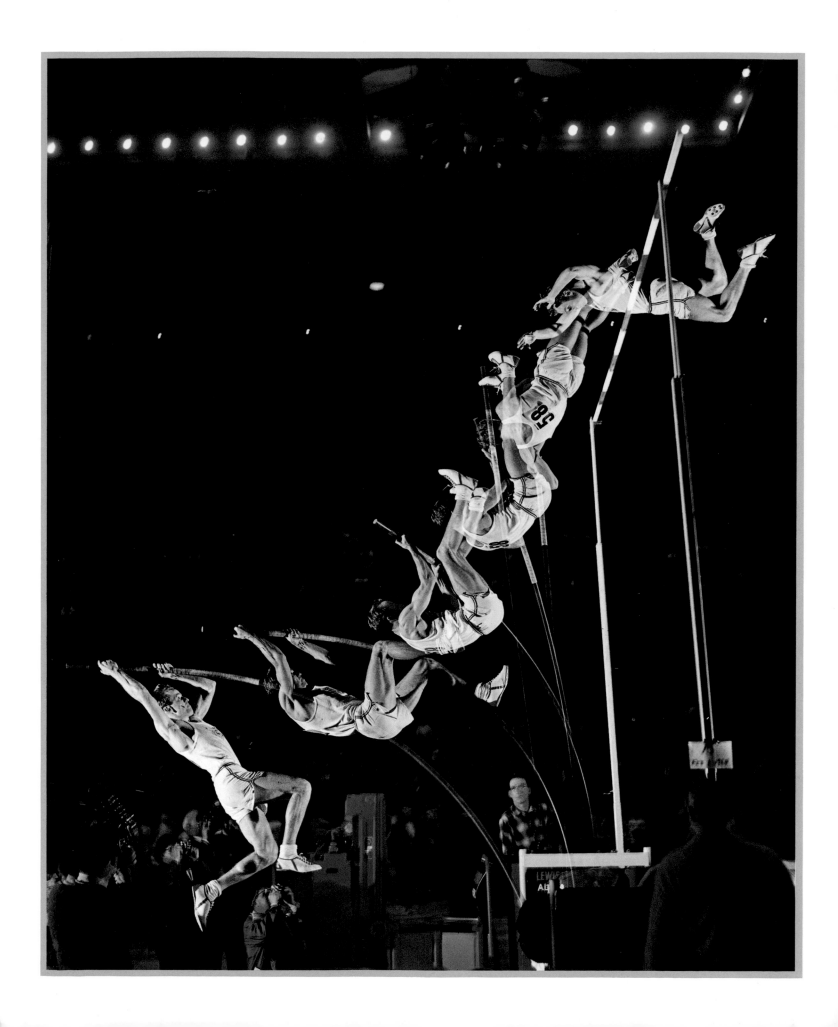

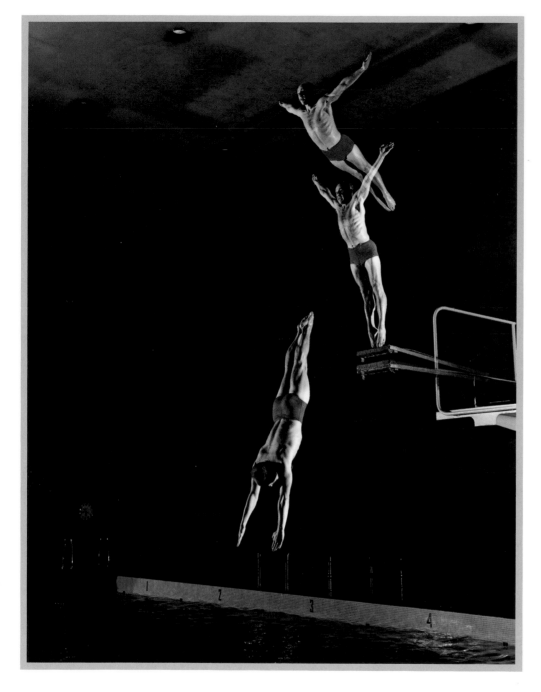

(opposite) *POLE VAULT.* 1964.

David Tork was a competitor at a major track and field meet held at the Boston Garden. Edgerton chose to operate the manually timed multiflash with a special shutter that was synchronized to open with each flash and then close immediately to eliminate bright ambient light. Note that the cinematographer's gestures are recorded as well.

DIVER. 1955.

Since the diver's movements through space are slower at the beginning of the dive than during the plunge, Edgerton used a manually timed multiflash to take the peak moments. The diver was Charles Batterman, a coach at MIT.

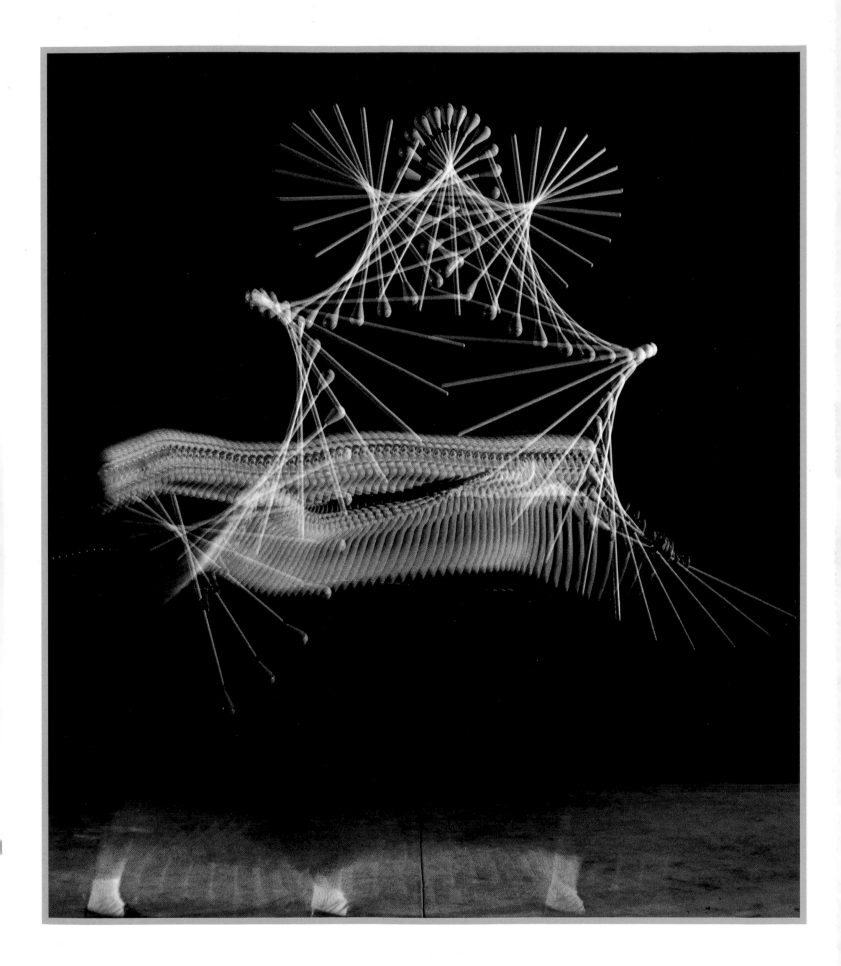

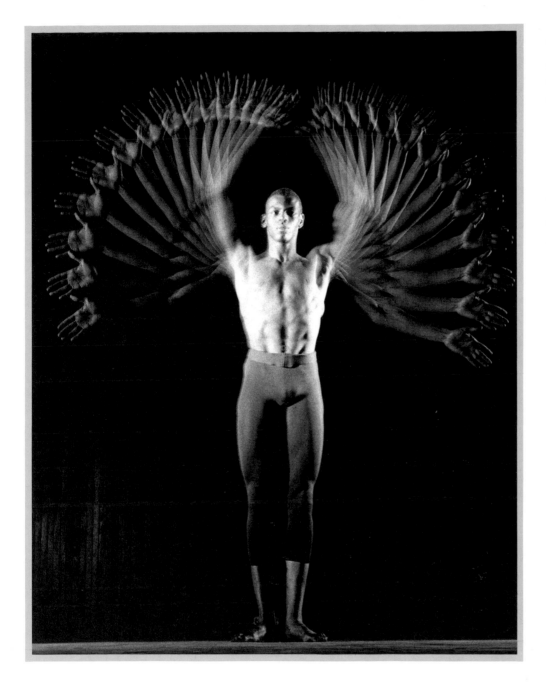

(opposite) *DRUM MAJORETTE.* 1953.
With ghostly feet and only parts of her fac
showing, young Muriel Sutherland intently
watches her baton as she throws it high ir
the air and moves rapidly forward to catch
it. The multiflash was firing 60 times pe:
second.

GUS SOLOMONS. 1960.
The dancer Gus Solomons, in his final year
at MIT, is captured by multiflash at 50 expo-
sures per second. Solomons later estab-
lished a famous dance troupe in
Manhattan.

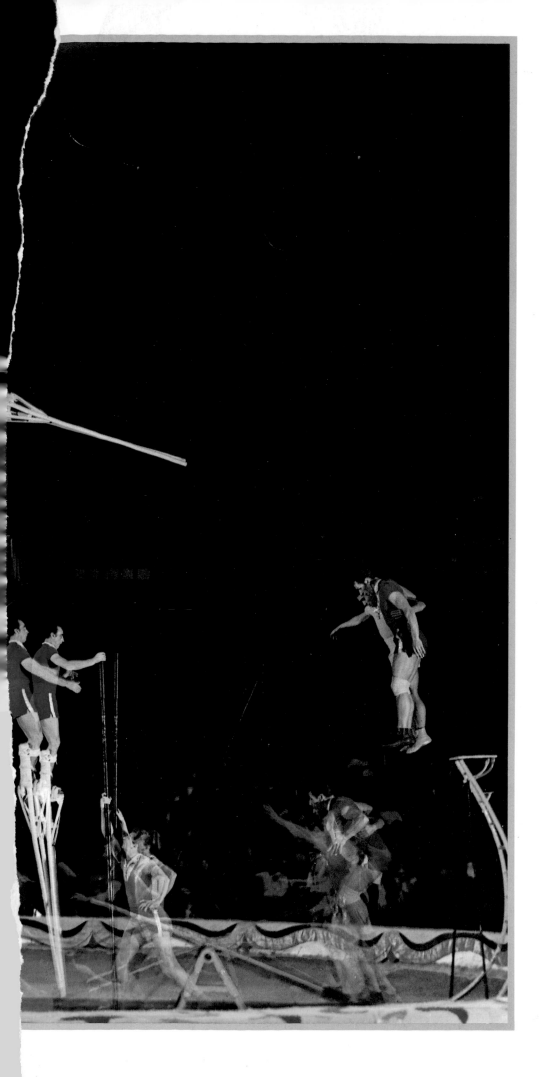

MOSCOW CIRCUS ACROBATS. 1963.

Because of the complexity of the activity, Edgerton used a manually timed multi-flash while an assistant kept the tumbling acrobat in the sighting tube of the powerful flash reflector. As this was a public performance at the Boston Garden, the arena lights could not be dimmed, requiring the special shutter which opened and closed with each flash of the strobe in order to exclude the intense ambient illumination.

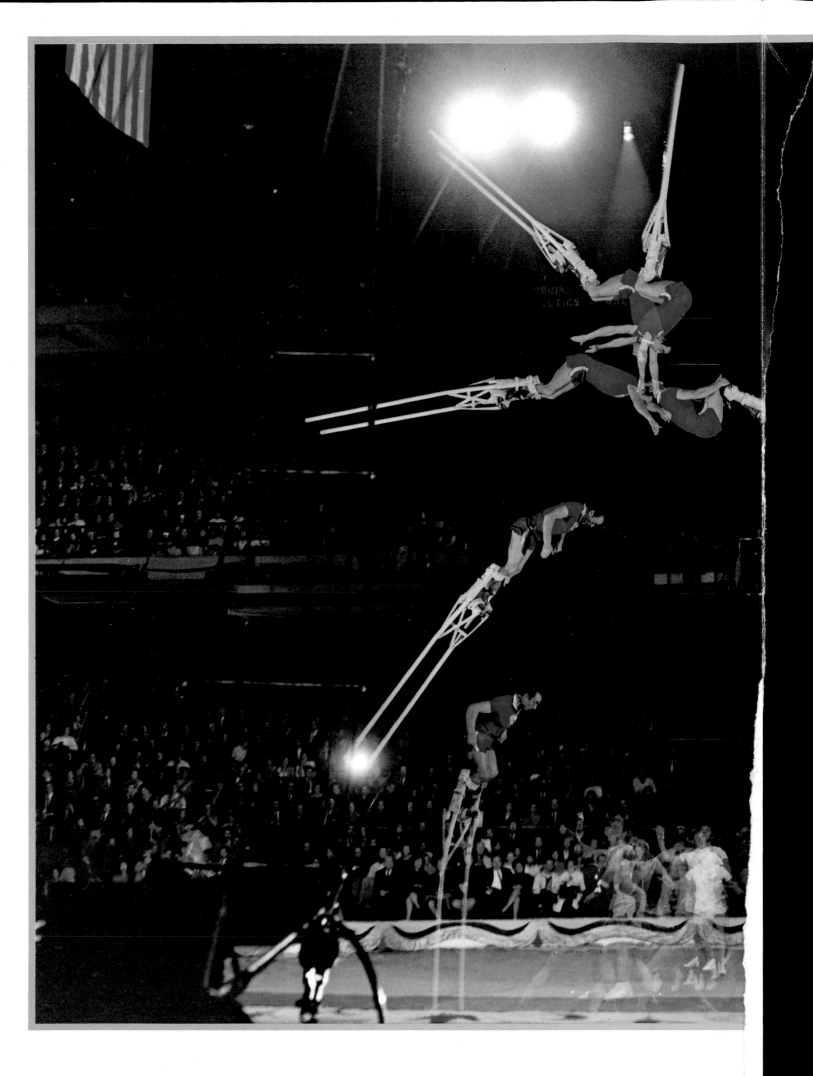

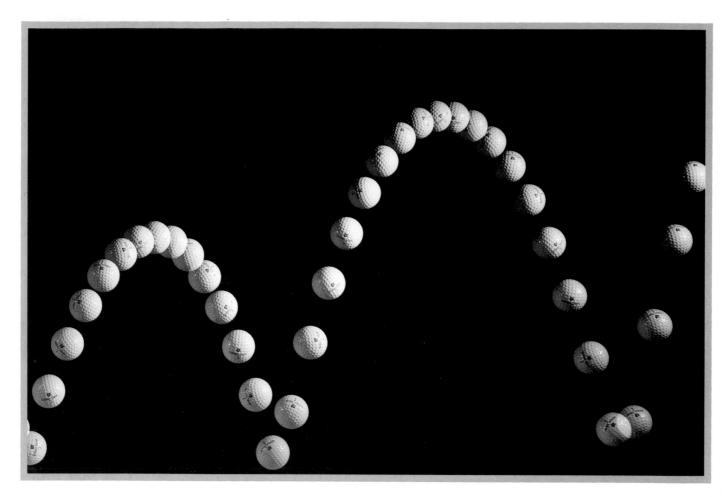

GOLF BALL BOUNCE. 1951.

The quintessential study of the arching parabo-
las produced by a bouncing ball. Every detail is
intact.

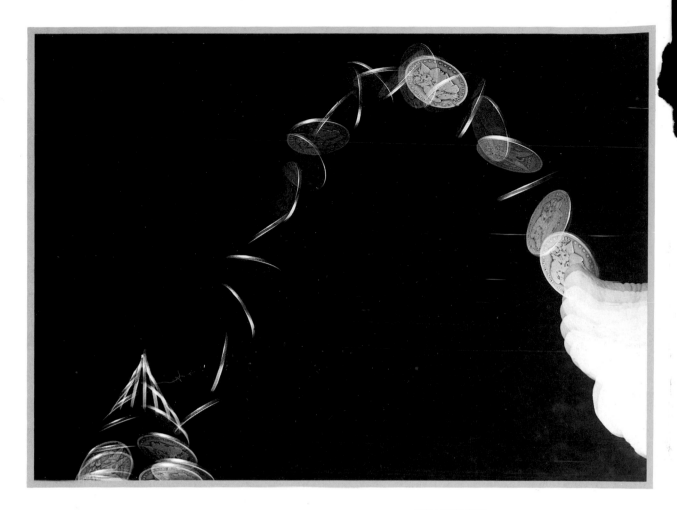

COIN TOSS. 1965.

With a flick of the thumb, an assistant sends a silver dollar spinning head over tail until it bounces from a tabletop. Even the strobe cannot predict which way the coin will ultimately land.

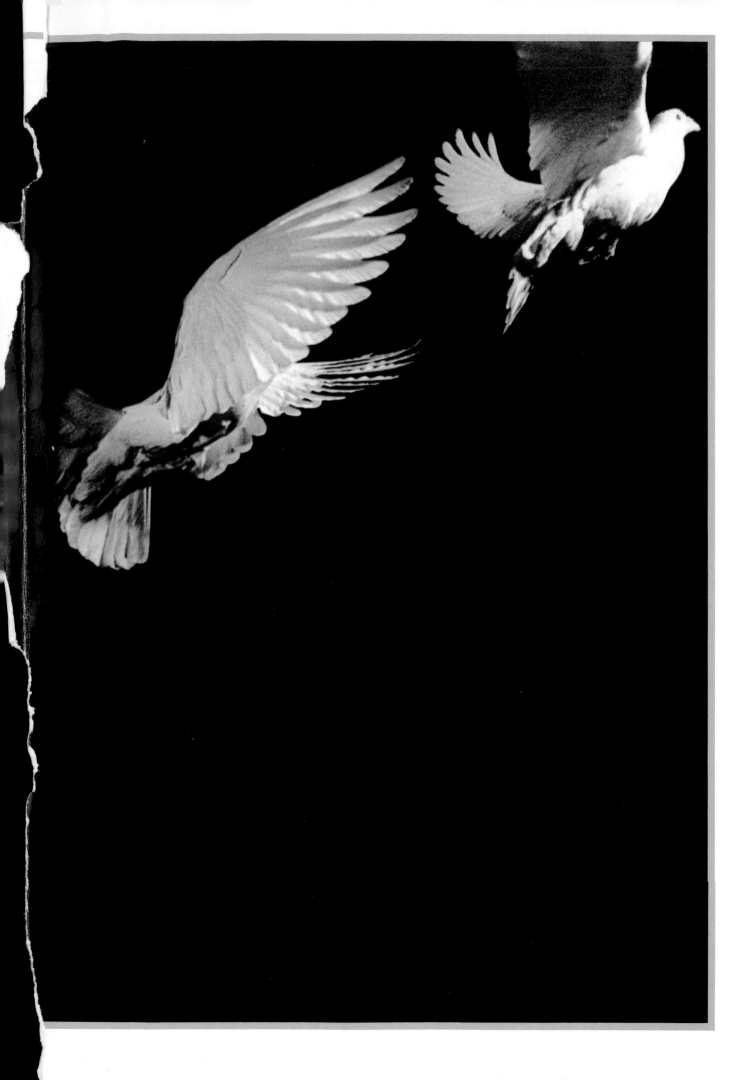

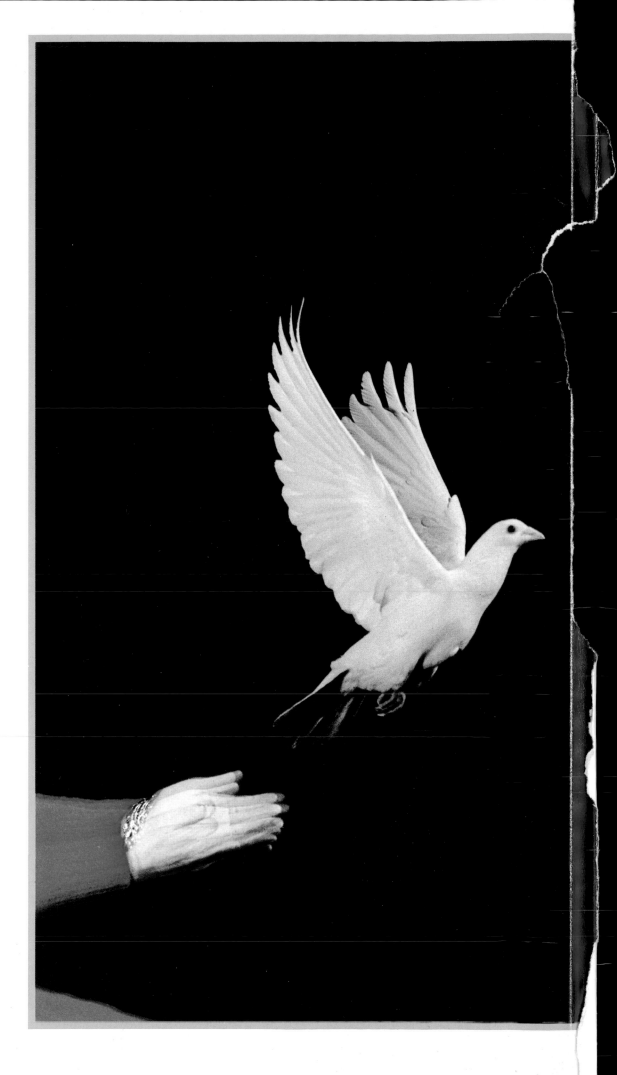

PIGEON IN FLIGHT. 1965.

Flying from the darkness into the light, a pigeon beats its way through three moments of its flight cycle. Its wings expand and curve before contracting into a fan of white feathers. To achieve this stunning effect, Edgerton manually selected the precise sequence of exposures, each lasting 1/100,000 of a second.

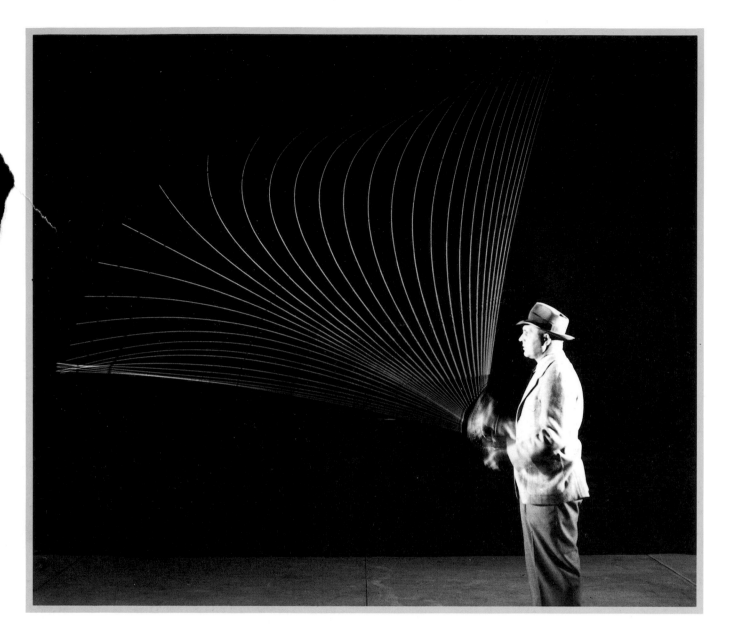

FLY FISHERMAN. 1952.

With a rapid flick of the wrist, an expert demonstrates the delicate and accurate art of fly casting.

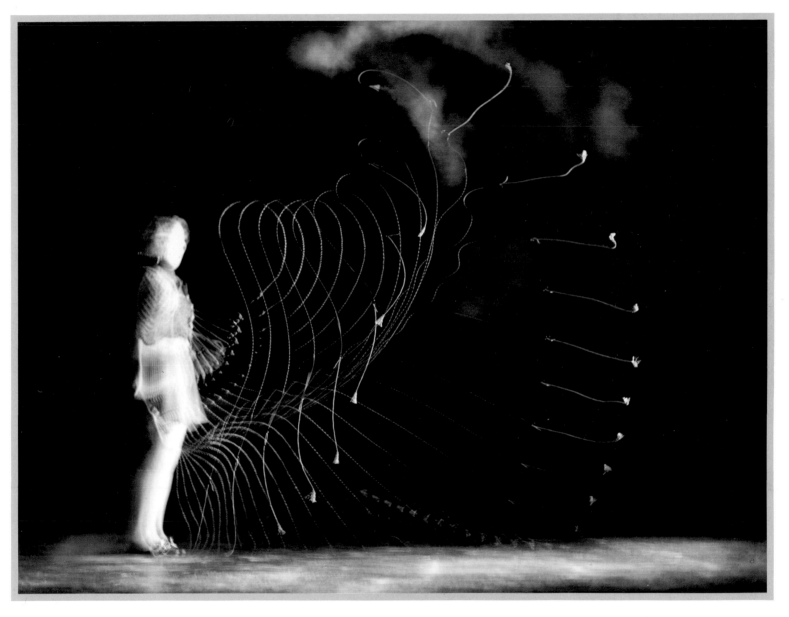

CRACKING THE WHIP. 1972.

Lucy Sloan cracks a bullwhip, generating a wave that travels the length of the whip. The characteristic "crack" occurs when the tip exceeds the speed of sound. Edgerton put chalk on the end of the whip to make a more visible trace of the tip's action.

(right) *NEWTON'S APPLE.* 1970.

To demonstrate the effects of gravity, specifically the acceleration of all falling objects, Edgerton inevitably recalled the legend of Sir Isaac Newton sitting under the apple tree. An assistant obligingly dropped a large Delicious apple for the strobe, firing at an even 60 flashes per second, to trace its increasingly rapid trajectory.

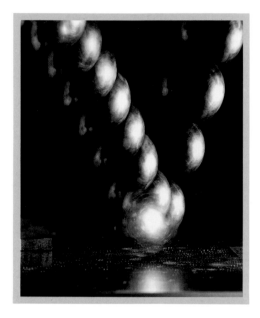

BOUNCING BALL BEARING. 1962.

Specular reflections of the multiflash light off the smooth, polished ball bearing create an ambiguous surface. The lack of measurable deformation as the ball bounces off the surface gives an insight into the solidity of this object.

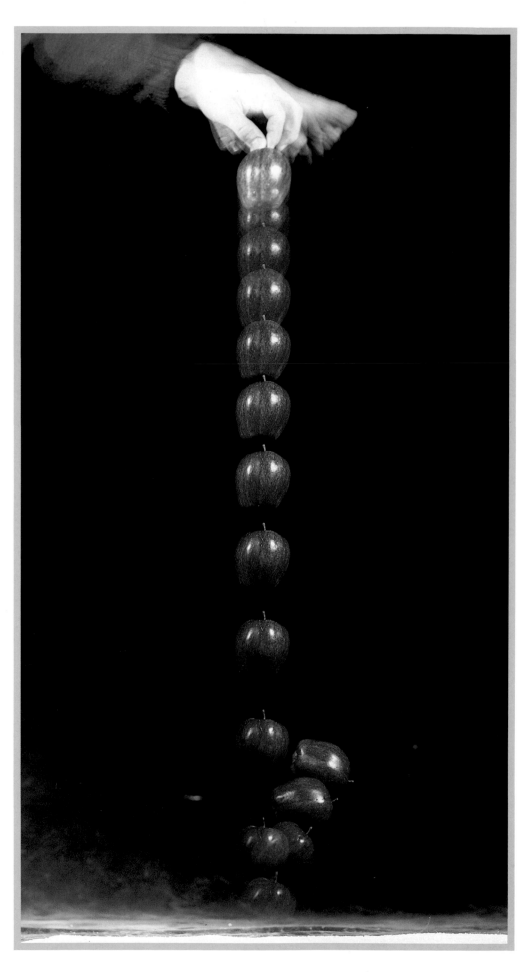

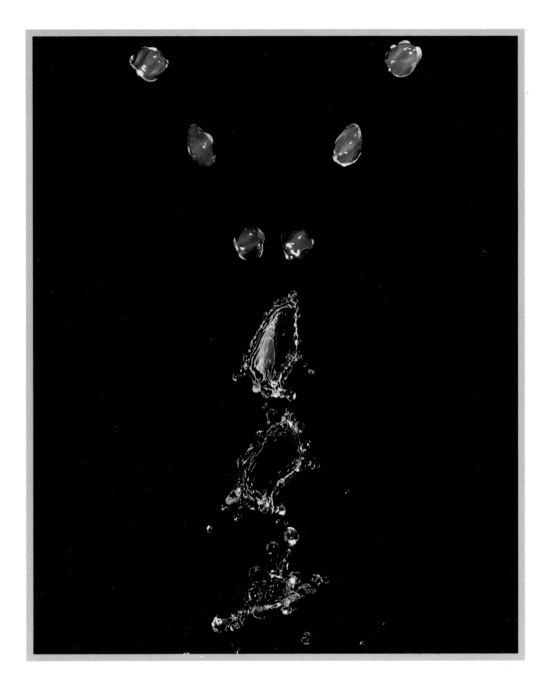

FALLING DROPS. 1976.

One of the many magical illusions produced by Edgerton's favorite teaching tool (a hydraulic pump with two spouts illuminated by a strobe). No crystal necklace, this is simply a procession of water globules containing a fluorescent dye that is brilliantly illuminated by the rich, ultraviolet light of the strobe.

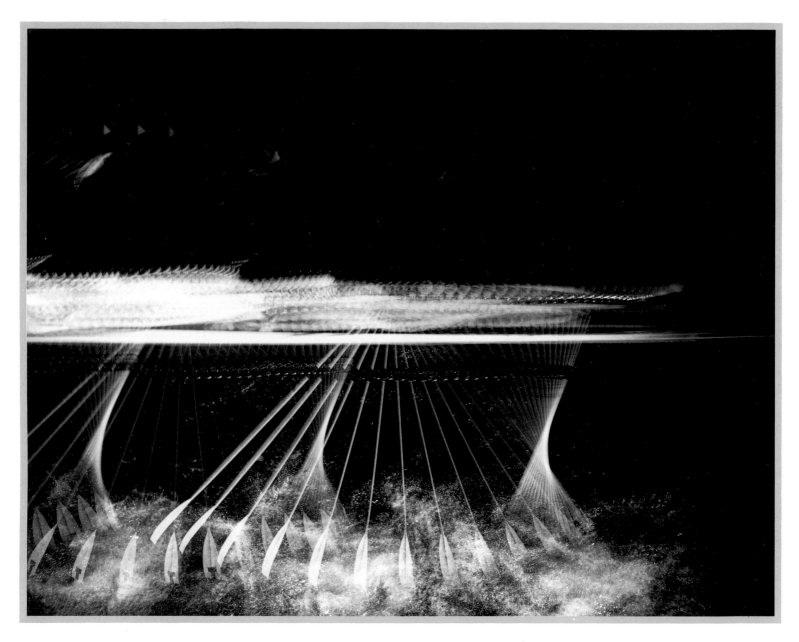

CREW. 1969.

The camera and multiflash unit, housed in an observation window below the water's surface, illuminated the intense strokes of MIT's crew. The light exposed the oars but left only a ghostly trace of the men powering them.

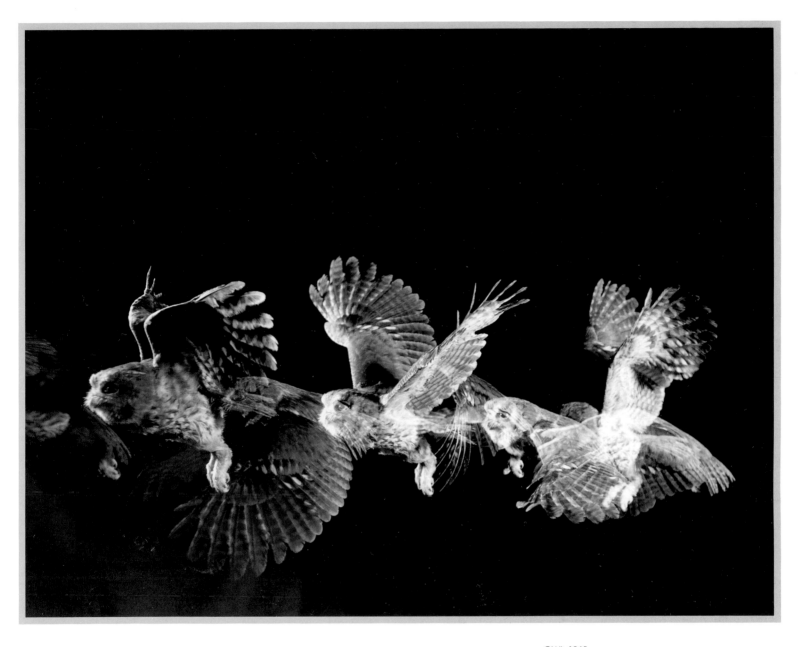

OWL. 1965.
A great horned owl in full flight. "Spooky," from the Boston Museum of Science, has been the subject of many multiflash and single-flash studies at Edgerton's lab.

This picture was made with an EG&G Microflash. In principle, it is not unlike the first flash pictures made in 1851 by William Henry Fox Talbot, who used an air-gap spark created by the release of stored energy. The air-gap spark is much less efficient and safe than the flashtubes used in strobes. One of the drawbacks of air-gap spark units is that the tubes are easily short-circuited and self-destruct from the large amount of energy released into them. Modern flashtubes contain the inert gas xenon. Xenon produces light that has very similar characteristics to sunlight and is therefore ideal for color film. It also has a longer duration time and greater light output than an air-gap spark flash as the ionization causes a longer afterglow. However, because of the relatively long duration necessary for maximum light production, xenon is not as effective in stopping ultra-fast action—such as bullets in flight. Typically, Edgerton's brainstorm was simple; to turn the air-gap spark tube "inside-out," so that the spark was triggered from the inside but occurred on the outside of the quartz tube, where it fires less destructively, thereby prolonging the life and reliability of the flash immensely. The speed of the flash and the avoidance of afterglow allow detailed pictures of microsecond activity.

When the Microflash is triggered, the displacement of air sounds like a gunshot. The duration is from one-third to one microsecond (3/10,000,000 to 1/1,000,000) and the total light output is quite low, necessitating exposure in total darkness. Since the speed of a .22 caliber bullet is about the speed of sound, a microphone, placed a little before the target subject, picks up the sound from the muzzle and relays it through an electronic delay circuit, which fires the Microflash. The sense of anticipation the careful lab preparation engenders never quite readies one for the surprise and the sense of wonder experienced while making a microflash picture. In the darkness, a retinal afterimage created by the exposure is a true record of what the flash illuminated, and the film—one hopes—recorded. It is also a confirmation of the timing and aim.

PUNCTURING A BALLOON. 1967.
Exposed at one third of a millionth of a second (3/10,000,000), an unimaginably short interval, a toy-store balloon pierced by a .22 caliber bullet erupts in a crater of gas and dust.

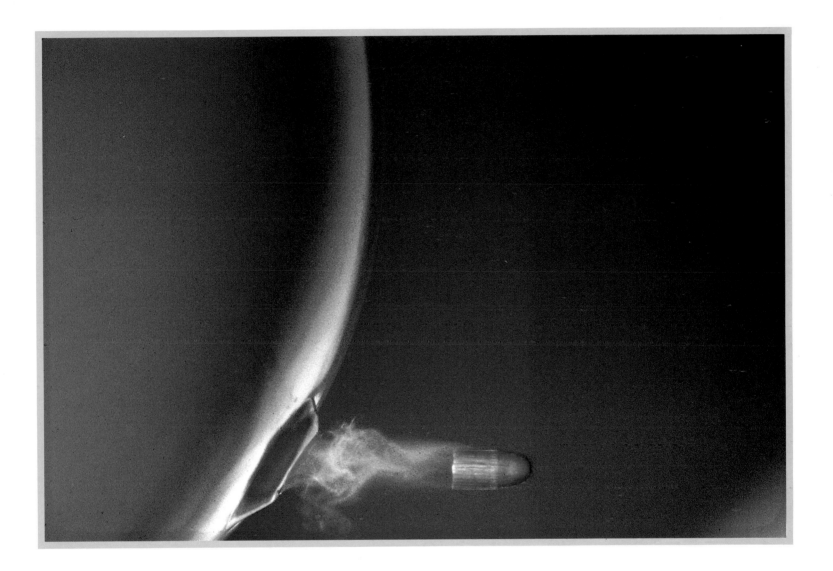

ANTIQUE GUN FIRING. 1936.

The gun took its own picture as the explosion of
the bullet being fired triggered the microphone,
visible in the foreground, that released the flash.
The bullet is barely out of the muzzle, still hidden
in the massive volume of smoke escaping from
the gun.

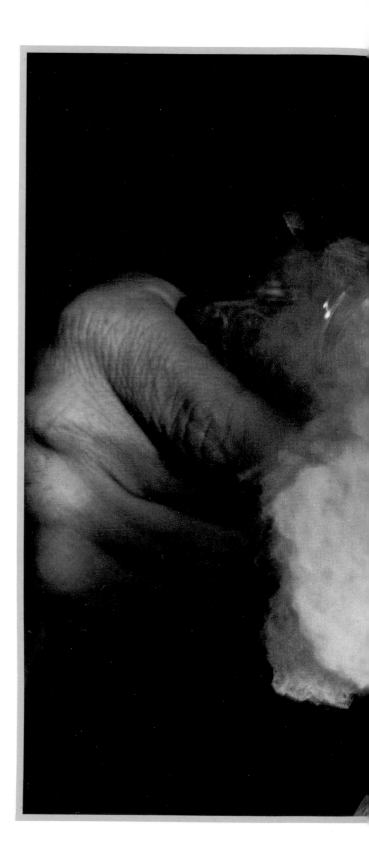

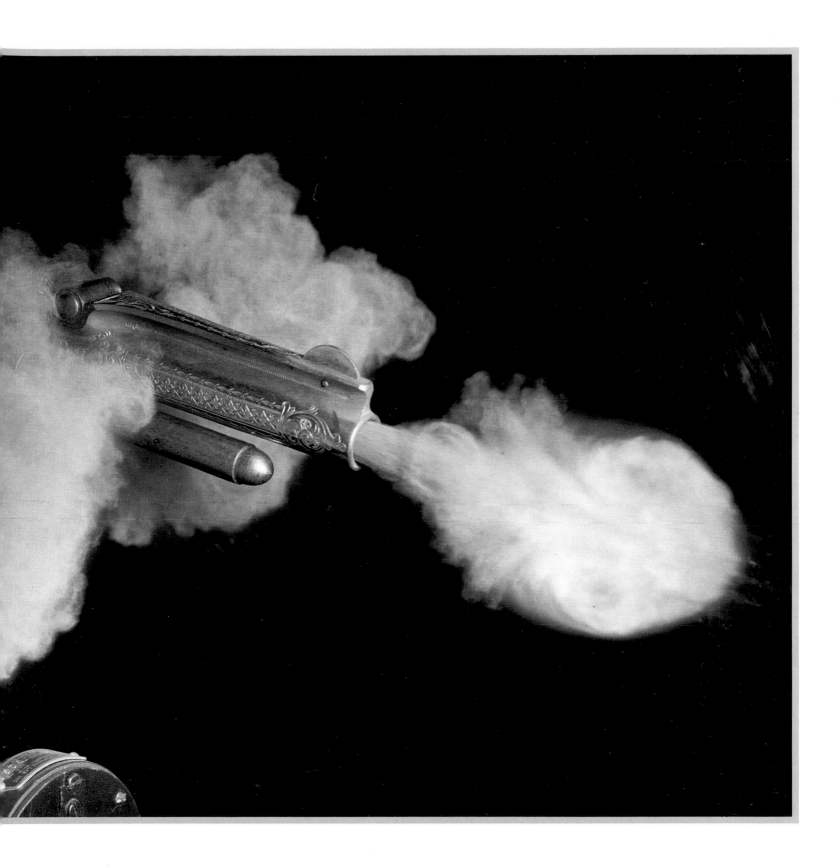

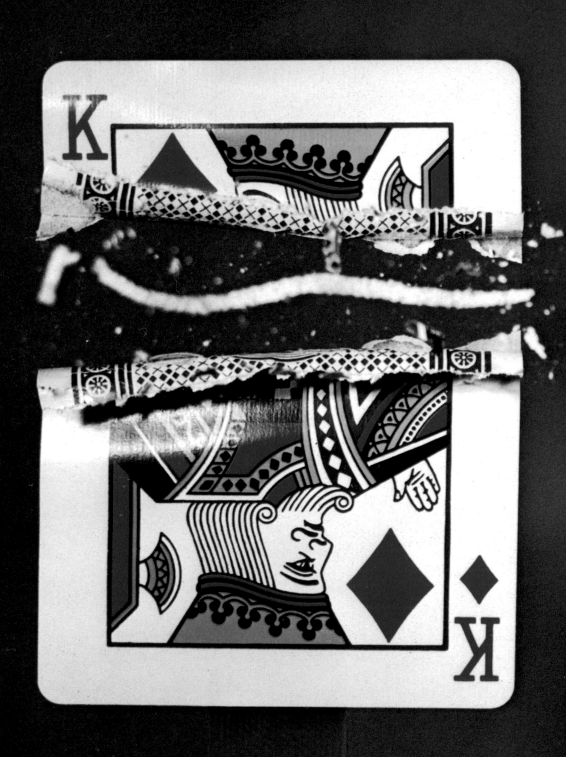

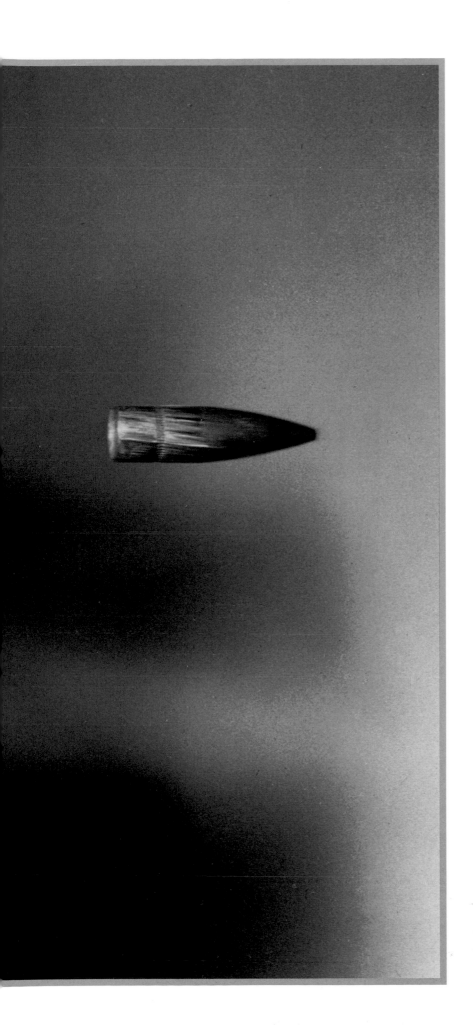

CUTTING THE CARD QUICKLY. 1964.

A .30 caliber bullet, traveling 2,800 feet per second, requires an exposure of less than 1/1,000,000 of a second. Edgerton outdid the gunslinging heroes of western movies by turning the card sideways when he shot through it. The rifling of the barrel caused the rotation of the projectile, which, in turn, carved out the S-shaped slice of card between the two halves.

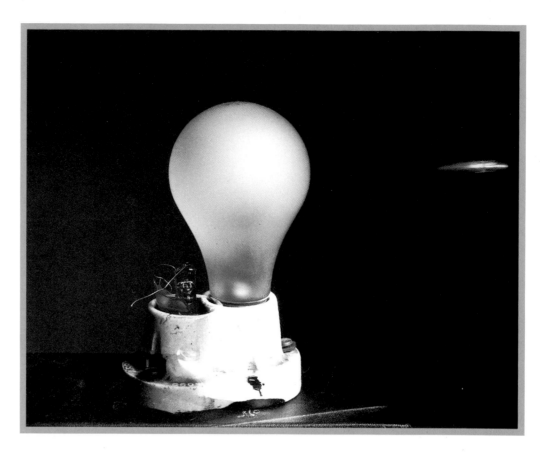

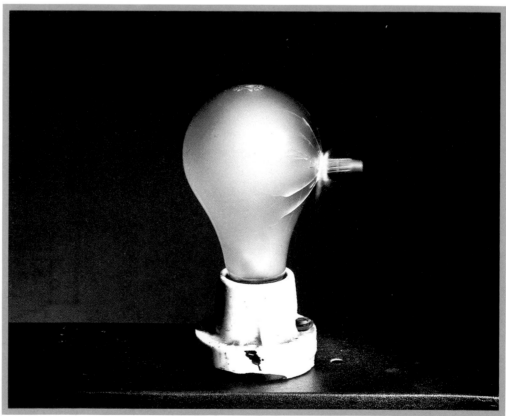

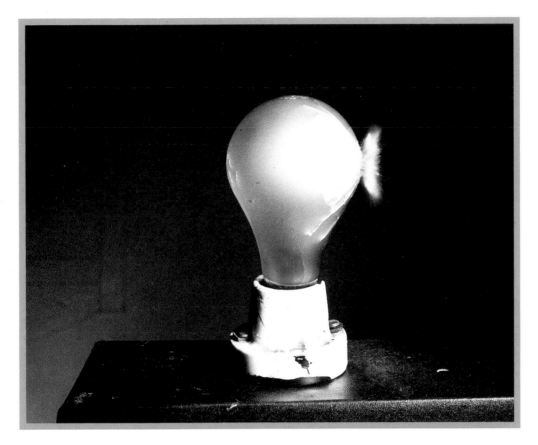

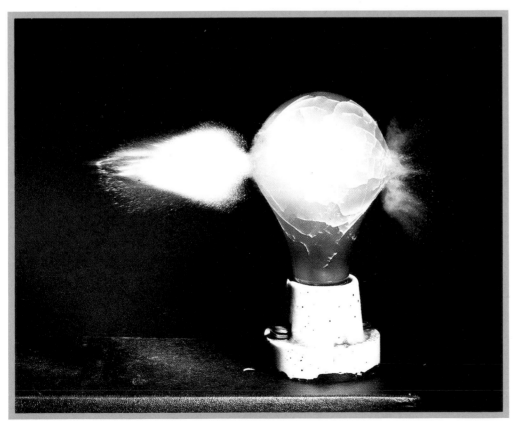

DEATH OF A LIGHT BULB. 1936.

The microphone used to trigger the flash for these pictures (each of a separate light bulb) was moved a little farther away from the rifle with each successive exposure. This allowed the .30 caliber bullet to travel father with each exposure. The most surprising is the third image, in which the shock wave caused by the pressure from the entrance of the bullet concentrates on the opposite side of the bulb, causing the glass to crack before the bullet has reached it. Perhaps the most important attribute of inveterate experimenters is the ability to pay attention to the actual, not anticipated, results.

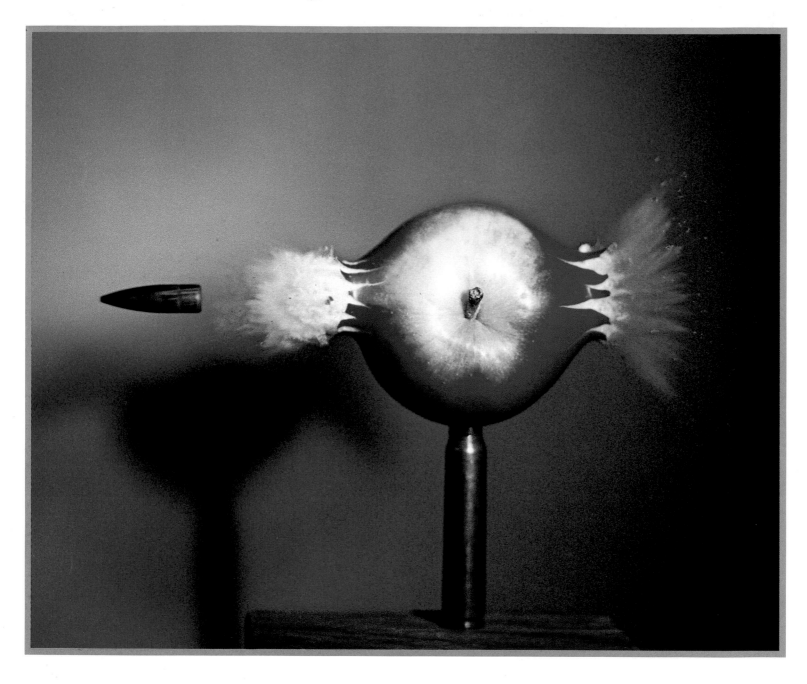

SHOOTING THE APPLE. 1964.

This startling image first illustrated a lecture by Edgerton entitled, "How to Make Applesauce at MIT." Moments after it is pierced by the .30 caliber bullet, the apple disintegrates completely. What is so surprising is that the entry of the supersonic bullet is as visually explosive as the exit.

(right) *MILK-DROP CORONET.* 1957.

Falling from a pipette, the first drop of milk creates a disk-shaped layer into which a second drop splashes, catapulting the milk into a diadem about one-half inch in diameter. Taken in 1957, this image is the culmination of twenty-five years of persistent search for aesthetic perfection. Since 1932, Edgerton has been dissatisfied with his attempts to create perfectly uniform tips on the crown, but others have judged him more generously: "We can instantly recall it: the drop of milk splashing against a red and shadowy background, frozen as a white, unworldly, porcelain crown by the camera and strobe. It is an image of intensity and subtlety, of show and substance, of beauty and precision. It surprises and delights us, not least because it rewards our hope that art and technology can come together with a lightness of touch. The photograph can stand for the man." (Citation for the Eugene McDermott Award of the Council for the Arts at MIT.)

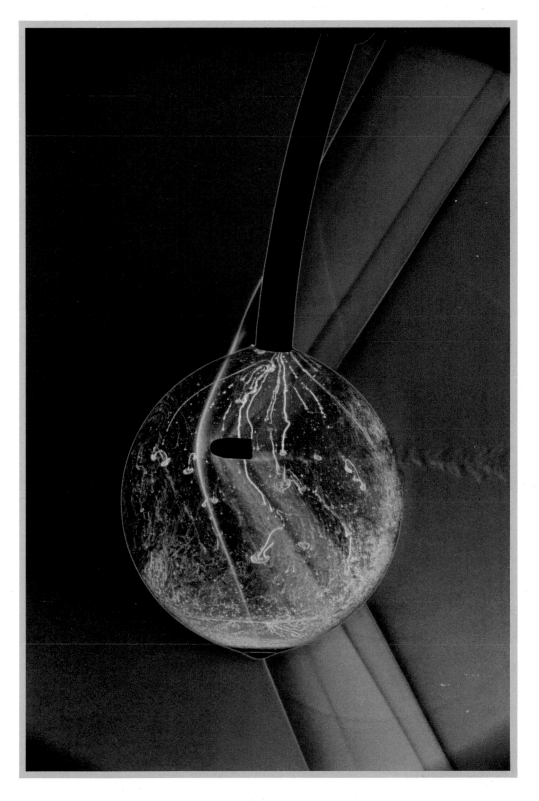

(opposite) *FAN AND FLAME VORTICES.* 1973.

Kim Vandiver, an assistant of Edgerton's at MIT, assisted him in a search through MIT storage rooms for unreturned equipment. They came across a pair of beautifully polished concave mirrors that struck a responsive chord: they were ideal for the obscure optical studies of the schlieren method, which Edgerton thought Vandiver would relish. With the schlieren technique, changes in density of air or other gases are made colorfully visible. Heat and pressure both change the density of air; thus, this photograph of the vortices produced by a metal fan blade rotating at 3600 rpm through the flame of an alcohol burner is particularly revealing. The light from the flash passes through an aperture, where it is filtered, and then enters the large concave mirrors. The camera, or eye, is aligned with the light coming off the array of mirrors and through another limiting aperture. The phenomenon, occurring within the array, is illuminated from behind, thus silhouetting the objects and making visible the refraction of light caused by the varying density of the atmosphere.

BULLET THROUGH BUBBLE. 1973.

A soap bubble filled with helium is pierced by a .22 caliber bullet, creating a shock wave (sharply delineated in yellow). Different gases were introduced into the bubbles in order to study the varying speed of sound through different media. The myriad refractions make the bubble resemble a living organism. The photograph required a highly complicated technique to make visible regions of varying refraction and varying density of air. Edgerton used the schlieren interference method for this optical study.

IGNITING A MATCH. 1973.

Spurting yellow flame in an intense burst of heat and gases, an ordinary kitchen match is transformed into a miniature firework display. Vandiver and Edgerton once again relied upon the singular schlieren method to capture the evanescent changes in the density of air around the match.

(opposite) *BULLET THROUGH FLAME.* 1973.

The sound from the rifle triggered a microphone that fired the microsecond flash. The optical field that allows the differences in air density to be visible to the camera is created by a careful alignment of large concave mirrors and apertures. Different filters allow the range of colors to be varied.

Pentalite explosions and atomic bombs emit light of such intensity that they allow ultra-short exposures to be made with no need for other illumination. The problem lies in the design of a shutter mechanism capable of handling the incredibly short exposures. The solutions embodied in shutters first designed by Edgerton and EG&G all come from basic research done by the nineteenth-century scientist Michael Faraday. Edgerton created a magnetic field around a device that rotates the polarizing axis of an optical system to allow light to pass through only during an ultra-short period of time. Many of these pictures, in particular the atomic bomb photographs, required systems of automatic cameras and control mechanisms whose complexity was enormous. The amounts of energy are so large, the exposure times so short, the mind simply cannot comprehend the chain of events. Edgerton's images, the first pictures of ultra-high-speed explosions, go beyond quantitative description to give us a visual idea of these extraordinary moments.

DYNAMITE CAP. 1956.
By using an exposure of one-hundred-millionth (1/100,000,000) of a second, Edgerton photographed these high-speed particles ejected from the end of a dynamite cap. They are traveling at 6,000 miles per hour, nearly ten times the speed of sound.

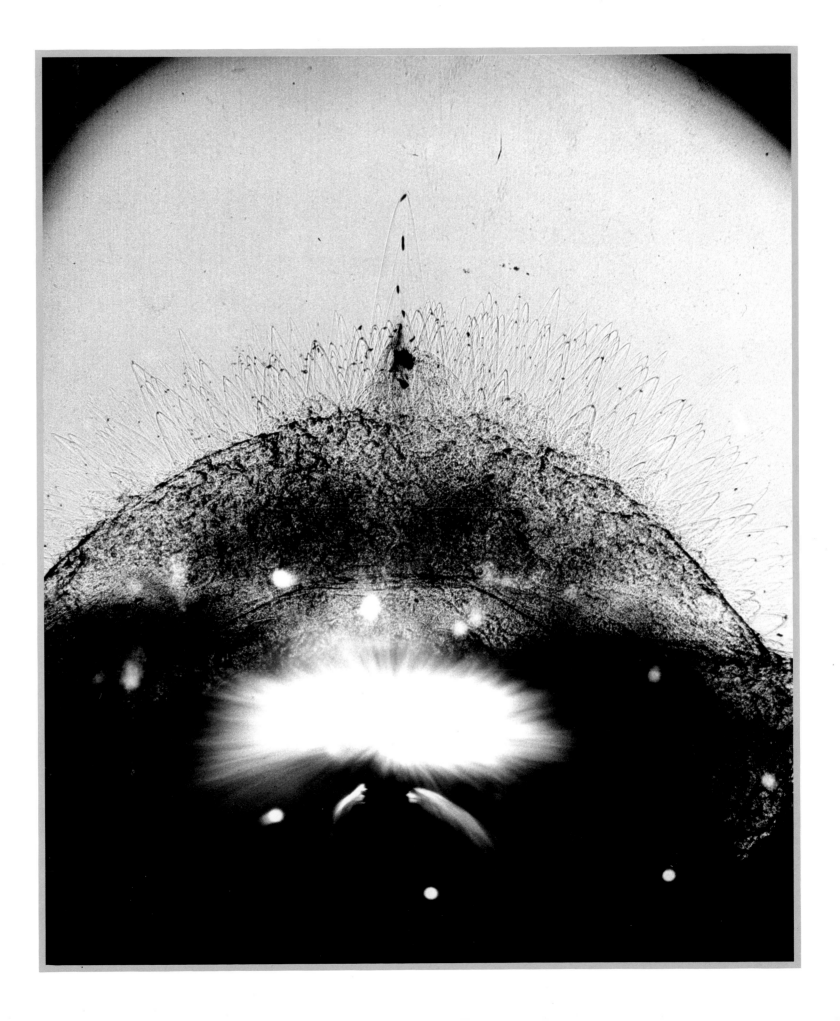

PENTALITE EXPLOSION. 1952.

Pentalite is an industrial and military explosive more powerful than gunpowder. A square stick of the substance, detonated by a dynamite cap, unexpectedly radiates shock waves from its flat surfaces. The microsecond exposure was controlled by a magneto-optic shutter.

(opposite) *DYNAMITE CAP.* 1956.

The dynamite's detonator was encased in a steel tube to protect the field lens and spark-light source that silhouetted its explosion and made the shock waves visible.

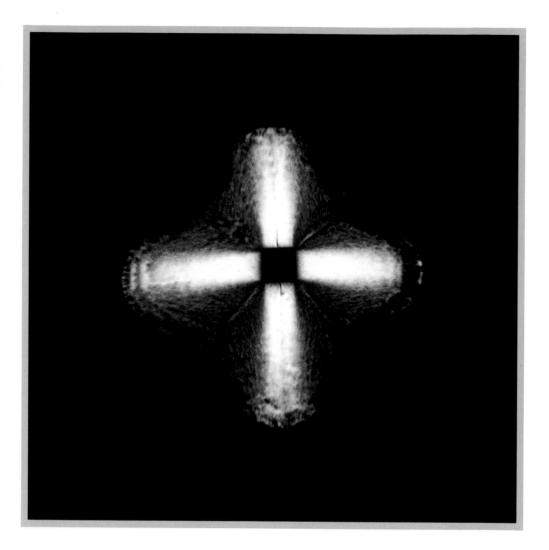

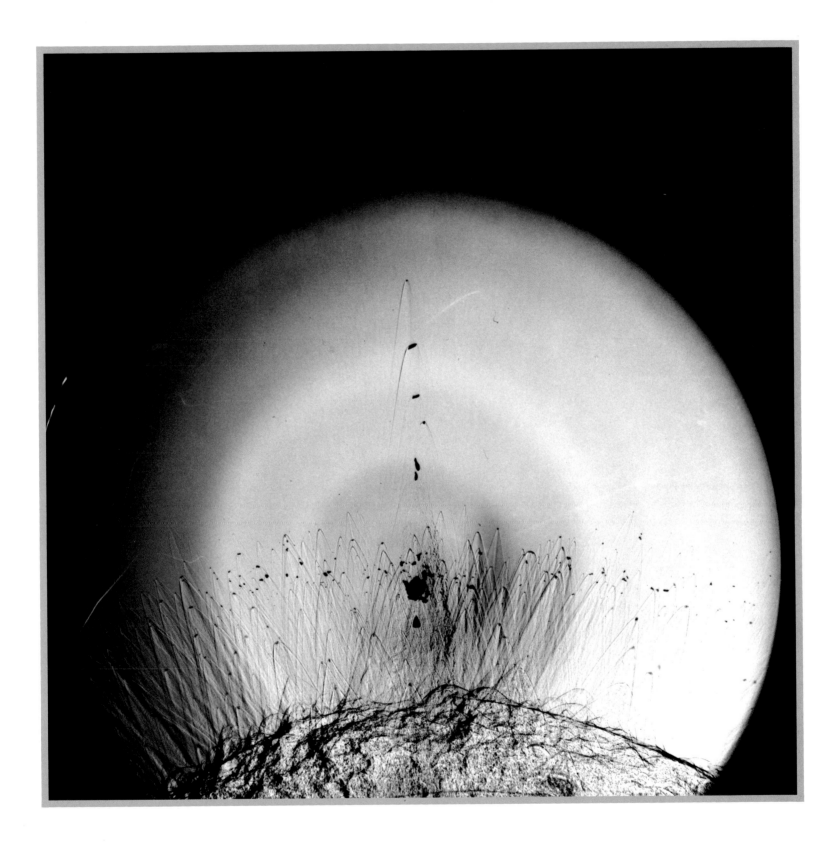

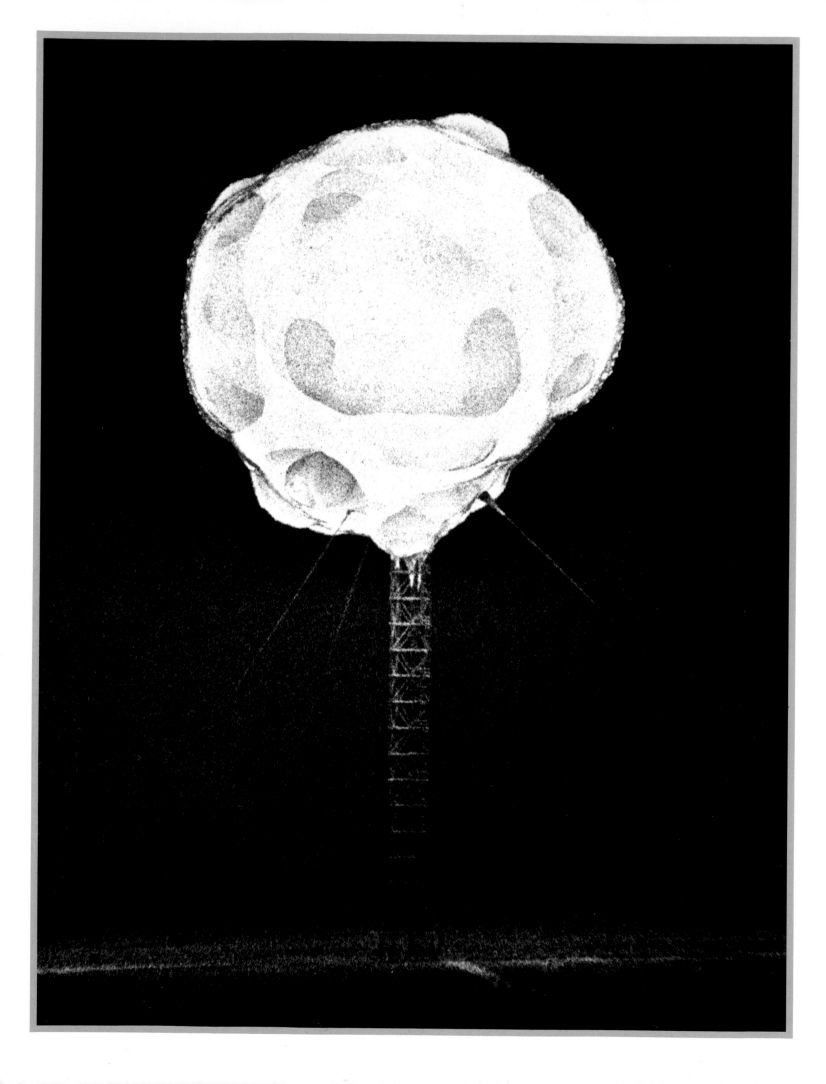

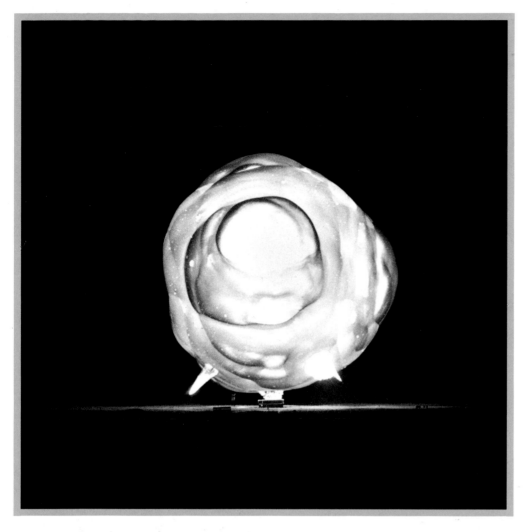

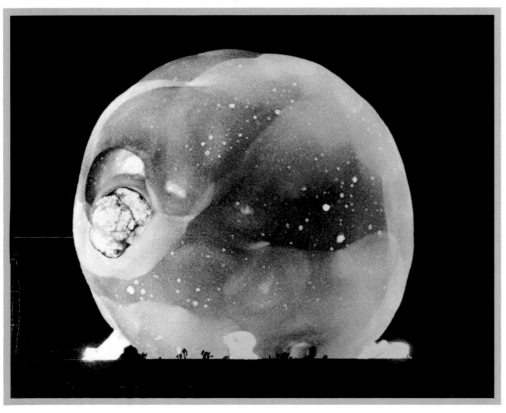

(opposite) *ATOMIC BOMB EXPLOSION.* Before 1952. Revealing the incredible anatomy of the first microseconds of an atomic explosion, this ominous fireball was documented in a 1/100,000,000-of-a-second exposure, taken from seven miles away with a lens ten feet long. The intense heat vaporized the steel tower and turned the desert sand to glass.

ATOMIC BOMB EXPLOSION. c. 1952. All these pictures of the atomic bomb tests were taken automatically by instrumentation situated seven miles from the blast. Edgerton's company, EG&G, developed the complex apparatus for capturing phenomena of ultra-short duration. The terrifying explosion caused lightning-like energy to descend the guide wires of the tower.

ATOMIC BOMB EXPLOSION. c. 1952. In another few microseconds, the Joshua trees, silhouetted at the base of the rapidly expanding explosion, will be engulfed by the shock and heat waves and incinerated.

The first photographs ever made were shadow-grams made from objects placed directly upon a photosensitive surface. In the same way that the shadows cast by bright, direct sunlight are very distinct, the shadow cast by a point source, like the strobe, is very sharp. The light from a point source also has the property of revealing the refraction or bending of light caused by heat and pressure in an atmosphere. If the point-source light has a very short duration, it can reveal the changes in the density of the air or other gases caused by shock waves, heat, explosions, and movement. An event pictured by the sharply edged shadow cast from a point-source flash can therefore reveal much more than a normal photograph.

BULLET THROUGH PLEXIGLAS. 1962.
A photograph made without a camera, this silhouetted exposure of less than one microsecond was accomplished by placing a sheet of film in a film holder behind the one-eighth-inch thick plastic sheet and a Microflash in front of it. Careful examination reveals shock waves striking the microphone at the bottom of the picture. The shock waves and hot gases from the bullet were made visible by the refraction of light around them. The irregular black spots to the right were caused by Plexiglas shards puncturing the film.

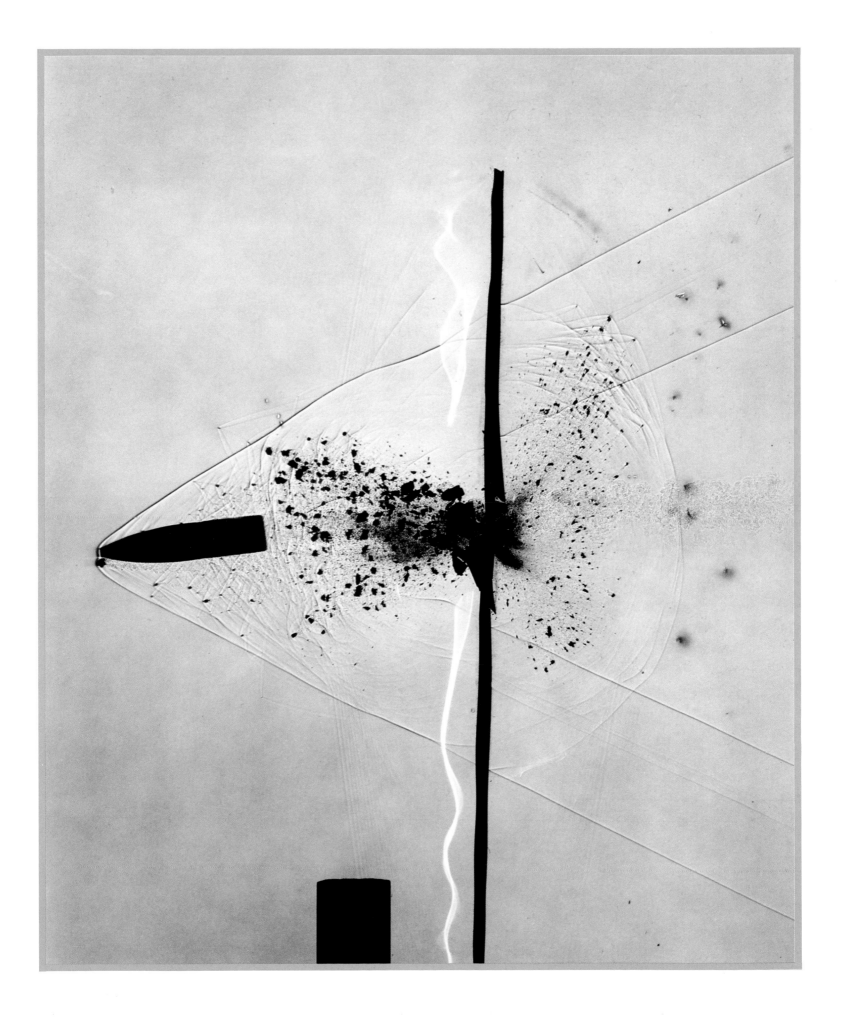

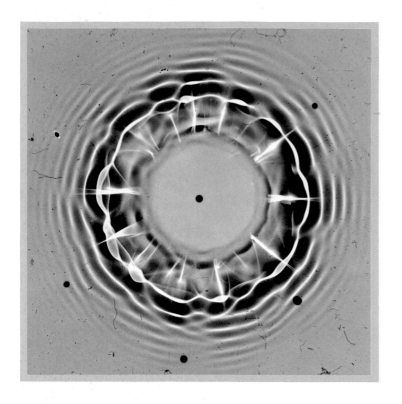

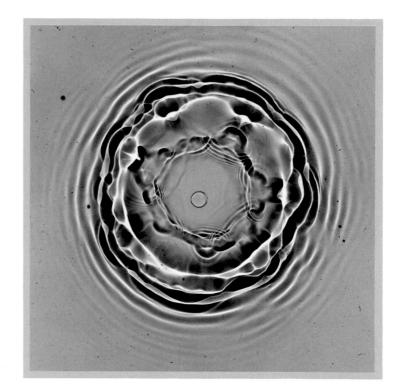

WATER-DROP SPLASHES. 1986.

A drop of water has fallen into a layer of water on top of the actual emulsion of very fine grain film; a tiny point-source strobe, triggered when the drop interrupts a photoelectric beam, stops the pattern created by the splash. The small particles of dust and debris found in the water create the black shapes scattered throughout the image.

MARINE ORGANISMS. 1980.

By placing them directly on the emulsion of his film and using a tiny electronic flash to expose the picture, Edgerton captured these miniature animals without a camera. Although this type of photograph is ordinarily called a shadow picture, the miniscule lobster is actually translucent enough for the flash to reveal its interior structure. This unique method allows scientists to study marine organisms while they are alive.

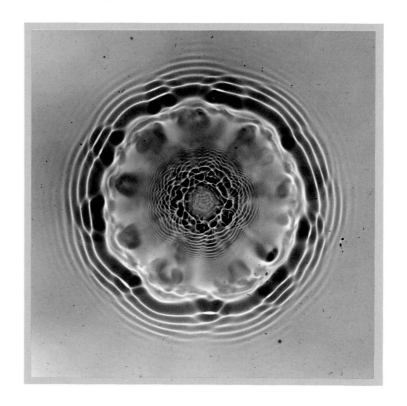

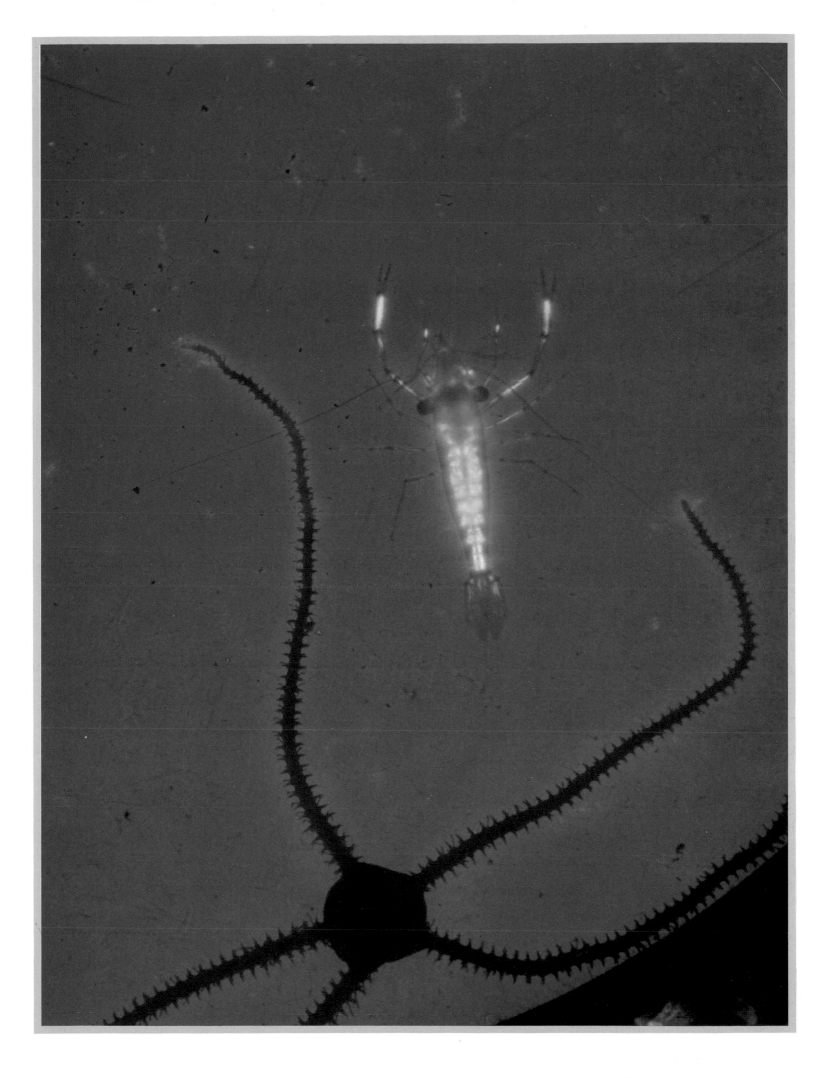

BULLET SHOCK WAVE. 1970.

A .22 caliber bullet travels faster than the speed of sound and therefore makes shock waves in the air. Edgerton, using the Microflash and a sheet of film placed behind the path of the bullet, was able to expose the waves' silhouettes directly onto the film.

(opposite) *SAFETY GLASS CRACKING.* 1938.

Exposed at 1/1,000,000 of a second, with the glass cracking outward at a speed of nearly a mile per second, this extraordinary photograph was taken without a camera. The film was placed directly on the glass sheet. The sound of the impact of the plunger used to break the glass plate (in the center) triggered an electronic timing circuit that controlled the moment of exposure. The pattern of the cracks racing through the glass was cast onto the film by the brief flash.

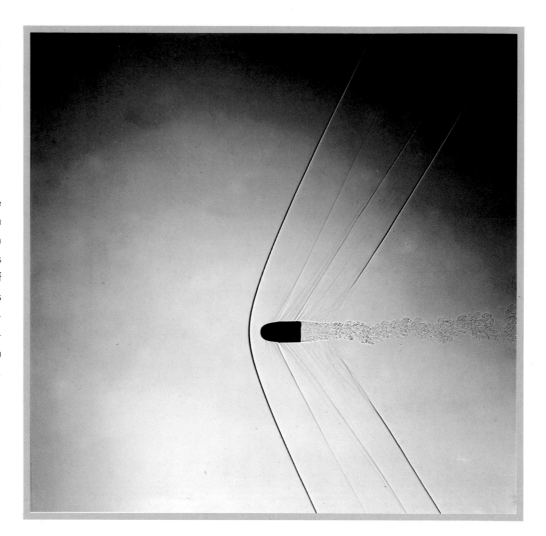

BIOGRAPHICAL OUTLINE: HAROLD EUGENE EDGERTON

In 1909, Edgerton and his father watched the Wright brothers perform one of their early flights at Fort Meyer, Virginia. It was an occasion that vividly impressed the young Harold. Edgerton still refers to it as one of his lifelong inspirations.

1903 Born April 6 in Fremont, Nebraska. Son of Mary Nettie (Coe) and Frank Eugene Edgerton. First of three children. Over the next twelve years, the family moves to Lincoln, Nebraska, Washington, D.C., and Winnebago, Nebraska, before settling in Aurora, Nebraska.

1915–21 Attends junior high and high school in Aurora. Learns photography from an uncle and sets up a darkroom in his parents' kitchen.

1920–25 Works summers at the Nebraska Power and Light Company. Studies the company's big generators and how they perform under increasing loads. In 1921, enrolls at the University of Nebraska in Lincoln.

1925 Receives B.S. in electrical engineering from the University of Nebraska.

1925–26 Works one year at the General Electric Company in Schenectady, New York, analyzing the performance of large rotating electrical motors.

1926 Enters the Massachusetts Institute of Technology (MIT). In his graduate studies, first uses the stroboscope to study the whirling rotors of an engine. By controlling a light that flashes at the same speed as the engine, he is able to see the rotors as clearly as when they are standing still.

1927 Receives M.S. in electrical engineering from MIT. From this time on, he is a permanent member of the MIT faculty: first as research assistant; then as instructor (1928); assistant professor (1932); associate professor (1938); full professor (1948); institute professor (1966); and institute professor emeritus (1968). Although retired in 1968, continues to work in the MIT Stroboscopic Light Laboratory.

1928 Marries Esther May Garrett. They will have three children: Mary (b. 1931), William (b. 1933), and Robert (b. 1935).

1931 Develops and perfects the stroboscope for use in both ultra-high-speed and still (or stop-motion) photography. This discovery is announced in the May issue of *Electrical Engineering*.

Forms partnership with former student Kenneth J. Germeshausen, an MIT research affiliate, to develop the stroboscope and its various applications.

Receives D.Sc. in electrical engineering from MIT.

1932 Begins taking high-speed photographs of familiar activities that move at speeds beyond the perceptive capacities of the human eye. The photographs appear in both popular and technical publications and are used to dramatize the strobe's potential in lectures given to scientists, industrialists, and the general public.

1933 Applies for a U.S. patent for the stroboscope (granted in 1949). Over the next thirty-three years, applies for forty-five patents in his name, including inventions for various electrical circuits, flash photography methods, and flash-producing systems.

Three of his photographs are included in the Royal Photographic Society's annual exhibition in London. This is the first time Edgerton exhibits his work.

1934 Herbert E. Grier, another former student of Edgerton's, joins the partnership of Edgerton and Germeshausen. They continue to develop ultra-high-speed photography and unique stroboscopic and other flash techniques. They apply the strobe to high-speed motion pictures by making possible the continuous

revolving machinery, thereby helping to increase the level of quality control. This application of the stroboscope is particularly useful in the textile, automobile, appliance, and structural engineering industries.

1937 Designs one of the first successful underwater camera and lighting systems. On an expedition aboard the research vessel *Bear* of the Woods Hole Oceanographic Institution, takes photographs of rare marine organisms.

Edgerton began his investigations of the strobe and photography as a young electrical engineer, because he was interested in trying to study the action of motors. He discovered that a light flickering at the same speed as the motor would make it appear to stand still. He is shown here in 1928 observing the whirling motor and its deceptively static compass points.

movement of film at a uniform speed. They build an electrical contactor for synchronizing flash and film, thereby raising the maximum number of frames possible to photograph per second in motion pictures from 250 to 6,000.

Ten of Edgerton's high-speed photographs are included in the Royal Photographic Society's annual exhibition. Edgerton, Germeshausen, and Grier are awarded the society's Bronze Medal. This is Edgerton's first photography award.

From this time on, the stroboscope is used in many factories for analyzing the revolution rate of rapidly

Begins long association with *Life* magazine photographer Gjon Mili, a graduate of MIT in electrical engineering. Builds and designs flash equipment for Mili. The collaboration produces high-speed photographs that help to bring worldwide attention to Edgerton's stroboscope and popularize the strobe light among commercial and journalistic photographers.

The photograph *Coronet*, taken by Edgerton, is chosen by Beaumont Newhall for inclusion in the first photographic exhibition held at The Museum of Modern Art in New York City. Photographs by Edgerton have continuously been exhibited on the walls of the museum since this exhibition.

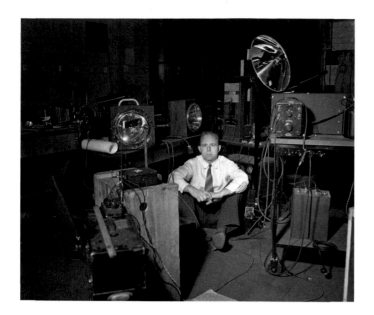

The early strobe equipment, shown surrounding the young Edgerton in his lab in 1942, was a far cry from today's compact cameras with built-in flash units.

1938 Perfects multiflash photography of athletes in action. Unsuccessfully attempts to sell the concept of electronic flash to major U.S. camera manufacturers. Contacts sports photographers and offers them his services and equipment. By 1940, sports photography is revolutionized by Edgerton's technique, which allows the camera to capture high-speed motion and preserve an unprecedented degree of detail. Electronic flash photographs of sports events are regularly published in major newspapers after 1940.

1939 The U.S. Army Air Force commissions Edgerton to design a strobe lamp powerful enough to be used for aerial photography at night.

First book, *Flash! Seeing the Unseen by Ultra High-Speed Photography*, coauthored with James R. Killian, Jr., is published to critical acclaim. E. F. Hall, reviewing *Flash!* in *The New York Times*, says, "This whole book . . . covering the fields of nature, sport, and industry, is a compilation of magic and of things undreamed, calculated to excite the most sluggish mind."

1940 Works at MGM Studios in Hollywood, demonstrating how to use high-speed photography to make movies. Collaborates with Pete Smith on the Academy Award–winning film short, *Quicker Than a Wink*.

Receives the Modern Pioneers Award from the National Association of Manufacturers, in recognition of his role as a "modern pioneer in the frontier of American industry."

1941 Receives the Howard N. Potts Medal from the Franklin Institute for the invention of a high-speed motion picture camera that "increased knowledge in the fields of pure and applied science."

1944 Serves in Italy, England, and France as a technical representative for the U.S. Army Air Force. Directs use of his strobes for nighttime aerial reconnaissance photography, providing vital intelligence information about troop movements in enemy territory. They are used in the nights immediately preceding the D-day invasion of Normandy, during the Battle of Monte Cassino, and in campaigns in the Far East.

1946 Receives the Medal of Freedom from the War Department in recognition of his achievements in developing nighttime aerial photography during the Second World War.

1947 With partners Germeshausen and Grier, forms Edgerton, Germeshausen, and Grier, Inc. (now EG&G,

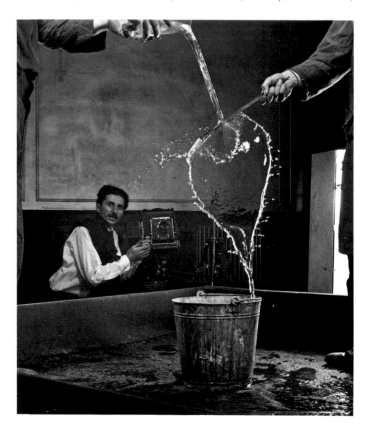

Gjon Mili, a classmate of Edgerton's at MIT, became a famous photographer on the staff of *Life* magazine and publicized the strobe with his eloquent and artistic multiflash pictures. Edgerton built equipment for Mili, who is shown here in a 1937 single-flash photograph taken by his mentor.

Inc.), a company specializing in electronic technology. As prime contractors for the Atomic Energy Commission, they design and operate systems that time and fire U.S. nuclear bomb tests. Edgerton and colleagues will invent a camera (the Rapatronic) capable of photographing nuclear explosions from a distance of seven miles.

The first of his many articles for *National Geographic* magazine is published. "Hummingbirds in Action" contains high-speed photographs that illustrate for the first time the wing movement and flight patterns of these tiny birds.

1949 *The Exact Instant*, a photographic exhibition curated by Edward Steichen, is held at The Museum of Modern Art in New York. A history of news photography, the exhibition includes photographs by Edgerton.

Receives the Joseph A. Sprague Memorial Award from the National Press Photographers Association for "outstanding major technical advances . . . to the profession of press photography" and for "the cumulative results of his work which have brought better pictures as well as hitherto impossible pictures into public print."

1950 With colleagues Germeshausen and Grier designs camera shutter with no moving mechanical parts, making possible still photographs with an exposure time of from four- to ten-millionths of a second.

1952 Goes to Eniwetok Atoll in the Pacific to photograph nuclear explosions. Despite adverse weather and environmental conditions, successfully photographs H-bomb tests at the moment of detonation.

1953 Under the sponsorship of the Research Committee of the National Geographic Society, becomes involved in underwater research. Designs electronic flashtube camera equipment capable of operating in the deepest parts of the ocean, where the pressure is eight and one-half tons per square inch. From this time on, designs underwater cameras and special sonars capable of data transmission, distance measurements, and the location of objects in underwater exploration.

Begins long association with French underwater explorer Jacques-Yves Cousteau, accompanying him on numerous expeditions aboard the research vessel *Calypso*. They explore and photograph sea floors from the Mediterranean to Lake Titicaca in the Andes Mountains. To position underwater cameras on these expeditions, Edgerton designs a "pinger" device that is attached to a submerged camera. Sound waves, emitted from the pinger and returning as echoes from the ocean floor, indicate how close the camera is to the bottom. On these expeditions, Edgerton also experiments with the side-scan sonar, an acoustic device used to locate objects lying on the ocean floor.

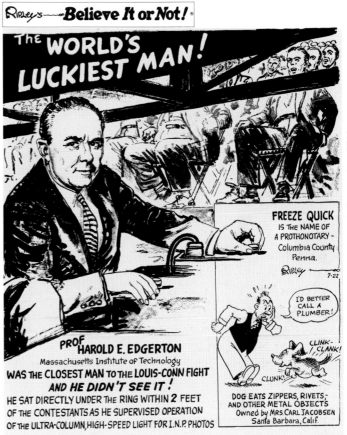

©Ripley's Believe It or Not! a division of Jim Pattison Industries, Inc., 1946.

Edgerton was happy to let his cameras view the Louis-Conn fight. He knew his strobe pictures would revolutionize the way all sports are seen.

1954 Designs and builds flash equipment for a 13,285-foot dive off the Senegal coast by the French bathyscaphe *FNRS III*. Assists with cameras and lighting for subsequent dives by the bathyscaphes *FNRS III*, *Trieste*, and *Archimede*.

1958 With colleagues at MIT, perfects new techniques for taking pictures of shock waves by electronic flash. This system allows pictures to be made of large-scale shocks, such as those made by explosives.

At about this time, EG&G begins to diversify its activities. Special electronic circuitry is applied to spacecraft and underwater equipment, and sonar

technology and specialized flash equipment are developed and manufactured.

1959 Receives the Progress Award from the Society of Motion Picture and Television Engineers for his "outstanding achievement in motion picture technology."

An exposure of 1/100,000 of a second caught this 1936 picture of hummingbirds in action. Since their wings beat sixty times per second, accurate observations of hummingbirds' activities had eluded naturalists before flash photography. Edgerton's strobe revolutionized bird photography and dozens of his pictures appeared in *National Geographic* magazine and naturalist publications.

1960 Aboard the research vessel *Chain* of the Woods Hole Oceanographic Institution, accompanies expedition to Puerto Rico to photograph ocean floor. Using his new sonar "thumper," a device capable of subbottom penetration of the sea floor, Edgerton and colleagues locate rocks thought to be the first specimens ever obtained from the deepest layer of the earth's crust.

1961 Designs the "boomer," a sonar device useful for continuous seismic profiling of the bottom of the sea.

1964 With colleagues at MIT, develops technique, using

stroboscopic lighting and special cameras, for taking motion pictures of the blood flow in the capillaries of humans.

Receives the New England Aquarium Citation for accomplishments in the field of oceanography that have "contributed immeasurably to man's knowledge, understanding, and enjoyment of the world of water and its inhabitants."

1965 One-man photographic exhibition held at the Museum of Science, Boston.

Becomes honorary chairman of the board of EG&G.

Receives the Morris E. Leeds Award from the Institute of Electrical and Electronics Engineers.

Receives the Technical Achievement Award from the American Society of Magazine Photographers for his "lifetime of dedication to exploring and developing new techniques in photography, not only on the earth, but in outer space and under the seas."

1966 With Greek archaeologists, goes on first of several sonar expeditions in search of ancient Helice in the Gulf of Corinth, a city submerged by earthquakes and volcanic eruptions in about 373 B.C.

Receives appointment as Institute Professor at MIT, an honor awarded to distinguished faculty members upon nomination by their colleagues on the faculty.

1967 John Szarkowski organizes *Once Invisible* at The Museum of Modern Art in New York, featuring photographs by Edgerton.

1968 Using his penetrating sonar, locates the *Mary Rose*, an English warship sunk during the reign of Henry VIII.

With colleagues, designs an elapsed-time photographic system capable of photographing underwater events, using strobe lights for illumination. This system makes possible the observation of underwater events normally too slow to be seen, such as the movement of sand dollars or sea urchins.

Receives the John Oliver LaGorce Gold Medal from the National Geographic Society for "contributions to science and exploration through invention and development of electronic, photographic, and geophysical equipment."

1969 Participates as guest scientist aboard the Soviet oceanographic research vessel *Akademik Kurchatov.*

Uses sonar equipment and underwater cameras in exploring the mid-Atlantic Rift Valley.

Second book, *Electronic Flash, Strobe*, is published.

1971 Dedication of the Harold E. Edgerton Research Laboratory at the New England Aquarium in Boston.

1973 Using side-scan sonar, Edgerton and colleagues locate the sunken Civil War battleship USS *Monitor*, lost since 1862, off Cape Hatteras, North Carolina. The battleship lies upside down in 220 feet of water.

With eighty other scientists, goes to Akjoujt in Mauritania to record changes in light and color during one of the longest solar eclipses (some seven minutes) in this century.

Receives the U.S. National Medal of Science, awarded by President Richard M. Nixon at the White House.

To honor Harold and Esther Edgerton for many years of hospitality and encouragement to students and faculty, the MIT Corporation establishes the Edgerton Fund to support younger faculty and student research at MIT.

1974 Second one-man photographic exhibition held at the Museum of Science in Boston.

An acclaimed teacher, who has been honored frequently for his contributions to education, Edgerton received in 1966 the rare nomination of Institute Professor at MIT. The Stroboscopic Light Laboratory is a favorite haunt of MIT students—for this class in 1963—and for generations of students before and after them.

1975 Using side-scan sonar, Edgerton and Cousteau locate the British Army hospital ship HMS *Britannic* (a sister ship to the *Titanic*), which was sunk by a mine off the Greek coast during the First World War.

Donates photographs and strobe exhibit to the Fox Talbot Museum in Lacock, England.

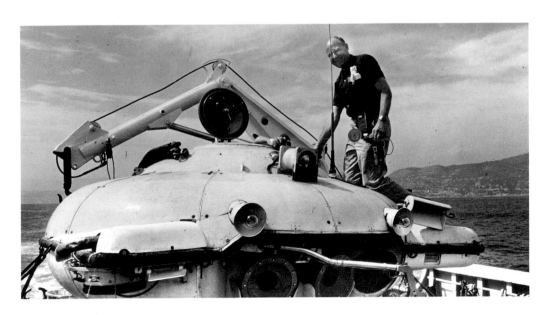

From their first meeting at MIT in 1953, Edgerton and Jacques-Yves Cousteau were regular collaborators on underwater expeditions. Edgerton was nicknamed "Papa Flash" by the *Calypso* crew, who were enormously endebted to his ingenious camera, lighting, and sonar systems. Edgerton is pictured here next to the famous bathyscaphe *Soucoup*, which could descend to depths of several thousand feet.

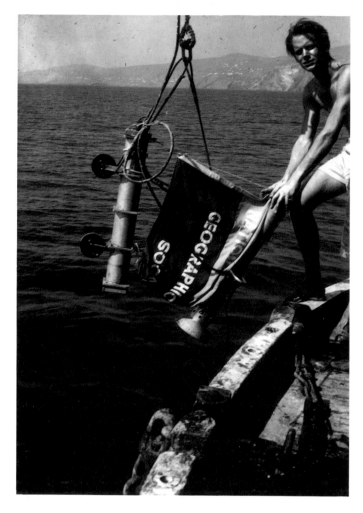

Bill Edgerton prepares an early deep-sea strobe camera, designed by his father, aboard the *Calypso*, Cousteau's research ship, near Toulon, France, 1954. A later camera with similar features (now manufactured by Benthos, Inc.) helped to record the *Titanic*'s wreck (page 161).

One-man photographic exhibitions held at the National Academy of Sciences in Washington, D.C., and the Massachusetts College of Art in Boston.

Ends active association with EG&G, Inc., and becomes emeritus chairman of the board.

1976 Accompanies expedition, cosponsored by *The New York Times* and the Institute of Applied Sciences, to Loch Ness in Scotland to conduct a search for the Loch Ness monster using sonar scanners and underwater cameras.

With colleagues, develops high-speed silhouette photography that allows live microscopic organisms to be photographed in the sea at their natural depths or just moments after being pulled from the sea. Before this, microorganisms could only be photo-

graphed and examined through a microscope under laboratory conditions.

One-man photographic exhibition, entitled *Seeing the Unseen*, travels to museums, universities, and galleries throughout Great Britain. This exhibition is now in permanent installations at the Victoria and Albert Museum and the Science Museum in London.

Year-long exhibition sponsored by the Association of Science-Technology Centers, also entitled *Seeing the Unseen*, travels to museums throughout the United States.

Permanent display of cameras, strobe equipment, and photographs is installed at the Plainsman Museum in Aurora, Nebraska.

Other photographic exhibitions held at the Galerie Agathe Gaillard and the Bibliothèque Nationale in Paris; The Museum of Modern Art in New York City; the Smithsonian Institution and the National Geographic Society in Washington, D.C.; the International Museum of Photography at the George Eastman House and the Visual Studies Workshop in Rochester, New York.

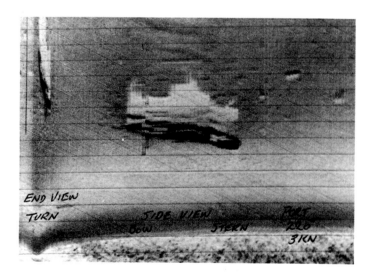

The marine world, underwater archaeology, and naval history are all passionate pursuits of Edgerton's. Using his sonar and photographic probes, he has helped discover rare organisms and lost ships (including the *Mary Rose* and the *Monitor*) and even gone in search of lost cities. To understand what is happening in the deepest parts of the ocean—or even below the surface of the seabed—Edgerton pioneered sonar-scanning systems that actually "draw" the data they record. In this 1969 scan, two views of a ship sunk in the Bay of Patras, off the coast of Greece, are detailed. The acoustical shadow of the ship can also be seen in the side view.

A view of the top of a lava mountain in the Rift Valley, eight thousand feet deep. The photograph was taken by an Edgerton-made camera while he was on expedition as a guest scientist aboard the Soviet ship *Akademik Kurchatov.*

1977 First limited-edition portfolio, *Seeing the Unseen: Twelve Photographs by Harold Edgerton*, is edited and published by Gus Kayafas. (From this time on Kayafas assumes role of picture editor for Edgerton.)

Dedication of the MIT Sea Grant research vessel *Edgerton*, a seagoing laboratory and classroom.

Appears in the PBS television program, "Return to the *Britannic*," which chronicles the search with Cousteau for the hospital ship HMS *Britannic.*

Photographic exhibitions held at the Vision Gallery of Photography in Boston; the Stephen Wirtz Gallery in San Francisco; and the Center for Creative Photography at the University of Arizona in Tucson.

1978 Photographic exhibitions held at the Tokyo Prince Hotel in Japan; the Fotografiska Museet in Stockholm; the Exhibition Gallery at the Toronto Super-Eight Film Festival; the Compton Gallery at MIT; the Gilbert Gallery in Chicago; and the Neikrug Galleries in New York City.

1979 Third book, *Moments of Vision*, coauthored with James R. Killian, Jr., is published.

1980 A National Geographic Society television special, "The Invisible World," features interviews with and documentary material about Edgerton.

1981 Accompanies geologists on expedition to Venice to conduct seismic profiles of the substrata of the Grand Canal.

One-man photographic exhibition held at Haverford College in Haverford, Pennsylvania.

Receives the *Kulturpreis der DGPh* (Cultural Prize of the German Society for Photography). Award presented in Cologne.

1982 The New England Aquarium establishes the Harold E. Edgerton Research Fund to enable young scientists to continue oceanographic research at the Aquarium.

Two-part photographic exhibition, *Floods of Light: Flash Photography 1851–1981*, at the Photographers' Gallery in London features works by Edgerton.

Named "New England Inventor of the Year" by MIT, the Boston Patent Law Association, and the Museum of Science in Boston. Citation reads: "He has pressed back the frontiers of our knowledge of vision and mo-

tion with his stroboscopic photography, and, through his marvelous medium, he has captured and revealed new beauty and order in both nature and industry."

One-man photographic exhibition held at the Daniel Wolf Gallery in New York City, edited by Gus Kayafas.

Other photographic exhibitions held at the Schenectady Museum in Schenectady, New York; the Sheldon Memorial Art Gallery in Lincoln, Nebraska; and the Joseloff Gallery at Hartford Art School in West Hartford, Connecticut.

1983 MIT dedicates "Strobe Alley," an eighty-foot corridor museum at MIT of Edgerton's photographs and equipment, as well as artifacts recovered on voyages.

Dedication of the EG&G Education Center at MIT, a teaching and conference facility built with gifts from Edgerton, Germeshausen, Grier, and EG&G, Inc.

One-man photographic exhibitions held at the Massachusetts College of Art in Boston and the Lehigh University Art Galleries in Bethlehem, Pennsylvania.

Receives the Eastman Kodak Gold Medal from the Society of Motion Picture and Television Engineers.

Receives the 18th Founders Award from the National Academy of Engineering.

1984 Second limited-edition portfolio, *Sports Multiflash Photographs*, is published by the MIT Museum and Palm Press, Inc.

One-man photographic exhibitions held at the Pace-MacGill Gallery in New York City and the Rose Gallery in Boston.

1985 Accompanies Cousteau aboard *Calypso* on expedition off Matanzas harbor, near Havana, Cuba, in search of Spanish wrecks.

Third limited-edition portfolio, *Harold Edgerton: Ten Dye-Transfer Photographs*, is published by Palm Press, Inc.

The PBS Nova series airs "Edgerton and His Incredible Seeing Machines," a program based on a film originally produced by Nebraska Educational Television that explores the career and inventions of Edger-

DOONESBURY by Garry Trudeau

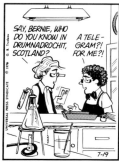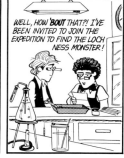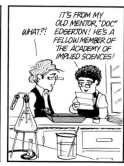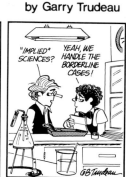

DOONESBURY by Garry Trudeau

In 1976, when Edgerton went to search for the Loch Ness monster as a member of an expedition cosponsored by *The New York Times* and the Academy of Applied Sciences, scientists and satirists took note. Cartoonist Garry Trudeau, always on the lookout for campus stories, used the opportunity to present the student's view of MIT's

esteemed professor. The monster, alas, eluded even Edgerton's highly sophisticated sonar and photographic equipment. Although the expedition's findings brought attention from the international science community, Edgerton chose not to draw any definitive conclusions about the monster's existence.

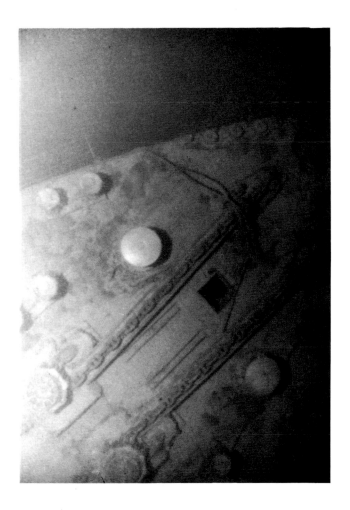

Perhaps the most sensational underwater discovery was made by Robert Ballard and the Woods Hole Oceanographic Institution's team, who found the *Titanic*. Views of the ship, which was lost in 1912, were recorded with an Edgerton-Benthos camera. Anchor chains on the bow of the ship are clearly visible. © Woods Hole Oceanographic Institution.

ton and documents the development of stroboscopic photography.

One-man photographic exhibition held at the Govinda Gallery in Washington, D.C.

Receives the Eugene McDermott Award from the Council for the Arts at MIT.

1986 Inducted into the National Inventors Hall of Fame by the United States Patent and Trademark Office, for the invention and application of the modern stroboscope to science, industry, and the arts.

Fourth book, *Sonar Images*, is published.

The Edgerton-Benthos underwater camera is used to photograph the sunken RMS *Titanic*, discovered off the coast of Nova Scotia during the summer. Photographic exhibition, *Beyond Sight*, begins a two-year tour at the Spencer Museum of Art in Lawrence, Kansas, featuring eighty-five photographs by Edgerton. At the Spencer Museum of Art, Edgerton's photo-

graphs are displayed with scientific drawings by Leonardo da Vinci.

One-man photographic exhibition held at the De Cordova Museum in Lincoln, Massachusetts.

Interactive art/science exhibition, *Making Waves*, at the Evanston Art Center, Evanston, Illinois, features photographs by Edgerton.

1987 Major retrospective exhibition held at the International Center of Photography in New York City. Receives ICP's Lifetime Achievement Award.

1988 Awarded the National Medal of Technology by President Ronald Reagan in a ceremony at the White House.

1990 On January 4, at the age of 86, after lunch at the MIT Faculty Club with Bill MacRoberts, his friend and associate of nearly fifty years, Harold Edgerton died of a sudden heart attack.

COMPLETE BIBLIOGRAPHY OF BOOKS AND ARTICLES BY HAROLD E. EDGERTON

BOOKS

With James R. Killian, Jr. *Flash! Seeing the Unseen by Ultra High-Speed Photography.* Boston: Hale, Cushman & Flint, 1939; 2d ed. Boston: Charles T. Branford, 1954.

Electronic Flash, Strobe. New York: McGraw-Hill, 1970. 2d ed. Cambridge: MIT Press, 1979.

With James R. Killian, Jr. *Moments of Vision: The Stroboscopic Revolution in Photography.* Cambridge: MIT Press, 1979.

Sonar Images. Englewood Cliffs, N.J.: Prentice-Hall, 1986.

ARTICLES

With W. V. Lyon. "Transient Torque-Angle Characteristics of Synchronous Machines." *Transactions of the American Institute of Electrical Engineers* 49 (April 1930): 686–99.

With F. J. Zak. "The Pulling-Into Step of a Synchronous Induction Motor." *Institution of Electrical Engineers Journal* 68, no. 405 (September 1930): 1205–10.

"Stroboscopic Moving Pictures." *Electrical Engineering (American Institute of Electrical Engineers)* 50, no. 5 (May 1931): 327–29.

"The Mercury Arc as a Source of Intermittent Light." *Journal of the Society of Motion Picture Engineers* 16 (June 1931): 735.

With P. Fourmarier. "The Pulling-Into-Step of a Salient-Pole Synchronous Motor." *Transactions of the American Institute of Electrical Engineers* 50 (June 1931): 769–81.

With P. Fourmarier. "Synchronizing Salient-Pole Motors." *Electrical Engineering (American Institute of Electrical Engineers)* 50, no. 6 (June 1931): 430–31.

"Stroboscopic and Slow-Motion Moving Pictures by Means of Intermittent Light." *Journal of the Society of Motion Picture Engineers* 18 (March 1932): 356–64.

With K. J. Germeshausen. "Stroboscopic Photography." *Electronics* 5, no. 1 (July 1932): 220–21.

With K. J. Germeshausen. "The Mercury Arc as an Actinic Stroboscopic Light Source." *Review of Scientific Instruments* 3, no. 10 (October 1932): 535–42.

With K. J. Germeshausen, et al. "Synchronous-Motor Pulling-Into-Step Phenomena." *Transactions of the American Institute of Electrical Engineers* 52 (June 1933): 342–51.

With K. J. Germeshausen, et al. "Pulling-Into-Step Equations Solved." *Electrical Engineering (American Institute of Electrical Engineers)* 52, no. 10 (October 1933): 707–12.

With K. J. Germeshausen. "Catching the Click with a Stroboscope." *American Golfer*, November 1933.

With K. J. Germeshausen. "Stroboscopic-Light, High-Speed Motion Pictures." *Journal of the Society of Motion Picture Engineers* 23 (November 1934): 284–98.

"High-Speed Motion Pictures." *Electrical Engineering (American Institute of Electrical Engineers)* 54 (February 1935): 149–53.

"Study of the Flow of Air with a Stroboscope." *Mechanical Engineering* 57 (April 1935): 228–29.

"A Stroboscopic Power Angle Recorder." *Electrical Engineering (American Institute of Electrical Engineers)* 54, no. 5 (May 1935): 485–88.

With K. J. Germeshausen and H. E. Grier. "High-Speed Photography." *Photographic Journal* 76 (April 1936): 198–204.

With K. J. Germeshausen. "A Cold-Cathode Arc-Discharge Tube." *Electrical Engineering (American Institute of Electrical Engineers)* 55, no. 7 (July 1936): 790–809.

With E. A. Hauser, et al. "The Application of the High-Speed Motion Picture Camera to Research on the Surface Tension of Liquids." *Journal of Physical Chemistry* 40, no. 8 (November 1936): 973–88.

With N. S. Gingrich and R. D. Evans. "A Direct-Reading Counting Rate Meter for Random Pulses." *Review of Scientific Instruments* 7 (December 1936): 450–56.

With K. J. Germeshausen and H. E. Grier. "High-Speed Photographic Methods of Measurement." *Journal of Applied Physics* 8, no. 1 (January 1937): 2–9.

With K. J. Germeshausen. "The Strobotron." *Electronics* 10, no. 2 (February 1937): 12–14.

With K. J. Germeshausen, et al. "The Strobotron—II." *Electronics* 10, no. 3 (March 1937): 18–21.

With E. A. Hauser and W. B. Tucker. "Studies in Drop Formation as Revealed by the High-Speed Motion Camera." *Journal of Physical Chemistry* 41, no. 7 (October 1937): 1017–28.

With F. E. Barstow. "Glass-Fracture Velocity." *Journal of the American Ceramic Society* 22, no. 9 (September 1939): 302–7.

With K. J. Germeshausen and H. E. Grier. "Multiflash Photography." *Photo Technique* 1, no. 5 (October 1939): 14–16.

With M. W. Jennison. "Droplet Infection of Air: High-Speed Photography of Droplet Production by Sneezing." *Proceedings of the Society for Experimental Biology and Medicine* 43 (1940): 455–58.

With C. E. Turner and M. W. Jennison. "Public Health Applications of High-Speed Photography." *American Journal of Public Health* 31, no. 4 (April 1941): 319–24.

With F. E. Barstow. "Further Studies of Glass Fracture with High-Speed Photography." *Journal of the American Ceramic Society* 24, no. 4 (April 1941): 131–37.

With C. M. Breder, Jr. "High-Speed Photographs of Flying Fishes in Flight." *Zoologica* (New York) 26, pt. 4 (December 1941): 311–14.

With P. M. Murphy. "Electrical Characteristics of Stroboscopic Flash Lamps." *Journal of Applied Physics* 12, no. 12 (December 1941): 848–55.

With C. M. Breder, Jr. "An Analysis of the Locomotion of the Seahorse, *Hippocampus,* by Means of High-Speed Cinematography." *Annals of the New York Academy of Science* 43 (June 1942): 145–72.

"Photographic Use of Electrical Discharge Flashtubes." *Journal of the Optical Society of America* 36, no. 7 (July 1946): 390–99.

"Night Aerial Photography." *Technology Review* 49, no. 5 (March 1947).

"Airborne Photographic Equipment." *Journal of the Physical Society of America*, July 1947, 439–40.

"The Past, Present and Future of High-Speed Photography." *Journal of the Physical Society of America*, July 1947, 437–38.

"Hummingbirds in Action." *National Geographic* 92, no. 2 (August 1947): 220–24.

"Circus Action in Color." *National Geographic* 93, no. 3 (March 1948): 305–8.

"Light Meter for Electric Flash Lamps." *Electronics* 21 (June 1948): 78–81.

"Electrical Flash Photography." *Journal of the Society of Motion Picture Engineers* 52 (March 1949): 8–23.

"Light-Meter Uses with Electronic Flash." *Journal of the Physical Society of America*, January 1950, 6–10.

With R. S. Carlson. "The Stroboscope as a Light Source for Motion Pictures." *Journal of the Society of Motion Picture and Television Engineers* 55 (July 1950): 88–100.

With C. W. Wyckoff. "A Rapid-Action Shutter with No Moving Parts." *Journal of the Society of Motion Picture and Television Engineers* 56 (April 1951): 398–406.

With R. J. Niedrach and W. Van Riper. "Freezing the Flight of Hummingbirds." *National Geographic* 100, no. 2 (August 1951): 245–61.

With C. H. Winning. "Explosive Argon Flashlamps." *Journal of the Society of Motion Picture and Television Engineers* 59 (September 1952): 178–83.

"Double-Flash Microsecond Silhouette Photography." *Review of Scientific Instruments* 23, no. 10 (October 1952): 532–33.

With K. J. Germeshausen. "A Microsecond Still Camera." *Journal of the Society of Motion Picture and Television Engineers* 61 (September 1953): 286–94.

"The One-Microsecond Rapatronic Camera." *Research Film* no. 3 (December 1953): 5–6.

With R. Bonazoli and J. T. Lamb. "Duration and Peak Candlepower of Some Electronic Flashlamps." *Journal of the Society of Motion Picture and Television Engineers* 63 (July 1954): 15–18.

"Electronically Produced and Controlled Illumination." *IRE Transactions on Industrial Electronics*, March 1955, 51–56.

"Photographing the Sea's Dark Underworld." *National Geographic* 107, no. 4 (April 1955): 523–37.

With L. D. Hoadley. "Cameras and Lights for Underwater Use." *Journal of the Society of Motion Picture and Television Engineers* 64 (July 1955): 345–50.

With B. F. Logan, Jr. "Characteristics of a Flashtube for Aerial Night Reconnaissance." *Photographic Engineering* 6, no. 2 (1955): 110–15.

With F. I. Strabala. "A Rapid-Closing Electronically Operated Shutter." *Review of Scientific Instruments* 27, no. 3 (March 1956): 162.

"Multiflash Microsecond Flash Photography." *Research Film* 2, no. 3 (July 1956): 110–13.

With P. Y. Cathou. "Xenon Flashtube of Small Size." *Review of Scientific Instruments* 27, no. 10 (October 1956): 821–25.

With G. W. LeCompte. "Xenon Arc Transients, Electrical and Optical." *Journal of Applied Physics* 27, no. 12 (December 1956).1427–30.

With J.-Y. Cousteau, et al. "Nylon Rope for Deep-Sea Instrumentation." *Deep-Sea Research* 4 (1957): 287.

"Xenon Flashtube of Small Volume." In *Proceedings of the Third International Congress on High-Speed Photography*, ed. R. B. Collins, 51–56. New York: Academic Press, 1957.

"Shock-Wave Photography of Large Subjects in Daylight." *Review of Scientific Instruments* 29, no. 2 (February 1958): 171–72.

With L. Breslau. "The Luminescence Camera." *Journal of the Biological Photographic Association* 26, no. 2 (May 1958): 49–58.

"Outdoor Daylight Photography of Shock Waves." *Research Film* 3, no. 1 (June 1958): 33–37.

"Shock-Wave Photography Improved." *Industrial Laboratories*, July 1958, 6–8.

"Electronic High-Speed Motion Pictures." *Electronic Equipment Engineering*, November 1958, 43–48.

"Photographing Shock Waves in Daylight." *Industrial Photography*, December 1958, 64–65.

"Photography of Very Early States of Nuclear Explosions." *Journal of the Society of Motion Picture and Television Engineers* 68 (February 1959): 77–79.

"Stopping Fast-Transient Events." *Industrial Photography*, February 1959, 58

With V. Sundra and D. Sinclair. "Double Flash Stops Caps." *Industrial Photography*, August 1959.

With F. E. Barstow. "Multiflash Photography." *Photographic Science and Engineering* 3, no. 6 (November–December 1959): 288–91.

With J.-Y. Cousteau. "Underwater Camera Positioning by Sonar." *Review of Scientific Instruments* 30, no.12 (December 1959): 1125–26.

"Examples of High-Speed Photography." In *Proceedings of the Fourth International Congress on High-Speed Photography*, ed. H. Schardin and O. Helwich, 9–15. Darmstadt: Verlag Dr. Othmar Helwich, 1959.

"Submicrosecond Flashes of Light." In *Proceedings of the Fourth International Congress on High-Speed Photography*, ed. H. Schardin and O. Helwich, 91–97. Darmstadt: Verlag Dr. Othmar Helwich, 1959.

With D. Andrus. "Tungsten Flash Lamps." *Society of Photo-Optical Instrumentation En-*

gineers Newsletter, January 1960.

"Seeing Far below the Sea." Technology Review 62, no. 5 (March 1960): 35–38.

With S. O. Raymond. "Instrumentation for Exploring the Oceans." Electronics 33, no. 15 (April 1960): 62–63.

"Stonehenge: New Light on an Old Riddle." National Geographic 117, no. 6 (June 1960): 846–66.

"Uses of Sonar in Oceanography." Electronics 33, no. 26 (June 1960): 93–95.

With J. B. Hersey, et al. "Sonar Uses in Oceanography." Instrument Society of America Conference, Preprint #21-NY-60, New York, September 1960.

With D. A. Cahlander. "Holdover in Xenon Flashlamps." Journal of the Society of Motion Picture and Television Engineers 70 (January 1961): 7–9.

With J. B. Hersey, et al. "Pingers and Thumpers Advance Deep-Sea Exploration." Instrument Society of America Journal 8, no. 1 (January 1961): 72–77.

With L. D. Hoadley. "Protection for Underwater Instruments." Transactions of the American Institute of Electrical Engineers 1: 79, no. 52 (January 1961): 689–94.

With J. Tredwell and K. W. Cooper, Jr. "Submicrosecond Flash Sources." Journal of the Society of Motion Picture and Television Engineers 70 (March 1961): 177–80.

With L. D. Hoadley. "Pressure Testing Facility Produced Inexpensively from 16-inch Naval Shells." Underwater Engineering 2, no. 2 (March–April 1961): 29–30.

With P. A. Miles. "Optically Efficient Ruby Laser Pump." Journal of Applied Physics 32, no. 4 (April 1961): 740–41.

With R. O. Shaffner. "Measuring Transient Light with Vacuum Phototubes." Electronics 34, no. 34 (August 1961): 56–57.

With A. J. Nalwalk, et al. "Improved Techniques of Deep-Sea Rock-Dredging." Deep Sea Research 8 (1961): 301–2.

With R. Hopkins. "Lenses for Underwater Photography." Deep-Sea Research 8 (1961): 312–17.

"Xenon Flash Lamp Design." In Second International Conference on Quantum Electronics, ed. Jay R. Singer, 276–87. New

York: Columbia University Press, 1961.

"Uses of Electronic Flash with Submicrosecond Duration." Society of Photo-Optical Instrumentation Engineers Newsletters, April–May 1962, 20–24.

"Concentrated Strobe Lamp." Journal of the Biological Photographic Association 30, no. 2 (May 1962): 45–51.

With G. T. Rogers. "Enhanced Afterglow in Neon by Removal of Electrical Excitation." Science 137 (July 1962): 34–35.

With P. W. Jameson. "Phototube Used for Short Flash Observation." Electronics 35, no. 37 (September 1962): 72–74.

"Close-Up Strobe Motion Pictures." Research Film 4, no. 4 (1962): 310–15.

With L. Breslau, et al. "A Precisely Timed Submersible Pinger for Tracking Instruments in the Sea." Deep-Sea Research 9 (1962): 137–44.

With S. O. Raymond. "Some Recent Advances in Underwater Camera Equipment." In Marine Sciences Instrumentation, vol. 1, ed. Roy D. Gaul, et al., 279–82. Pittsburg: Instrument Society of America, 1962.

With J.-Y. Cousteau, et al. "Nylon Rope for Deep-Sea Instrumentation." Undersea Technology 4 (May 1963): 18–20.

"Sub-Bottom Penetrations in Boston Harbor." Journal of Geophysical Research 68, no. 9 (May 1963): 2753–60.

"Comments on Light Sources." Journal of the Society of Motion Picture and Television Engineers 72 (July 1963): 541.

With J. B. Hersey, et al. "Adaptation of Sonar Techniques for Exploring the Sediments and Crust of the Earth Beneath the Ocean." Journal of the British Institute of Radio Engineers 26, no. 3 (September 1963): 245–49.

"Electronic Flash Illumination of a Large Wilson Cloud Chamber." Applied Optics 2, no. 10 (October 1963): 1013–15.

"Underwater Pinpoint Photography." Journal of the Society of Photo-Optical Instrumentation Engineers 2 (October–November 1963): 3–5.

"Underwater Lamp-Camera Combination." Skin Diver, December 1963, 54–55.

With J. H. Goncz and P. W. Jameson. "Xenon

Flash Lamp Limits of Operation." In Proceedings of the Sixth International Congress on High-Speed Photography, ed. J. G. A. De Graaf and P. Tegelaar, 143–51. Haarlem, Netherlands: H. D. Tjeenk Willink & Zoon N. V., 1963.

With O. Leenhardt. "Experiénces de Sondage Élastique du Fond de la Mer." Rapports et Procès Verbaux des Réunions de la Commission Internationale pour l'Exploration de la Mer Méditerranée 17, no. 3 (1963): 975–84.

With G. G. Hayward. "The 'Boomer' Sonar Source for Seismic Profiling." Journal of Geophysical Research 69, no. 14 (July 1964): 3033–42.

"Ultra-Fast Strobe Photography." Professional Photographer, July 1964, 89–91.

With R. E. Wells, et al. "Cinemicrophotography of Blood Flow in Man." Journal of the Society of Motion Picture and Television Engineers 73 (August 1964): 627–28.

"Underwater Slave." Skin Diver, August 1964, 40–42.

With J. A. Yules. "Bottom Sonar Search Techniques." Undersea Technology 5 (November 1964): 29–32.

With J. F. Carson. "Motion Picture Photomicrography with Electronic Flash." Applied Optics 3, no. 11 (November 1964): 1211–14.

With H. Payson. "Sediment Penetration with a Short-Pulse Sonar." Journal of Sedimentary Petrology 34, no. 4 (December 1964): 876–80.

With H. Payson, et al. "Sonar Probing in Narragansett Bay." Science 146, no. 3650 (December 1964): 1459–60.

"Sub-Bottom Penetration in Boston Harbor, 2." Journal of Geophysical Research 70, no. 12 (June 1965): 2931–33.

With J. F. Carson. "Photographic Guide Factor." Professional Photographer, July 1965, 54–55.

"Electronic Flash Photography." Photographic Journal 105 (September 1965): 237–47.

With P. N. Gallagher, et al. "Measurement of Capillary Blood Flow Using an Electronic Double-Flash Light Source." Review of Sci-

entific Instruments 36, no. 12 (December 1965): 1760–63.

With R. E. Wells and E. R. Schildkraut. "Blood Flow in the Microvasculature of the Conjunctiva ot Man." *Science* 151, no. 3713 (February 1966): 995–96.

"Water-Drop-Producing Equipment." *Science* 151, no. 3717 (March 1966): 1563–64.

With R. T. Troutner. "Deep Sea Incandescent Lamps." *Undersea Technology* 7 (April 1966): 21–26.

With O. Leenhardt. "Mesures d'épaisseur de la Vase sur les Fortes Pentes du Précontinent." *Compte Rendu Académie Sciences* (Paris) 262 (May 1966): 2005–7.

With O. Leenhardt. "Monaco: The Shallow Continental Shelf." *Science* 152, no. 3725 (May 1966): 1106–7.

With P. F. Spangle and J. K. Baker. "Mexican Freetail Bats: Photography." *Science* 153, no. 3732 (July 1966): 201–3.

"Exploring the Sea with Sonar." *Discovery* 27, no. 9 (September 1966): 40–45.

"Sonic Detection of a Fresh Water–Salt Water Interface." *Science* 154, no. 3756 (December 1966).

With D. Neev, et al. "Preliminary Results of Some Continuous Seismic Profiles in the Mediterranean Shelf of Israel." *Israel Journal of Earth Sciences* 15 (1966): 170–78.

With E. Seibold. "Morphologische Untersuchungen am Mittelgrund (Eckernforder Bucht, Westliche Ostsee)." *Meyniana* 16 (1966): 37–50.

With L. Breslau. "The Sub-Bottom Seismic Structure of the Gulf of La Spezia." *Rapports et Procés Verbaux des Réunions de la Commission Internationale pour l'Exploration de la Mer Méditerranée* 18, no. 3 (1966): 951–55.

With O. Leenhardt. "Progrès dans les Études Élastiques du Fond Marin." *Rapports et Procès Verbaux des Réunions de la Commission Internationale pour l'Exploration de la Mer Méditerranée* 18, no. 3 (1966): 927–28.

"Underwater with Strobe Lighting." *Industrial Photography,* July 1967.

"Applications of Xenon Flash." In *Proceed-ings of the Seventh International Congress on High-Speed Photography,* ed. O. Helwich, 3–16. Darmstadt: Verlag Dr. Othmar Helwich, 1967.

With G. Giermann and O. Leenhardt. "Étude Structurale de la Baie de Monaco en Sondage Sismique Continu." *Bulletin of the Institute of Oceanography* (Monaco) 67, no. 1377 (1967).

"The Instruments of Deep-Sea Photography." In *Deep-Sea Photography,* ed. J. B. Hersey, 47–54. Baltimore: Johns Hopkins Press, 1967.

"Light and Sound under Water," In *Proceedings of the Seminar on Underwater Photo-Optics.* Redondo Beach, Calif.: Society of Photo-Optical Instrumentation Engineers, 1967.

With L. Breslau and G. L. Clarke. "Optically Triggered Underwater Cameras for Marine Biology." In *Deep-Sea Photography,* ed. J. B. Hersey, 223–28. Baltimore: Johns Hopkins Press, 1967.

With V. E. MacRoberts. "Multiflash Strobe." In *Proceedings of the Seventh International Congress on High-Speed Photography,* ed. O. Helwich, 72–76. Darmstadt: Verlag Dr. Othmar Helwich, 1967.

With M. Klein. "Sonar: A Modern Technique for Ocean Exploitation." *Institute of Electrical and Electronics Engineers Spectrum* 5, no. 6 (June 1968): 40–46.

With L. Breslau. "A Technique for the Location of Buried Sand and Gravel Deposits in Shallow-Water Areas." *Informal Report,* IR No. 68–77 (Naval Oceanographic Office), October 1968.

"Sound in the Sea: Pictures with Sonar." *Technical Engineering News,* October 1968, 7–13.

"Deep Sea Photography." *NEREM Record,* November 1968, 200–201.

With L. Breslau. "The Sub-Bottom Structure of the Gulf of La Spezia, Italy." *SACLANTCEN Technical Report* (NATO)129 (1968).

With T. Uyemura. "Displacement-Time Recording with a 'String'." In *Proceedings of the Eighth International Congress on High-Speed Photography,* ed. N. R. Nilsson and L. Hogberg, 391–94. New York: John Wi-ley, 1968.

With V. E. MacRoberts and K. R. Read. "An Elapsed-Time Photographic System for Underwater Use." In *Proceedings of the Eighth International Congress on High-Speed Photography,* ed. N. R. Nilsson and L. Hogberg, 488–91. New York: John Wiley, 1968.

With V. E. MacRoberts and M. Khanna. "Improvements in Electronics for Nature Photography." *Institute of Electrical and Electronics Engineers Spectrum* 6, no. 7 (July 1969): 89–94.

"Rift Valley Expedition." *Aquasphere* (New England Aquarium), December 1969, 17–23.

"Seismic Profiling with Sonar." *Oceanology International* 5, no. 8 (August 1970): 22–24.

"Technical Development of Photographic and Undersea Equipment." In *National Geographic Society Research Reports, 1961–1962 Projects,* ed. P. H. Oehser, 73–76. Washington, D.C.: National Geographic Society, 1970.

With V. F. MacRoberts and K. R. Crossen. "Small Area Flash Lamps." In *Proceedings of the Ninth International Congress on High-Speed Photography,* ed. W. G. Hyzer and W. G. Chace, 237–43. New York: Society of Motion Picture and Television Engineers, 1970.

With P. E. Throckmorton and E. Yalouris. "The Battle of Lepanto: Search and Survey." *International Journal of Nautical Archaeology and Underwater Exploration* 2, no. 1 (1971): 121–30.

With D. M. Rosencrantz and M. Klein. "The Uses of Sonar." In *Underwater Archaeology: A Nascent Discipline,* 257–70. Museums and Monuments, Series 13. Paris: UNESCO, 1972.

With L. Breslau. "The Gulf of La Spezia, Italy: A Case History of Seismic-Sedimentologic Correlation." In *The Mediterranean Sea,* ed. D. J. Stanley, 177–88. Dowden, Hutchinson & Ross, 1972.

With N. C. Skoufopoulos. "Sonar Search at Gytheion Harbor." *Athens Annals of Archaeology* 5, no. 2 (1972): 202–6.

With G. Udintsev. "Rift Valley Observations by Camera and Pinger." Letter to the Editor. *Deep Sea Research* 20 (1973): 669–71.

"Search for Helice with Sonar." In *National Geographic Society Research Reports, 1966 Projects*, ed. P. H. Oehser, 75–77. Washington D.C.: National Geographic Society, 1973.

With G. T. Rowe, et al. "Time-Lapse Photography of the Biological Reworking of Sediments in Hudson Submarine Canyon." *Journal of Sedimentary Petrology* 44, no. 2 (June 1974): 549–52.

With E. Linder and M. Klein. "Sonar Search at Ashdod, Israel." In *National Geographic Society Research Reports, 1967 Projects*, ed. P. H. Oehser, 71–82. Washington D.C.: National Geographic Society, 1974.

"The *Monitor* is Found." *Technology Review* 77, no. 4 (February 1975).

"Lost Camera on the *Monitor*." *Skin Diver*, June 1975, 40–41.

With D. J. Krotser. "Bright Reflections in High-Resolution Seismic Recordings." In *Ocean 75*, 315–20. New York: Institute of Electrical and Electronics Engineers, 1975.

With P. B. Newell. "Xenon Flash Lamps of the Bulb Type." In *Proceedings of the Eleventh International Congress on High-Speed Photography*, ed. P. J. Rolls, 364–70. London: Chapman & Hall, 1975.

"Techniques and Equipment, Sonar Survey." *International Journal of Nautical Archaeology and Underwater Exploration* 4.1 (1975): 111–16.

With R. H. Rines, et al. "Search for the Loch Ness Monster." *Technology Review* 78, no. 5 (March–April 1976): 25–40.

With D. Wyman. "Rotary Side-Scan Sonar." *Sea Technology*, May 1976, 23–24.

With C. W. Wyckoff. "Moving Objects Observed with Sonar in Loch Ness." *Technology Review* 79, no. 2 (December 1976): 12–13.

"Shadow Photography Revived with a Strobe." *Industrial Photography*, May 1977, 24–25.

"Silhouette Photography of Small Active Subjects." *Journal of Microscopy* (Oxford) 110, pt. 1 (May 1977): 78–81.

With J. S. Wilson. "High-Speed Silhouette Photography of Small Biological Subjects." In *Proceedings of the Twelfth International Congress on High-Speed Photography (Photonics)*, ed. M. C. Richardson, 486–90. Bellingham, Washington: Society of Photo-Optical Instrumentation Engineers, 1977.

"The Camera Raised from the *Monitor* Wreck." *Technology Review* 80, no. 3 (January 1978): A20–A21.

With C. W. Wyckoff. "Sonar: Loch Ness Revisited." *Institute of Electrical and Electronic Engineers Spectrum* 15, no. 2 (February 1978): 26–29.

"Mid-Atlantic and Rift Valley Expedition." In *National Geographic Society Research Reports, 1969 Projects*, ed. P. H. Oehser and J. S. Lea, 121–32. Washington, D.C.: National Geographic Society, 1978.

With O. Leenhardt. "Mediterranean 'Knee-Line' Studies." In *National Geographic Society Research Reports, 1969 Projects*, ed. P. H. Oehser and J. S. Lea, 365–80. Washington, D.C.: National Geographic Society, 1978.

With P. Throckmorton. "Exploring Subbottom Features of a Harbor with Sonar and Magnetometer." In *National Geographic Society Research Reports, 1969 Projects*, ed. P. H. Oehser and J. S. Lea, 133–39. Washington, D.C.: National Geographic Society, 1978.

"Underwater Archaeological Search with Sonar." *Historical Archaeology* 10 (1978): 46–53.

With P. B. Ortner, et al. "Silhouette Photography of Oceanic Zooplankton." *Nature* 277, no. 5691 (January 1979): 50–51.

With P. Throckmorton. "Exploration by Sonar and Coring of the Helice Site, Greece." In *National Geographic Society Research Reports, 1970 Projects*, ed. P. H. Oehser and J. S. Lea, 135–41. Washington, D.C.: National Geographic Society, 1979.

"Techniques and Applications of Xenon Flash." In *Proceedings of the Thirteenth International Congress on High-Speed Photography and Photonics*, ed. Shin-ichi Hyodo, 27–36. Tokyo: Japan Society of Precision Engineering, 1979.

With F. P. McWhorter. "Shadowgraph 'Camera' Makes Giant Enlargements." *Modern Photography*, August 1980.

"Electronic Flash Sources and Films for Plankton Photography." *Journal of Biological Photographic Association* 49, no. 1 (January 1981): 25–26.

With F. P. McWhorter. "Precise Shadowgraphing: A History and a How-To." *Journal of the Physical Society of America*, February 1981, 10–11.

With V. E. MacRoberts. "Spark Point Light Source." *Review of Scientific Instruments* 52, no. 4 (April 1981): 624–25.

"Use of Blue-Sensitive Film." *Photomethods* 24, no. 5 (May 1981): 38–40.

"Bullet Photography." *Photomethods* 24, no. 11 (November 1981): n.p.

"Shadow Photography: An Aid to Microscopy." *Journal of Microscopy* (Oxford) 124, pt. 3 (December 1981): 335–37.

With P. B. Ortner and L. C. Hill. "*In Situ* Silhouette Photography of Gulf Stream Zooplankton." *Deep-Sea Research* 28A (1981): 1569–76.

"Resolution of a Shadow Image." *Optical Engineering* 21, no. 1 (January–February 1982): 30–33.

With W. Bascom. "Sonic Scattering Layers Influenced by Artificial Light." *Bulletin of Marine Science* 32, no. 2 (April 1982): 629–32.

With J. G. Newton. "Search for the *Monitor* and Development of a Camera for Horizontal Underwater Photography." In *National Geographic Society Research Reports, 1973 Projects*, ed. P. H. Oehser, J. S. Lea, and N. L. Powars, 157–60. Washington, D.C.: National Geographic Society, 1982.

"Search for the *Mary Rose*." *Technology Review* 86, no. 1 (January 1983): 64–71.

"Experiences with Inventions." In *Lectures for Inventors*, 56–77. Boston: Trustees of the Public Library of the City of Boston, 1983.

"Exposure Time: It Can Be Important." In *Proceedings of the Fifteenth International Congress on High-Speed Photography and Photonics*, ed. L. L. Endelman, 67–74. Bellingham, Washington: Society of Photo-Optical Instrumentation Engineers, 1983.

"Strobe Photography: A Brief History." *Optical Engineering* 23, no. 4 (July–August 1984): 100–105.

With H. A. Moffitt, II, and M. J. Youngbluth. "High-Speed Silhouette Photography of Live Zooplankton." In *Underwater Photography: Scientific and Engineering Applica-*

tions, comp. Paul Ferris Smith, 305–19. New York: Van Nostrand Reinhold, 1984.

"Time-Lapse Photography." In *Underwater Photography: Scientific and Engineering Applications,* comp. Paul Ferris Smith, 9–11. New York: Van Nostrand Reinhold, 1984.

"Silhouette Camera Plankton Studies." In *National Geographic Society Research Reports, 1978 Projects,* ed. W. Swanson, 185–90. Washington, D.C.: National Geographic Society, 1985.

SELECTED BIBLIOGRAPHY

BOOKS

Dalton, Stephen. *Split Second: The World of High-Speed Photography.* London: J. M. Dent, 1983.

Maloney, T. J., ed. *U.S. Camera 1942.* New York: Duell, Sloan & Pearce, 1941.

Mili, Gjon. *Photographs and Recollections.* Boston: Little, Brown & Co., New York Graphic Society, 1981.

Photography Year, 1980 edition. Alexandria, Va.: Time-Life Books, 1980.

Wildes, Karl L., and Nilo A. Lindgren. *A Century of Electrical Engineering and Computer Science at MIT, 1882–1982.* Cambridge: MIT Press, 1985.

ARTICLES

Basta, Nicholas. "Still Lighting the Way." *Graduating Engineer,* September 1985, 24–27.

"Camera Stops 37-mm. Shell in Flight." *Life,* 7 July 1941, 33.

"Clocking the Nuclear Bomb Tests." *Business Week,* 30 June 1962, 128–32.

"Corporations: Growing with the Mushrooms." *Time,* 17 August 1962, 70.

Crittenden, Jack. "The Man Who Froze Time: A Conversation with 'Doc' Edgerton." *Earthwatch,* Fall 1983, 6–9.

Davis, Stephen. "Doc." *Omni,* September 1979.

"Electronic Flash Is for You." *U.S. Camera,* January 1955, 18–61.

Esterow, Milton. "Faster than a Speeding Bullet." *Art News,* April 1986, 103–6.

Fahey, David. "Interview." *PhotoBulletin* (G.

Ray Hawkins Gallery), May–June 1979.

"Flashes of Inspiration." *Amateur Photographer,* 17 April 1982, 88–89.

Germer, Lucie. "Harold Edgerton and Underwater Photography." *Faces,* May 1985, 25–27.

Goodwin, Derek. "The Sorcerer of Strobe Alley." *Science 82,* June 1982, 37–45.

Graham, David M. "Dr. Harold E. Edgerton: Sonar and Photography Cult Hero," *Sea Technology,* January 1986, 54.

Hall, Carla. "Faster than a Speeding Bullet." *Washington Post,* 6 May 1985.

Hall, E. F. "On Freezing Speed with a Camera." *The New York Times* 14 January 1940.

Hughes, James. "Edgerton of MIT." *Industrial Photography,* November 1961, 40–42.

"Interesting People." *American Magazine,* May 1934, 48.

Kane, H. B. Review of *Flash!* in *Boston Transcript* 6 January 1940.

"Keep off the Grass: High-Speed Cameras Shoot New Revue." *Life,* 2 July 1940, 52–54.

Littell, Robert. "Stopping Time." *Scientific American,* February 1940, 82–84.

McPhee, Michael B. "At MIT, They Call It the Edgerton Factor." *Boston Globe,* 20 September 1983.

Murray, Donald. "The Man Who Stopped Time." *True,* March 1958.

Pepper, Alice. "Tempo Furioso." *Saturday Review,* 2 June 1962.

Pollock, Steve. "Photo-Instrumentation: The

View from 'Strobe Alley'." *Industrial Photography,* July 1976, 48–54.

"Portrait." *Fortune,* November 1936.

Roberts, David. "Doc." *American Photographer,* September 1984, 40–48.

"Speaking of Pictures . . . Stroboscopic Lights Make Action Stand Still." *Life,* 20 November 1939, 10–13.

"Speaking of Pictures . . . These Show Science True and Beautiful." *Life,* 28 July 1941, 9–11.

"Speaking of Pictures . . . These Culminate 70 Years of High-Speed Photography." *Life,* 27 October 1941, 13–15.

"Speaking of Pictures . . . This Is a Cock Fight." *Life,* 14 December 1936, 2–3.

Tassel, Janet. "Pickled Antiquities: Explorations under the Sea." *Moment,* July–August 1984, 24–29.

Thornton, Gene. "Stroboscopic Lighting in the Realm of Art." *The New York Times,* 10 January 1982.

Torrey, Lee. "Harold Edgerton: Inventor and Photographic Wizard." *New Scientist,* 25 October 1979, 264–67.

Trupp, Phil. "Profile: Dr. Harold Edgerton." *Sport Diver,* May–June 1981.

"Twinkler." *American Magazine,* January 1941, 78–79.

White, Pepper. "The Magic of Edgerton." *Technology Review,* January 1984, A6–A9.

Wylie, Francis E. "Genius of the Stroboscope." *Aquasphere* (New England Aquarium) 7, no. 2 (1973): 3–7.

LIST OF ILLUSTRATIONS
PHOTOGRAPHS BY HAROLD EDGERTON
REPRODUCED IN THIS VOLUME.

The number of the page on which the illustration is shown is listed after the photograph's date.